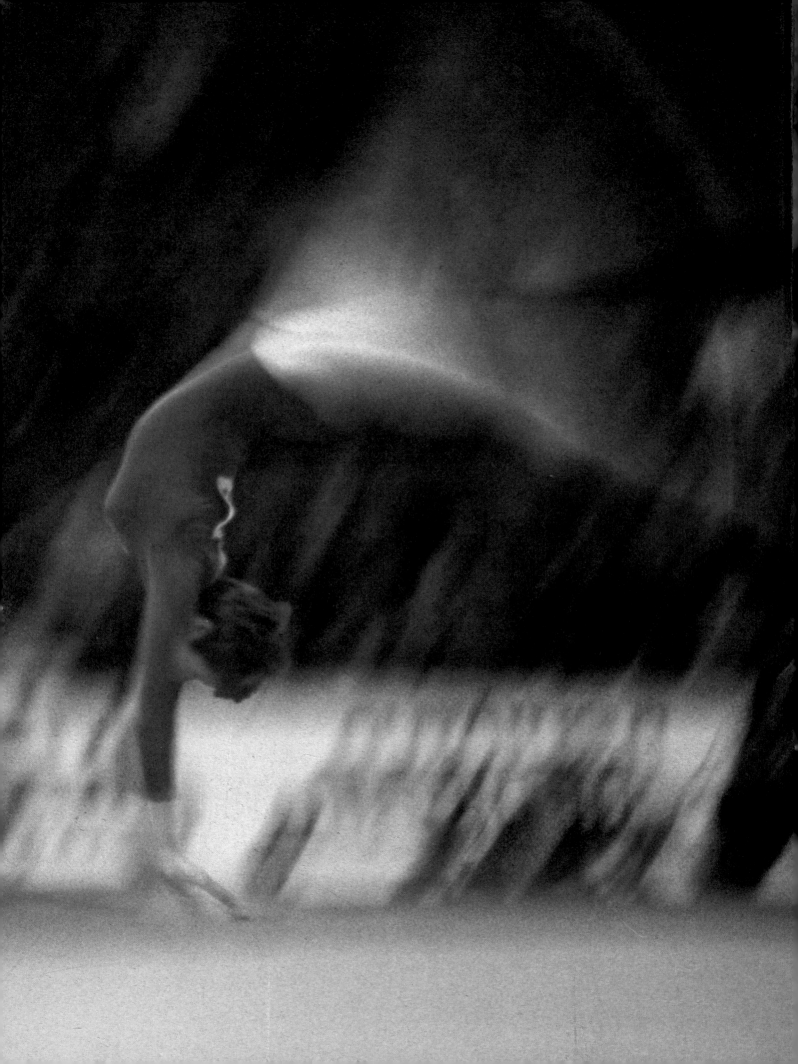

GREAT ACTION PHOTOGRAPHY

Edited by Bryn Campbell

Ebury Press

Published by
Ebury Press
National Magazine House
72 Broadwick Street
London W1V 2BP

First impression 1983

ISBN 0 85223 325 6

Front cover photograph
Francoise Dardelet
Frontispiece photograph
Erich Baumann

Back cover photographs
(top to bottom)
Erich Baumann, Gerry Cranham
and Tony Duffy

Designed by
Peter Baistow

Typeset by
Advanced Filmsetters (Glasgow)
Limited
Printed and bound by
Amilcare Pizzi, s.p.a., Milan

INTRODUCTION

CONTENTS

In interviewing the eight photographers represented in this book, what came through most powerfully was their enthusiasm for sport and their continuing pleasure in photographing it. 'Sports photography is a wonderful profession', exclaimed Erich Baumann, a pro' now for over 30 years but obviously far from blasé. Gerry Cranham, equally as experienced, said, 'I must have covered about 80 different sports and I still find the subject endlessly fascinating'. Neil Leifer, born and bred on the Lower East Side of New York, talked about his early career and his realization that, 'Someone is paying me to do what I enjoy and putting me in the best seat in the house'. Tony Duffy used to deliver newspapers as a kid and marvel at the sports pictures on the back pages. That excitement has stayed with him – 'Photography for me is purely a way of expressing my wonder at the world of sport and all it involves'.

All these photographers are professionals. They have a living to make and responsibilities to fulfil. The problem for them has not been simply how to communicate that sense of wonder but how to do so within the constraints of their everyday work, year in and year out.

Another need has been to acquire the technical skill that would allow them to capture split-second moments that seemed special to them. Seeing is one thing; photographing is another. Some of these contributors are more interested than others in exploring the possibilities of a wide range of equipment and materials, but they are all remarkably proficient with what they choose to use and they have a very real respect for their craft. To quote Gerry Cranham, 'I have my standards and my pictures have to live up to that. So many people settle for second best.'

Sport can bring a rare intensity of experience both to the competitor and to the spectator – an experience of drama and of grace, of achievement and of failure. The greatest sports photographers have the aesthetic sensitivity and the technical expertise to record and interpret elements of that experience, as can be seen in the following pages.

Erich Baumann

German photographer famed for his impressionistic images of sport and his in-depth coverage of major international events

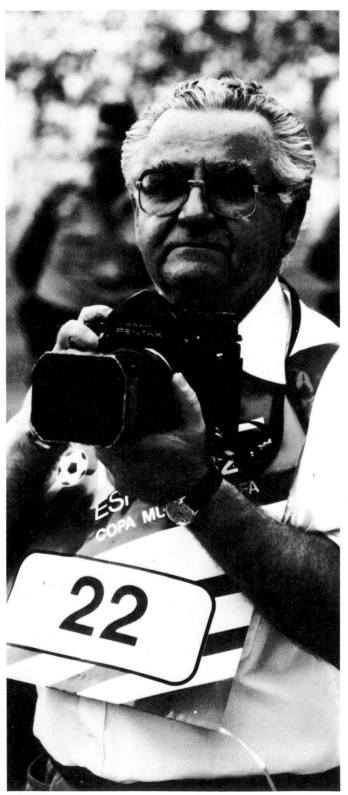

Bryn Campbell What is it that you particularly enjoy about photographing sport?

Erich Baumann It is a subject that has always excited me. Even as a small boy, eight to ten years old, I took part in all kinds of sport, football, skiing, wrestling, swimming and so on.

There is something so alive about sport. I couldn't photograph landscapes, flowers, weddings, or make old women look beautiful. Animals, yes, I might enjoy taking pictures of them but not in a zoo, in Africa or wherever else their natural environment may be.

If you photograph the World Cup Final between England and Germany at Wembley Stadium, it is fascinating. If you photograph a Grand Prix at Monaco surrounded by half a million spectators, it is fascinating. It is a remarkable experience, something that you remember all of your life. There is such an excitement about being part of events like that. Sports photography is a wonderful profession.

B.C. Do you often work abroad?
E.B. Yes, I've spent half my life working in other countries.

B.C. Do you photograph anything other than sport?
E.B. No, never.

B.C. Do you have a favourite sport to photograph?
E.B. Yes, football because usually the whole match is over in about $1\frac{1}{2}$ hours.

But more seriously, some sports do go on for so long that they can become boring. With football, you have to concentrate totally right through the match – if there is just one goal, for example, you want to catch it. You cannot afford to relax even for a moment. But it is quite impossible to concentrate at that level for perhaps six hours at a stretch.

B.C. Does one have to understand a sport in order to photograph it well?
E.B. If you do not understand a sport, you cannot photograph it properly. In any sport there are always some moments which are more significant or more attractive than others. For instance, in gymnastics when a girl is working on the bars, for just one split-second her body will be poised in mid-air. One has to know when this happens and where to position oneself to get the best possible picture of such a moment.

B.C. Do you ever plan your pictures in advance?
E.B. If I am going to cover an event for the very first time, I think about it beforehand a lot. When I get to the actual location, I often have sleepless nights going over the problems in my mind and wondering what I can do that might produce an extra-special picture.

B.C. Do you like setting-up pictures?
E.B. Setting-up, no. Thinking about possibilities, yes. For example, if I know I have to photograph a high-jump, would it be a good idea to lie on the ground and get a really low angle? Camera position is so vitally important whichever subject you

tackle. Then I like to mull over the techniques I might use to manipulate the situation, for example, panning the camera, or zooming. If I dream up something new, I try it. Nothing is barred. I'll experiment with anything to get the best result.

A little while ago, I spent eight days on location at my own expense, trying to get a picture that would sum up for me something of the beauty of sailing. I played around with all manner of ideas, even going out in a boat myself but nothing really worked. Then I thought of turning the camera during the exposure and that did the trick, producing the impressionistic effect that I wanted. But it took eight days of struggle. The idea came out of necessity.

B.C. Why do you try to create these impressionistic effects?
E.B. When techniques like these work, people often say I am an artist. I find that description an exaggeration and yet there is a certain degree of artistry involved. I want to do more than just take snaps. I want to produce images that show a deeper understanding of the subject, that evoke the essence of it.

B.C. Which photographers have most influenced you?
E.B. I can't really answer that. I had to find my own way. Please remember that colour photography is still very young. I took my first colour photograph in 1965 and won a gold medal with it in the World Press Photo contest.

The early colour films were very slow and not really suitable for catching fast movement. I've been a sports photographer for 33 years, but it is only in the last 15–20 years that colour has been a major part of my work. Today, of course, colour dominates the market. I shoot black and white now only on less important stories.

B.C. Have any photographers outside sport influenced you?
E.B. Their work would have no relevance to me. You cannot make comparisons between different areas of photography. In sport, as I said, I have had to make my own way. I have had to clear my own path through the jungle.

B.C. How did you become a photographer?
E.B. It happened by accident. I was not trained in photography but in book printing. I bought my first camera second-hand for 100 marks – a Kodak Retina 1, the collapsible type.

Once a year, here in Ludwigsburg, all the various sports clubs – athletics, swimming, gymnastics, football and so on – run against one another. I used to photograph these races and one day the editor of the local newspaper asked me if I would supply a couple of pictures of this event for publication. And that is how I started. I kept on working for newspapers, on more or less an amateur basis, but after the World Cup football championships in Switzerland in 1954, I turned professional and started my own agency.

I have been self-employed ever since, though I did arrange publishing contracts with firms such as the West German company Sigloch Edition, Künzelsau, to produce books on the Olympic Games, World Cup football and the Tour de France.

Today, my wife, Hannelore, and my son, Dieter, work with me as photographers.

B.C. How many books have you produced?
E.B. About 15 and I'm working on another at the moment, about motor sport. It should be published next year. The expense and effort involved in producing one of these books can be colossal. For example, my family and I worked with four other photographers on a book about the 1978 world soccer championships in Argentina. The total cost of our international and domestic flights was colossal and we took about 12,000 photographs. Fortunately, the book sold well – about 750,000 copies world-wide.

B.C. Why do you prefer 6×7 or 6×6 format cameras to 35 mm types?
E.B. Simply because of quality. I can easily make a poster 1×2 metres in size, or even 3×4 metres, from a 6×7 cm transparency, without an unacceptable loss of image quality. That would just not be possible with 35 mm.

Many of the pictures I take are in relatively poor light conditions, such as floodlit stadiums, but using large format equipment I can maintain the quality I want. That is why publishers come to me, because of the excellent quality, not because of my pretty face.

B.C. What method of measuring exposures do you use?
E.B. My Pentax 6×7 cameras have built-in exposure meters and I rely on them, together with my own experience. In the early days I worked without a meter and I learned about exposure the hard way.

B.C. Do you use any other kind of cameras?
E.B. A whole range of camera systems. For example, the Hasselblad, with every lens from super wide-angle to extreme telephoto. Also Canon, Leitz and Nikon. Canon has a high-speed camera that takes nine frames a second. This is ideal, for instance, for photographing football from behind the net.

Let me emphasize that each sport requires a different approach and presents its own particular problems.

B.C. Do you have a favourite lens?
E.B. I can't really answer that because it is the circumstances which dictate how to deal with a situation. For instance, if I photograph a motor race, I may have to keep 50 metres away from the track for safety reasons and so I probably wouldn't want to use a wide-angle lens.

B.C. Which films do you use?
E.B. For black and white, Tri-X. For colour, High-Speed Ektachrome. Almost always, nowadays.

Even in sunny weather I use the same high-speed colour film because it enables me to stop down more and so increase the depth of field. Providing one doesn't push the film too much, the image quality is high enough for books and posters.

We develop and enlarge the black and white ourselves but not the colour.

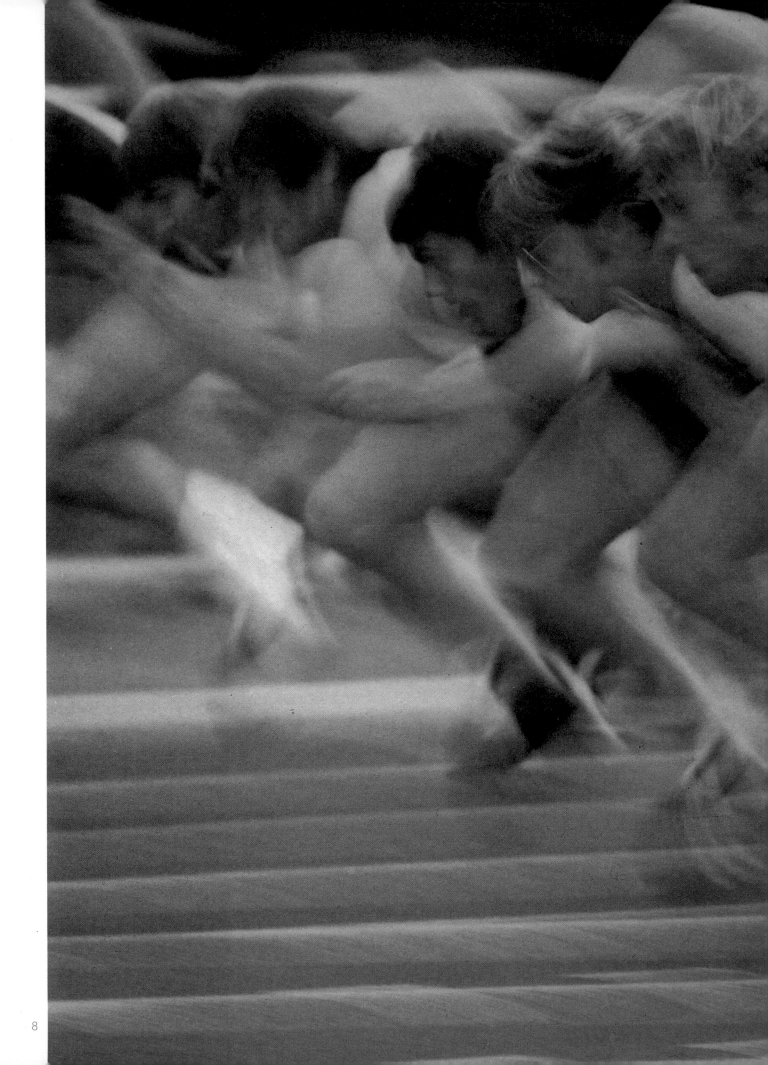

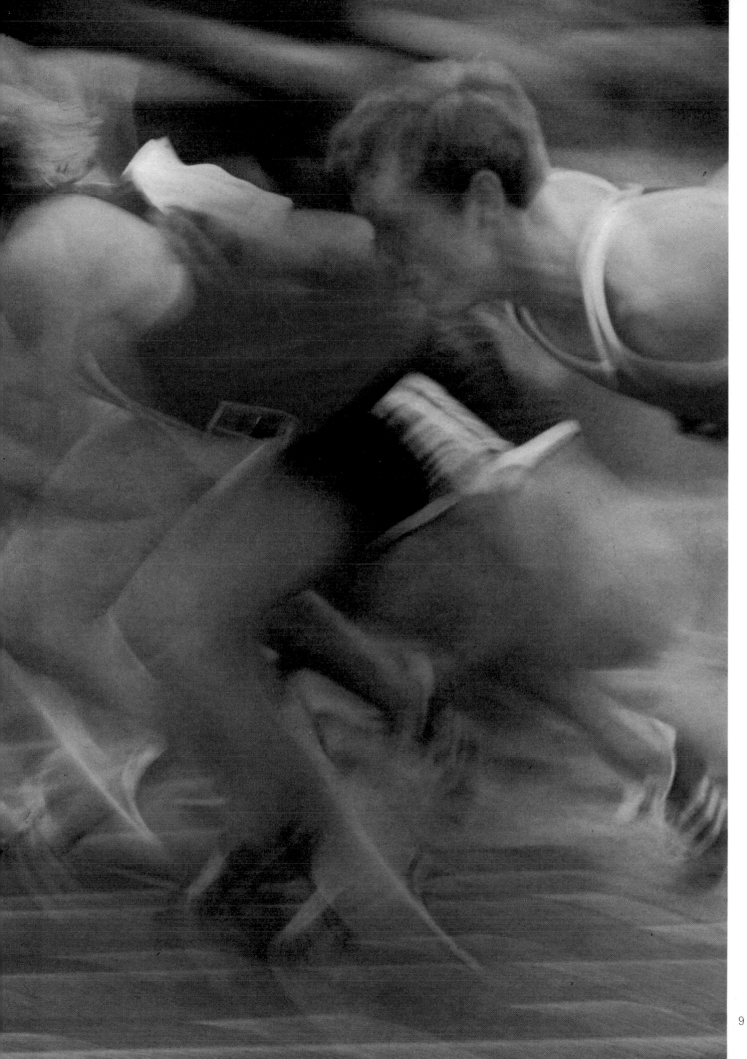

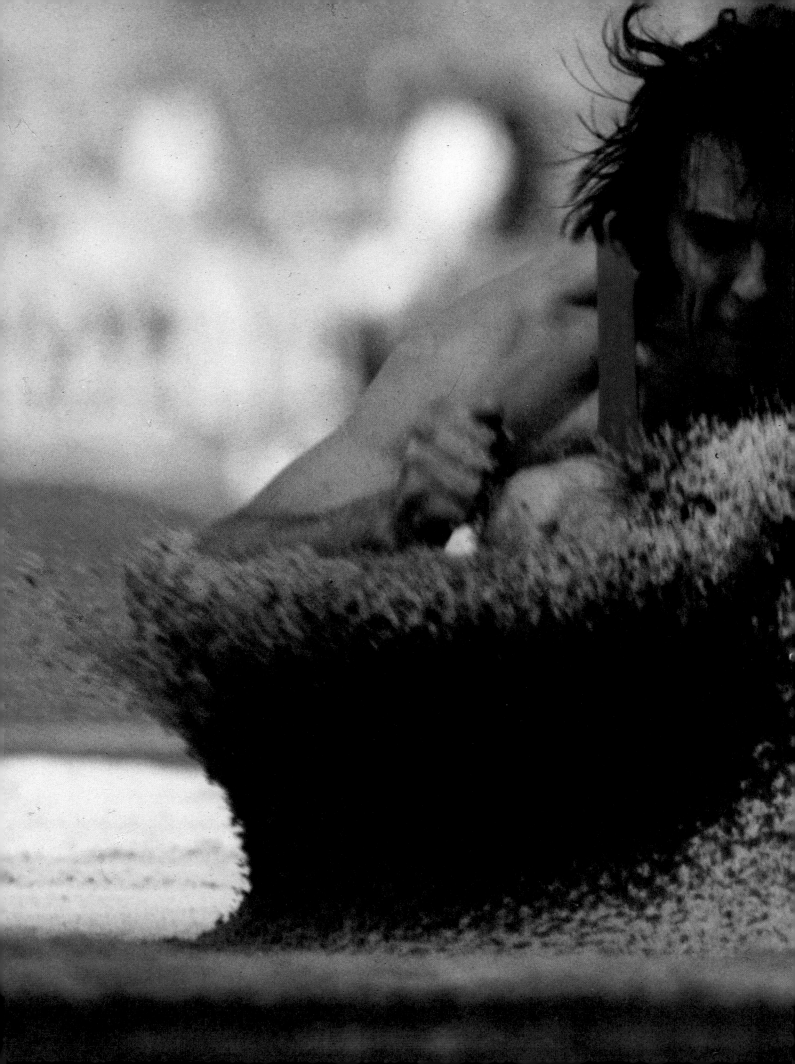

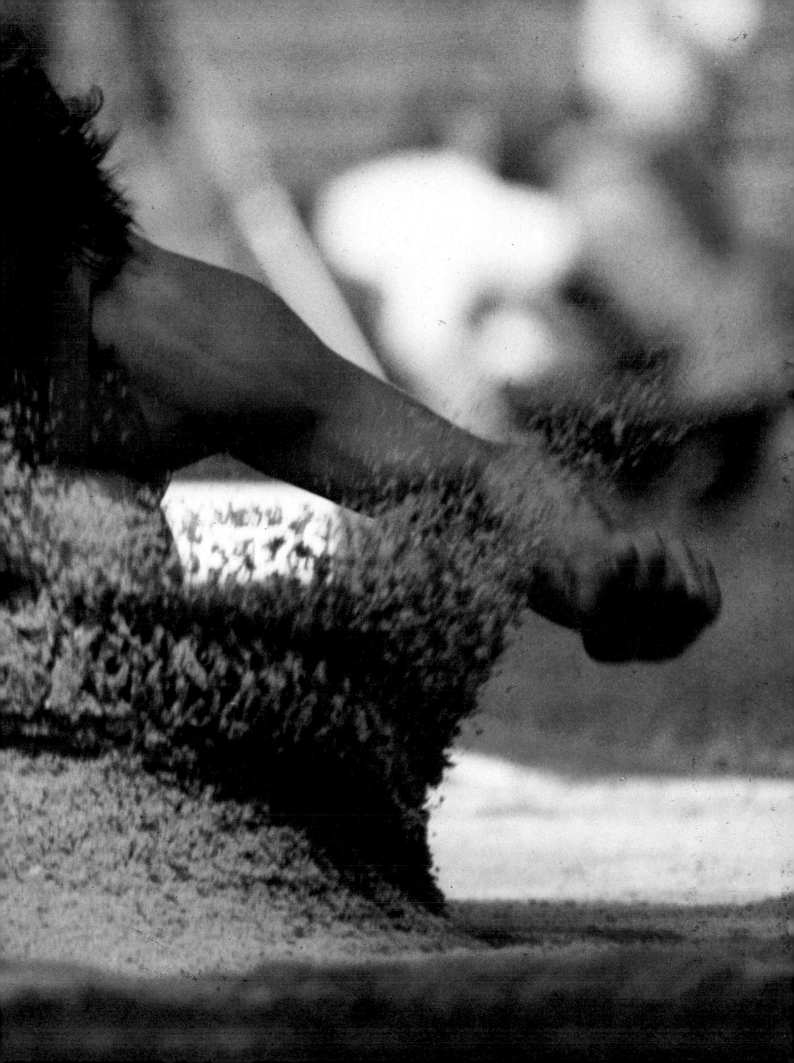

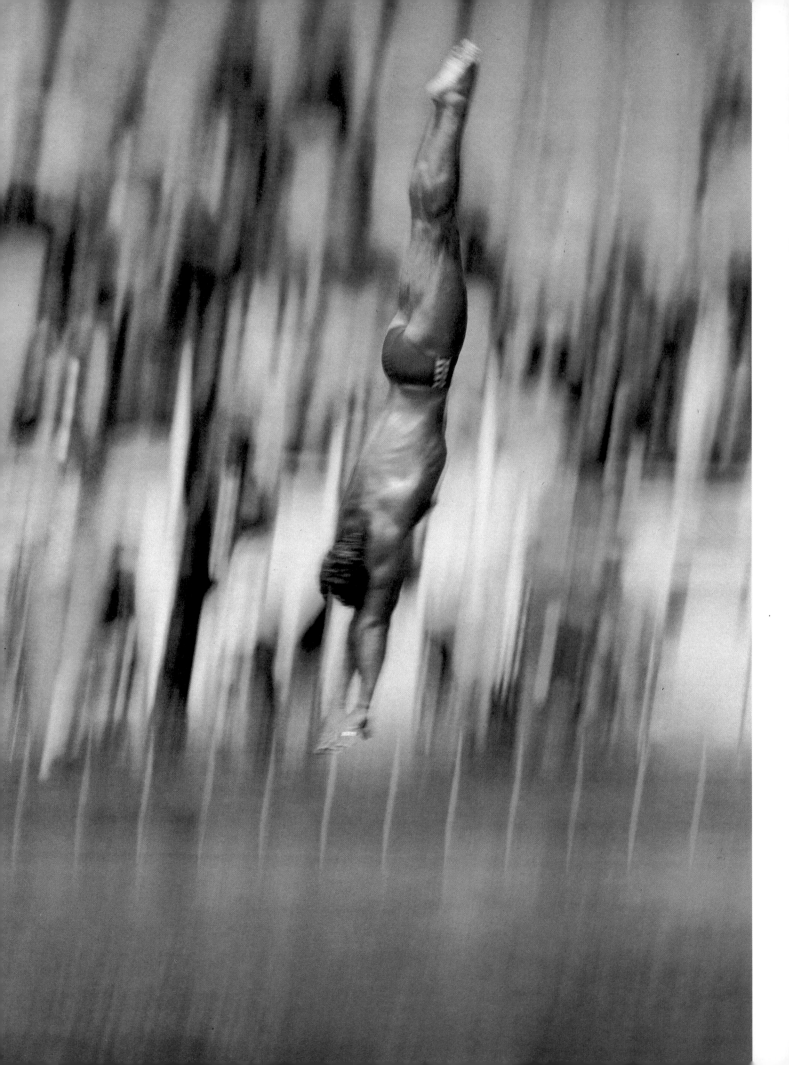

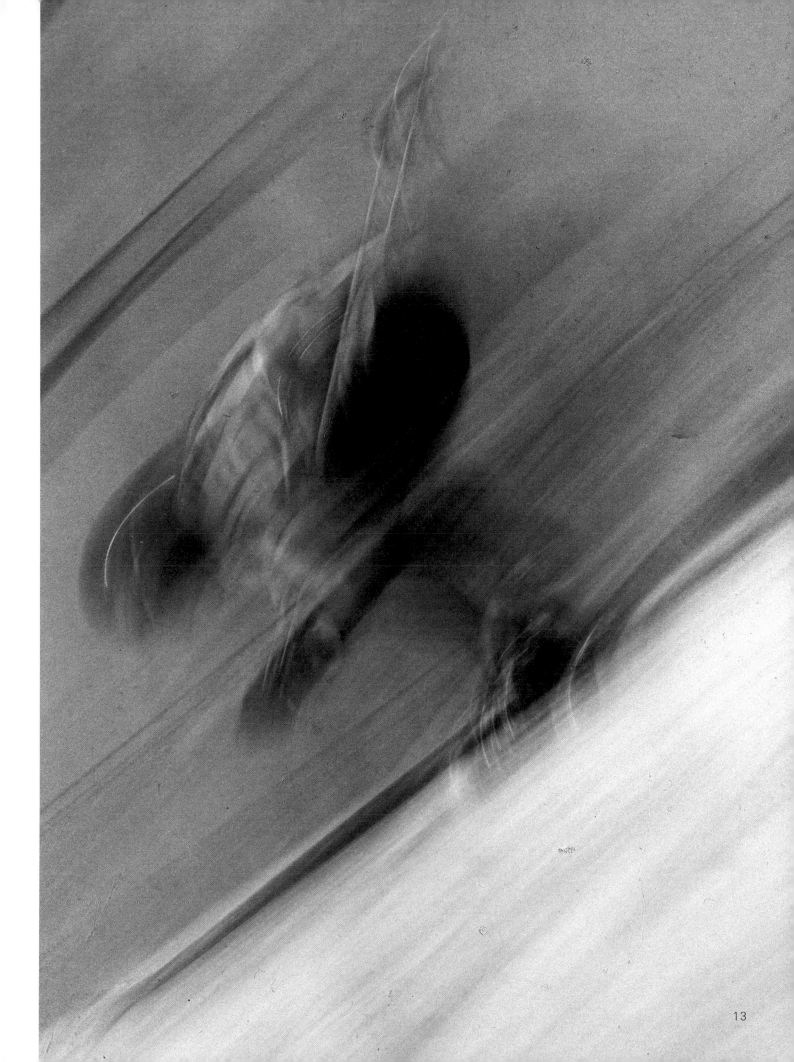

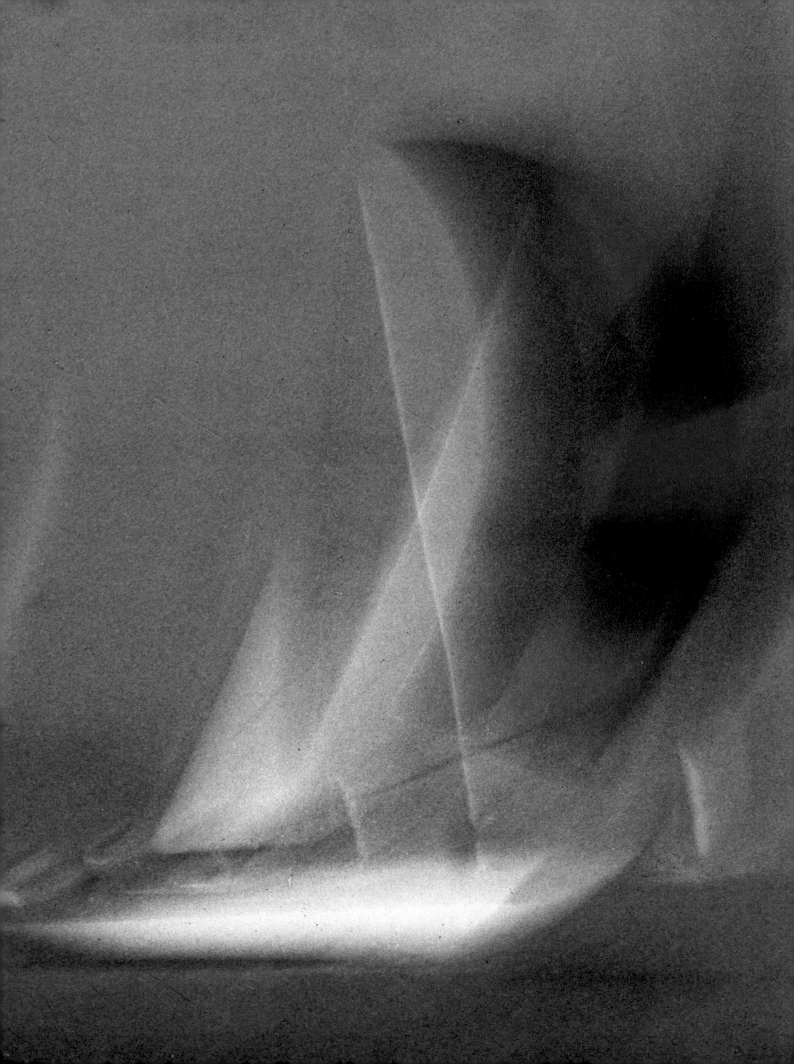

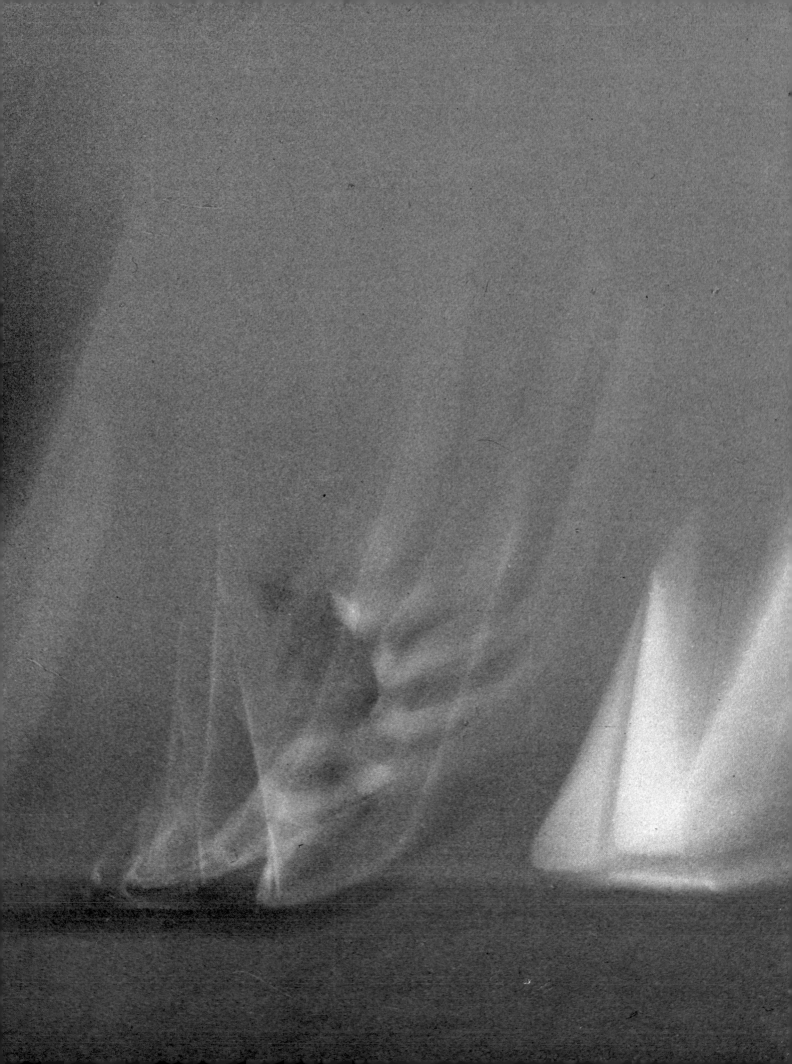

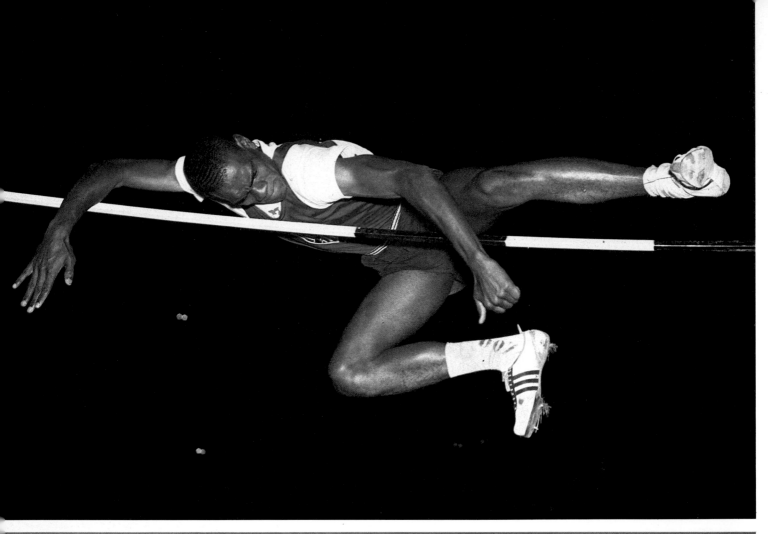

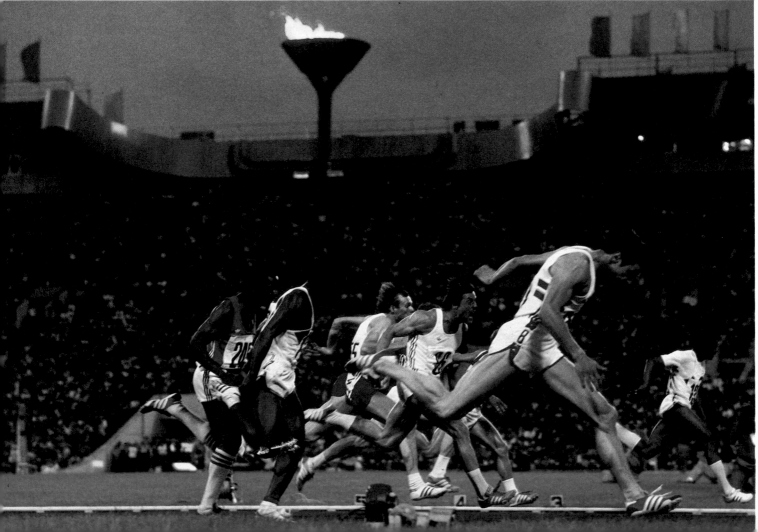

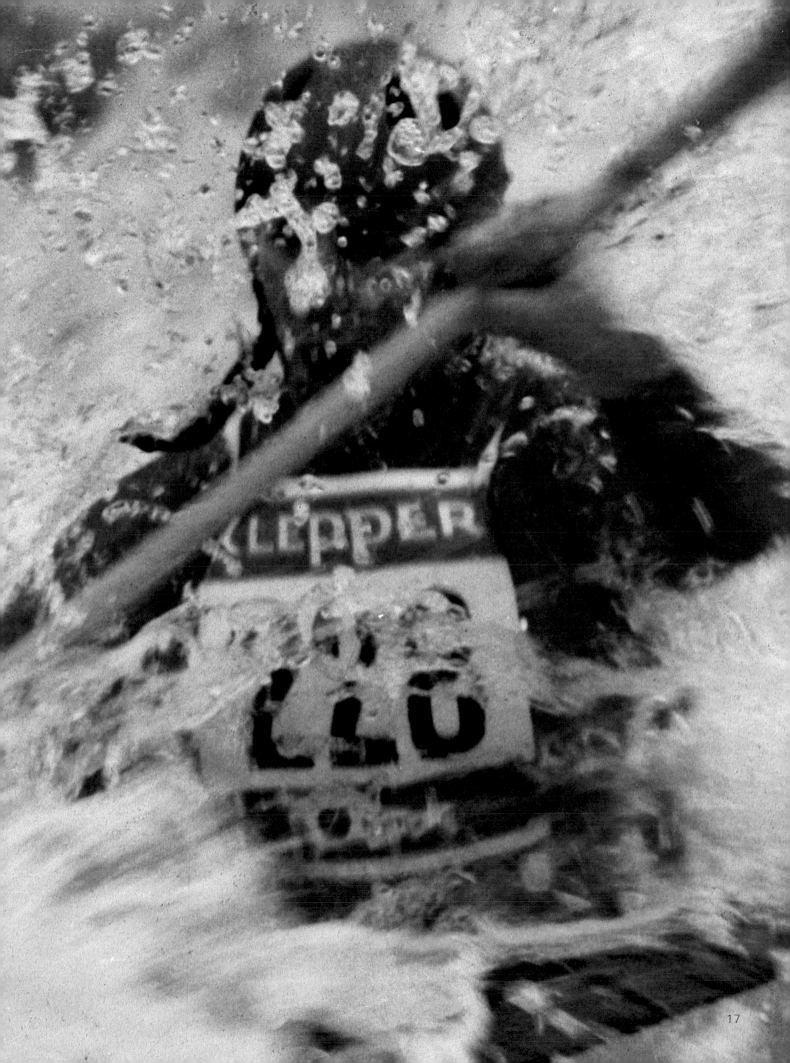

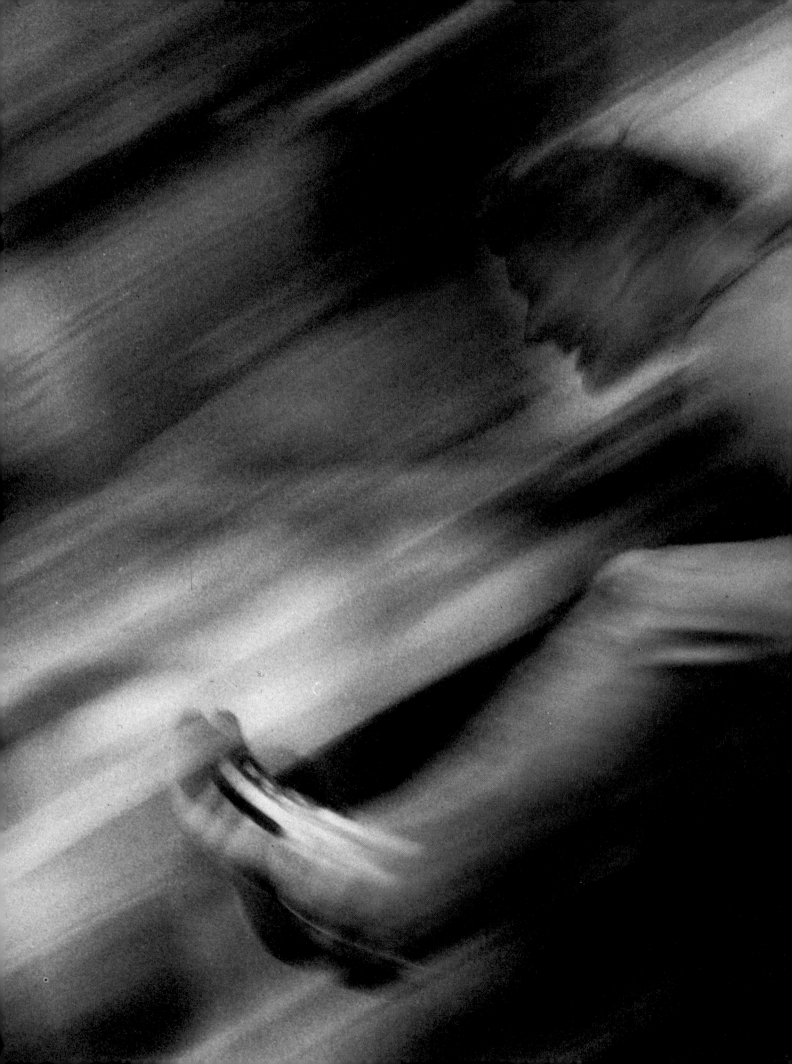

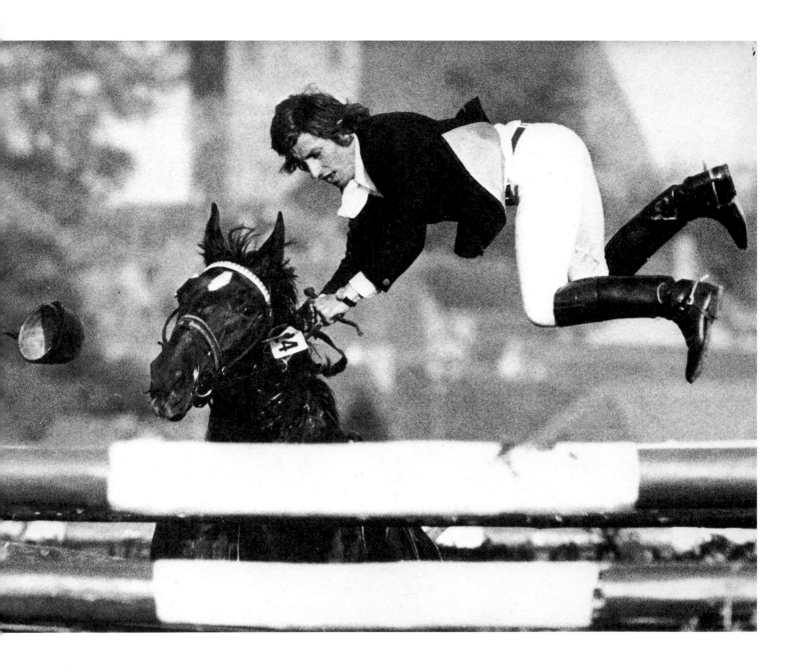

BIOGRAPHY

1919 Born in Felbach, near Stuttgart, West Germany
1926/34 Educated at Untertürkheim
1934/38 Apprenticed as book printer
1939/45 Military service
1948 Bought first camera – a secondhand Retina 1
1954 Began as a professional photographer.
He has since travelled all over the world to photograph major sporting events such as the Olympic Games and football's World Cup

AWARDS

1965 Gold and silver medals – World Press Photo, The Hague
1966 Special Prize for colour photography – Inter Press Photo, Moscow
1980 Gold medal – Olympic Games Photo Contest, Moscow, sponsored by Association Internationale de la Presse Sportive. He has also won many lesser international awards and major national honours

BOOKS

He has produced about 15 books in all, including a series on various Winter and Summer Olympics, and another on football's World Cup competitions
1977 *Sport-Impressionen* – a collection of his work on various sports.
At the moment, he is also preparing a book of his best photographs of motor sport

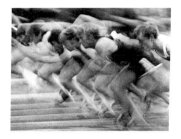

100 metres start, Stuttgart, 1969 *pages 8–9*
The conventional way of photographing action is to 'freeze' it by using a fast shutter speed. But whatever the merits of this technique, it often fails to suggest any feeling of actual movement. Photographers like Ernst Haas, George Silk and Erich Baumann have explored different methods of conveying a stronger impression of motion, even at the expense of losing sharpness and detail.

In this picture, for example, instead of keeping the camera rock-steady and exposing with a shutter speed of 1/500 or 1/1000 second, Baumann used a speed as slow as 1/30 second and during that exposure, moved the camera very quickly with the sprinters as they left their blocks. As a result, the picture is blurred but it does certainly produce a strong effect of movement.

A telephoto lens compressed the space, making the athletes seem closely bunched together and so adding to the dramatic strength of the composition.

Equipment – Hasselblad camera and 500 mm Tele-Tessar lens.
Film – Kodak colour negative.

Long jump, Munich, 1971 *pages 10–11*
This photograph had to be very carefully planned and carried out. In order to work from a head-on position and to achieve this effect, a telephoto lens and a fast shutter speed (1/500 second) were both essential. The lens had to be used at its maximum aperture (f8), giving little depth of field and so Baumann had to estimate very accurately where the jumper would land. He pre-focused on that point and shot from a very low camera angle to show as much as possible of the competitor's face and of the eruption of sand. Then it was a matter of good timing.

Equipment – Hasselblad camera and 500 mm Tele-Tessar lens.
Film – Kodak colour negative.

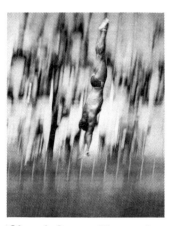

Olympic Games, Montreal, 1976 *page 12*
The technique of moving the camera during an exposure, in the same direction as the subject and in pace with it, is known as panning. Baumann's picture of the sprint-start was produced by a very vigorous use of this method. A quick but more flowing, vertical pan was called for in photographing this diver.

Equipment – Pentax 6×7 camera and 150 mm lens.
Film – High-Speed Ektachrome.

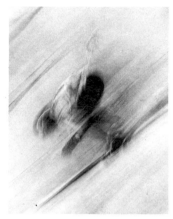

Olympic Games, Grenoble, 1968 *page 13*
In panning the camera, the choice of shutter speed in relation to the movement of the subject varies the degree of blur. Other things being equal, the slower the shutter speed, the greater the blur. The art is in matching subject speed and shutter speed to create the effect one wants. In this photograph, Baumann has pushed the technique almost to its limit – an even slower shutter speed and the subject would have dissolved into meaningless streaks.

Equipment – Hasselblad camera and 80 mm lens.
Film – Kodak colour negative.

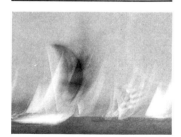

Bodensee, 1977 *pages 14–15*
As Baumann said in the interview he was finding it very difficult to produce a sailing picture that satisfied him, until he tried rotating the camera during an exposure of 1/15 second.

Equipment – Hasselblad camera and 500 mm Tele-Tessar lens.
Film – Kodak colour negative.

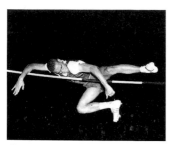

Germany v U.S.A., Augsburg, 1963 *page 16*
The light was so poor for this event, held outdoors in the evening, that Baumann decided to use flash. The very tight framing of the figure, the precise moment of exposure – the body wrapped around the bar at the exact instant before success or failure, and the isolation of the action against the dark background, all contribute to the tension and graphic strength of this image.

Equipment – Hasselblad camera and 80 mm lens.
Film – High-Speed Ektachrome.

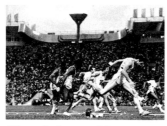

Olympic Games, Moscow, 1980 *page 16*
This picture won Erich Baumann the Gold Medal in the Olympic Games Photo Contest in Moscow in 1980. The low viewpoint helped him to set the specific race in its overall context, the figures of the runners leading up to the Olympic flame. The excitement of the sprint finish was captured in all its detail by using a fast shutter speed.

Equipment – Pentax 6 × 7 camera and 150 mm lens.
Film – High-Speed Ektachrome.

German National Championships, 1975 *page 17*
Compared to the 35 mm frame (24 × 36 mm), a 6 × 6 cm image is just over four times the area, and a 6 × 7 cm image is almost five times bigger. The larger formats therefore have a decided advantage in terms of picture quality, since they require that much less enlargement up to any given size. It is also easier for the rollfilm user to enlarge from just a section of the image without an unacceptable loss of quality.

This photograph, for example, was cropped from a much wider scene and the main subject was never intended to be pin-sharp – the shutter-speed setting was only 1/125 second.

However, the 35 mm camera user can work with Kodachrome – one of the finest colour films – which is not available for larger format cameras.

Equipment – Hasselblad camera and 500 mm Tele-Tessar lens.
Film – High-Speed Ektachrome.

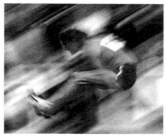

Long jump, Stuttgart, 1975 *pages 18–19*
The different effects of 'freezing' or blurring movement can be clearly seen if one compares this photograph with another of a long jump on pages 10–11. Both are by Erich Baumann and both are brilliant examples of their kind.

This image was produced by panning the camera during a slow exposure, so keeping the jumper relatively sharp but totally blurring the crowd in the background.

Equipment – Hasselblad camera and 500 mm Tele-Tessar lens.
Film – Kodak colour negative.

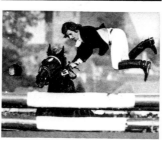

Herrenberg (Germany), 1975 *page 20*
The tightness of this framing is an object lesson in composition. A telephoto lens used at wide aperture keeps depth of field to a minimum and picks out the subject sharply against an out-of-focus background. The photograph is trimmed down to its bare essentials.

Equipment – Leicaflex SL-2 camera and 400 mm Novoflex lens.
Film – Tri-X.

Tony Duffy

Much talented and widely published British photographer. Founder-partner of a highly successful sports picture agency

Bryn Campbell What are the most important qualities needed by a sports photographer?
Tony Duffy An ability to visualize a picture and the capacity to work to get that picture.

Obviously, there are other vital factors, such as sharp reflexes, but I don't think you can overestimate the value of having an eye for a picture and a feeling for the subject.

B.C. Which photographers have influenced you most?
T.D. First and foremost must be Co Rentmeester, who is Dutch-born but has worked most of his life in the U.S.A. Currently he shoots most of the sports features in *Life* magazine.

For me, he is simply the best because he has got the most range. He is tremendous on straight action or on feature stories. He has a very visual approach, he always tries to find a different angle and he works quite incredibly hard. Heinz Kluetmeier and Walter Iooss are also superb but possibly do not have the breadth of Rentmeester.

Nearer to home, I was very influenced to begin with by Ed Lacey, the acknowledged master of the super-sharp action shot, and I'm also a great admirer of Chris Smith.

I haven't really studied photography as an art-form and I don't know much about photographers in other areas of the medium. Certainly, I do not believe that they have influenced my approach to sports photography.

B.C. Why did you become a sports photographer?
T.D. My interest in sport came first and photography was just a way of translating that fascination into something visual. If I could have painted or drawn, I might have tried to express myself that way instead.

As a kid I used to deliver newspapers and I would marvel at the sports pictures on the back pages. I felt that there was a kind of magic in being able to capture one isolated moment of a complicated event. That excitement has always stayed with me. Photography for me is purely a way of expressing my wonder at the world of sport and all it involves. Why I am so interested I would not pretend to be able to analyse, but big-time sport fascinates me.

I bought my first camera in my twenties, a Voigtländer Vito B, and photographed school sports and club events. Later I had a girlfriend who was an Olympic athlete and I took pictures of her at various meetings. She showed me press photographs of herself and encouraged me to send my pictures, printed by the local camera shop, to athletics magazines. They used them and that gave me the confidence to continue.

At the time, I was working as an accountant and so I could afford to plough back any money I made into better equipment. As I covered more and more events, I met journalists who would suggest ideas for picture stories. Producing these features gave me a better understanding of what Fleet Street wanted and valuable all-round experience. After three or four years I realised that if I persevered I might be able to turn full-time professional. I might have taken the plunge sooner but I was married then and 23

had responsibilities. When the marriage broke up and I was divorced, there was no longer anything to stop me doing what I wanted to do most. I had just returned from the 1968 Olympic Games in Mexico, a tremendous thrill for me, and I decided it was a good time to make the break. I always knew that if necessary, I could go back to accountancy but I made a pact with myself that I was never going to do that. Looking back on it now, it wasn't so hard to make the break.

B.C. Is it an advantage to specialize at all in certain areas of sports photography?

T.D. It is an advantage to gain a better knowledge of a sport and its personalities. For example, I have photographed Bjorn Borg for so many hours that sometimes I feel that I know the shot he is going to play before he does himself and this allows me to anticipate his next position.

Where perhaps it is a disadvantage to specialize too narrowly, is that if you spend 12 months following the tennis circuit, you can get very stale. You go to the same places and you photograph the same people week in, week out. You lose the freshness of approach and the willingness to try different angles. You do what you did last year because it worked then. Becoming stale is a major problem for the outright specialist.

B.C. What are you looking for when you go out to photograph a sports event?

T.D. A range of things really. The agency's bread and butter is good stock action pictures in colour and so that must be my basic priority. But obviously if I can produce a striking, unusual photograph, I know it is going to boost my reputation and make a lot of money.

I would love to be in a position just to shoot for that one great picture and if it doesn't happen the first time, to keep going back until it does. But unfortunately things don't quite work out like that. We are under constant pressure to take the stock pictures that guarantee the agency's income. We are so busy shooting every incident and catching every competitor that we are not able to go for the really unusual picture as often as we would like.

B.C. How important is the organization behind you?

T.D. Absolutely critical. If you have somebody to take care of your travel arrangements, your credentials, your hotel, currency and film stock, you can work on other jobs up to the last minute. When you come back from assignment, if your film is handled for you, processed, edited, captioned, filed and distributed, it leaves you free to get on with what you do best, taking pictures.

B.C. Many of your best photographs are deceptively simple in appearance. Is that the result of a deliberately cultivated style?

T.D. I consciously go for the simple picture. My whole philosophy of sports photography is that sport itself is so fascinating, dramatic and visual that if one can only record accurately what is happening, the subject will do the rest for you and you will be surprised at the tremendous pictures that you can pro-

duce. Nine times out of ten when you are photographing events, the subject is powerful enough to speak for itself. You don't need a repertoire of photographic tricks and an armoury of gimmicks. Normally I just frame the subject very tightly and then simply record what happens. Often the camera 'freezes' detail that is invisible to the naked eye and then a moment is even more interesting than you hoped.

Working on feature pictures is a quite different proposition. I frequently have to add something to a situation to make the most of it, whether it is asking the subject to wear more colourful clothing or using a special lens or filter.

B.C. How important is it to you to keep abreast of the latest developments in equipment and materials?

T.D. Absolutely vital. If a new lens comes out that is a stop faster than its predecessors, for example, I would want to get hold of it as soon as possible. It might allow us to shoot Kodachrome when everyone else was using Ektachrome and it would certainly make it easier to work in poor light conditions.

In the same way, a new long lens would let us frame the action tighter or a brighter viewfinder would help our focusing. Whatever technical improvements might enable us to take better pictures, we will want to know about them.

At the moment we are testing an extremely fast, artificial-light colour film and that, of course, could help us considerably in photographing indoor sports.

B.C. What equipment and materials do you use now?

T.D. Like everyone else at All-Sport, I use Nikon cameras and lenses. We are all great believers in the old F2 cameras and we use them with motor-drives. I also own one Nikon FE camera body because it is synchronised for flash at 1/125 second instead of the usual 1/60.

I have a range of the super-fast, long focal-length Nikkor lenses, the f4 600 mm, f3.5 400 mm, f2.8 300 mm and, my favourite, the f2 200 mm. This lens is so useful indoors and if I need a longer lens outdoors, I often couple it to a Nikon 1.4× converter and that gives me an f2.8 300 mm.

In the middle range, I tend to use 135 mm and 85 mm lenses and in the short range, 50 mm, 35 mm, 24 mm, and, another favourite, the 16 mm. It does give a noticeable distortion but sometimes this can be turned to one's advantage.

Our one regret is that we sold an 8 mm fish-eye lens, that we owned back in 1972, after about 18 months, and since then we've hired one so many times. We should have kept it.

Whenever possible we all rely on Kodachrome 64 colour film. We find that its colour saturation and fine grain are so superior to any other film that we go to inordinate lengths to use it, even if it means working at full aperture most of the time and risking slower shutter speeds. But sometimes, of course, we have to resort to one of the faster Ektachrome films.

For working out exposures I use two Minolta meters, one to get an overall measurement and the other for a spot reading. In sport you are often photographing distant events and

possibly the light conditions there are very different from those near you. The spot meter has tremendous magnification and you can zoom right in on a subject's face to measure the skin tones, even across a tennis court, for example.

I don't pretend to have an infallible system but experience does help. I never rely on the cameras' built-in automatic metering. One has to take so many factors into account that one might as well take a proper reading.

B.C. To what extent would the introduction of a new lens, or other piece of equipment, suggest a picture possibility to you, a picture that hitherto you might not have been able to take?
T.D. It could well happen. For example, if someone produced a very good mirror lens, I would be looking for a chance to use the out-of-focus background effect, those doughnut-like images. I would think of different sports and then go for a certain picture with it.

B.C. What control do you exercise over the processing and printing of your work, colour and black and white?
T.D. At All-Sport we have a darkroom manager and staff who know far more about this side of photography than I do and so I tend to leave it to them. Kodachrome, of course, is simply sent back to Kodak for processing but we have our own set-up for handling Ektachrome. We used to produce our own colour prints, using Cibachrome, but our demand for prints was so limited that it didn't make economic sense and so we switched to placing orders with an outside commercial lab.

I shoot very little black and white these days. When I do, I use Ilford XP1 film and then hand it over to our darkroom.

B.C. How important is it to cultivate relationships with competitors themselves?
T.D. Most important. If you know top-class competitors, it is that much easier to work with them and feature stories form a major part of our output. We try to spot the stars on their way up. For example, three or four years ago I did a feature on John McEnroe that I just could not repeat today because he is too well-known and under too much pressure.

We make a point of giving the athletes large colour prints of themselves, especially when we have promised to do so. You would be amazed at the number of photographers who promise faithfully to send prints and then don't. We need these competitors, their expertise and their cooperation. If we let them down, next time we approach them, they won't want to know.

I really try to be totally sympathetic to the athletes, both in terms of photography – showing what they go through, the moments of jubilation and despair – and in terms of dealing with them as people. I know that there are times when they don't want a camera thrust into their faces and so if I feel I have to take a picture, I keep my distance and use a long lens.

It is essential to discuss set-up shots very thoroughly with the sports people. These special sessions give you the chance to get the kind of pictures, and even the kind of image quality, that

are impossible to capture during actual events. If the athletes know exactly what you are after, it can be so much easier to bring it off. I find it often helps to let them look through the camera, especially if I'm using a superwide-angle or fish-eye lens. You have to arouse their interest, to get them involved.

B.C. But is it possible to create that fine edge of competitive tension and concentration in a set-up picture?
T.D. I think so, if the athlete has to do something that is intrinsically difficult. Take a juggler, for instance. If he or she is juggling with half-a-dozen plates, whether it is during a cabaret performance or simply for a photograph, the tension is there because the action itself is so hard to control.

B.C. How do you manage to keep up with captioning your photographs during a busy competition?
T.D. Obviously, if you spend all your time writing out captions, you stand a very good chance of missing good pictures. So what we do, at the risk of using up frames unnecessarily, is to photograph the number on the competitor's back or the scoreboard, if we can't see the number on the front of the vest as people actually compete. Then our library staff have something to work on, using the programme with a list of numbers and names.

B.C. Do professional photographers have a huge advantage over amateurs in covering major events?
T.D. Yes indeed. There are occasions when an amateur may get just as good, or perhaps even better, shots than the pro but nine times out of ten, the main difference is that if you are not in a good position to cover an event; no matter how brilliant you are as a photographer, you are most unlikely to get pictures that are as good as those taken by a pro.

One of our biggest problems is obtaining the right credentials for such occasions as the Olympic Games or Wimbledon. You have to acquire the proper passes to get close enough to the action to photograph it and usually that is impossible for the amateur.

Even for professionals, facilities at most European events are inadequate. Although the Professional Sports Photographers Association in the U.K. has made tremendous strides in the last 10 years in liaising with event organizers, there is still enormous room for improvement. When you go to the U.S.A. and see how their media are treated and what attention is paid to their needs, you return home very dissatisfied with the cloth-cap image of photographers in Britain.

What the amateur should remember is that sometimes the audience is more interesting to photograph than the action itself. Emotions are just as likely to be laid bare among the spectators as among the competitors, for example, a highly partisan football crowd. In their own way too, the racegoers at Ascot and the fans at Wimbledon are all part of the overall sporting picture and contribute to its atmosphere and interest. There is abundant scope there for any photographer whether working as a professional or as an amateur.

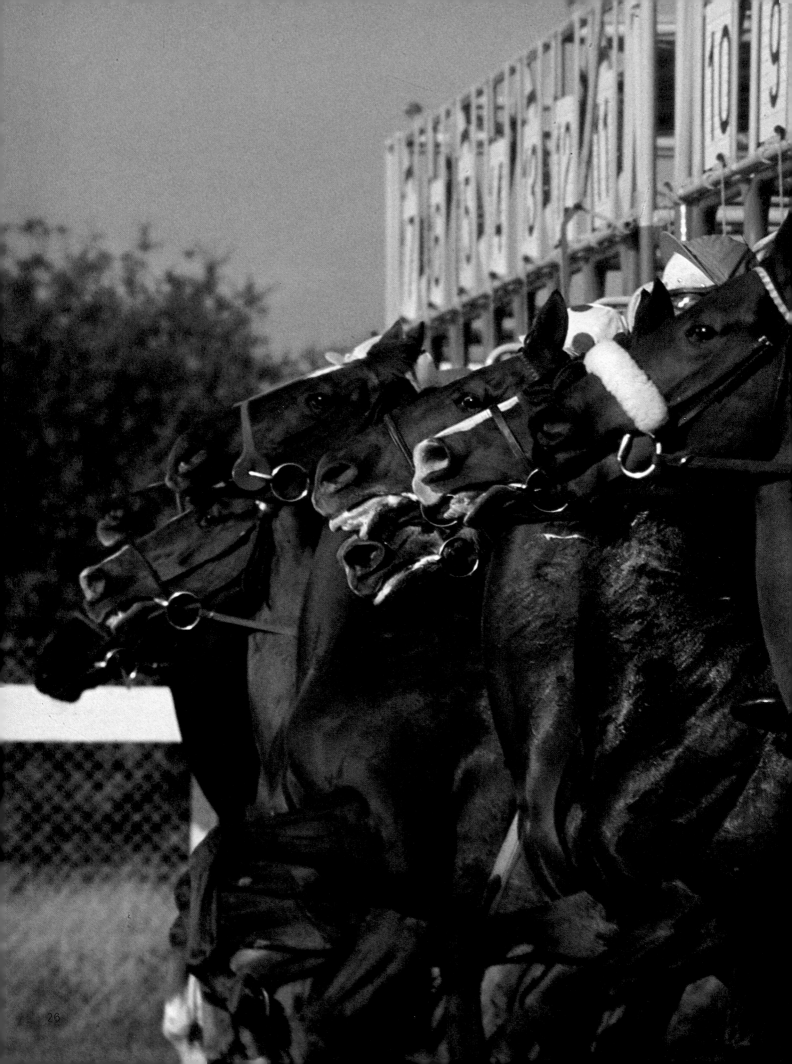

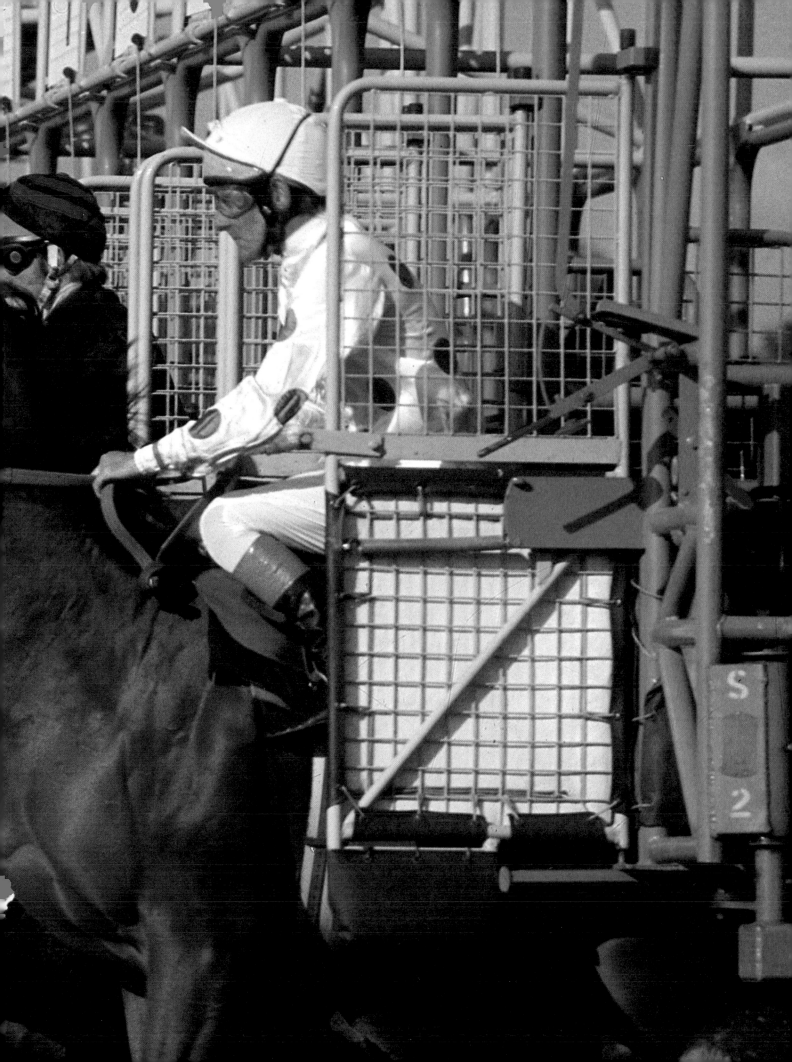

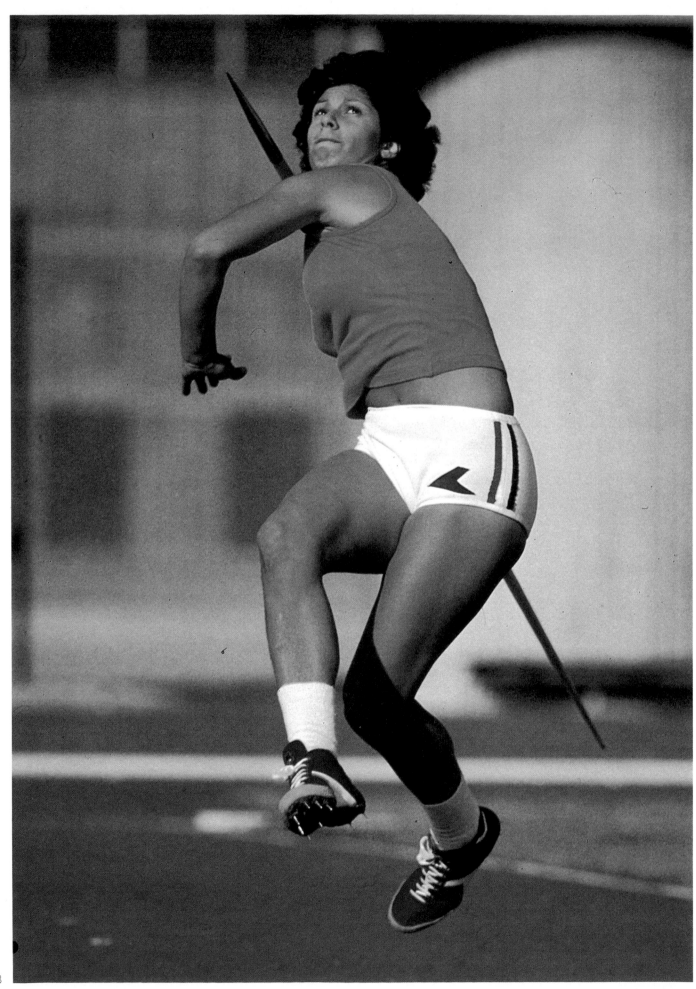

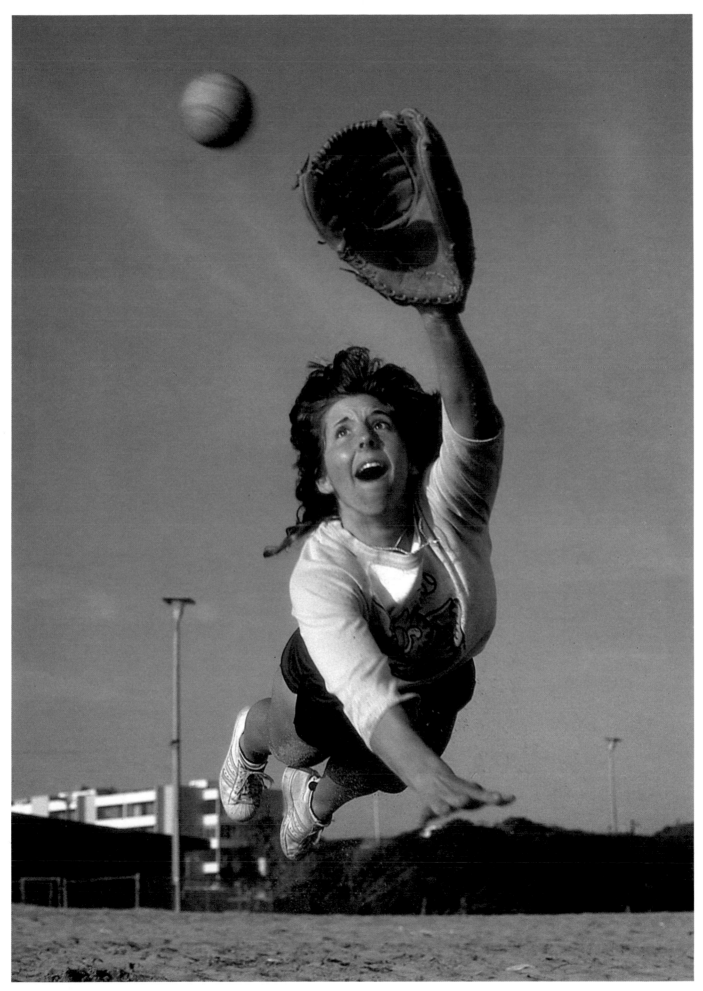

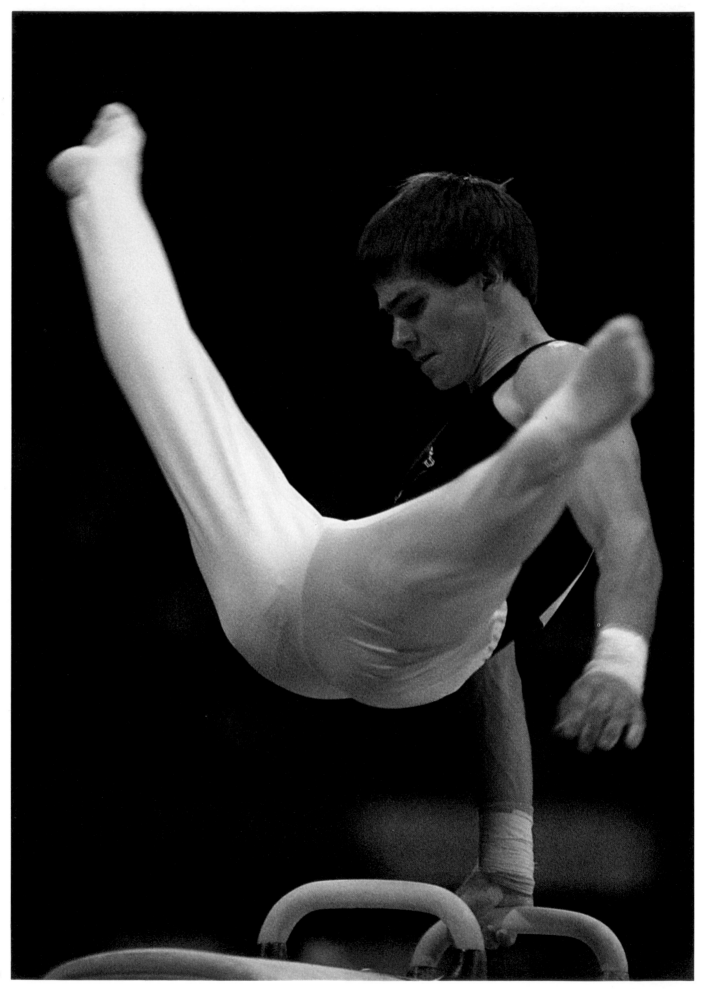

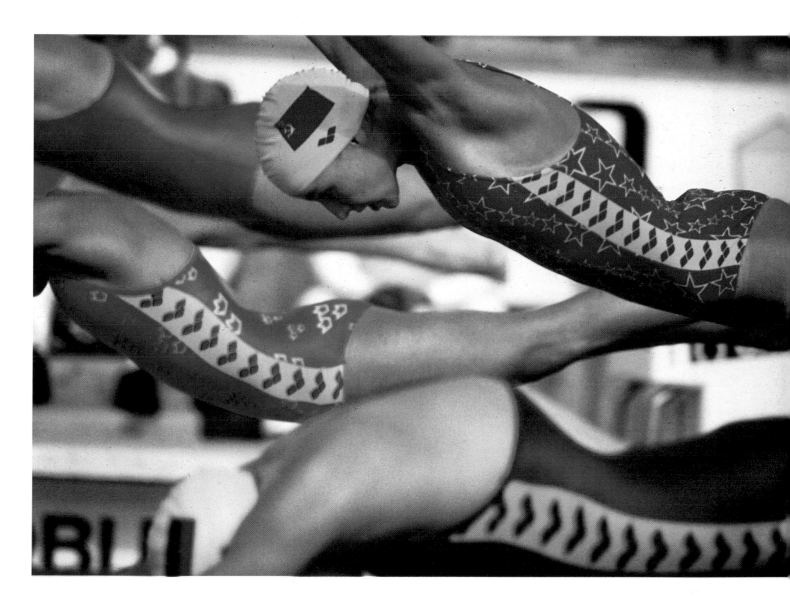

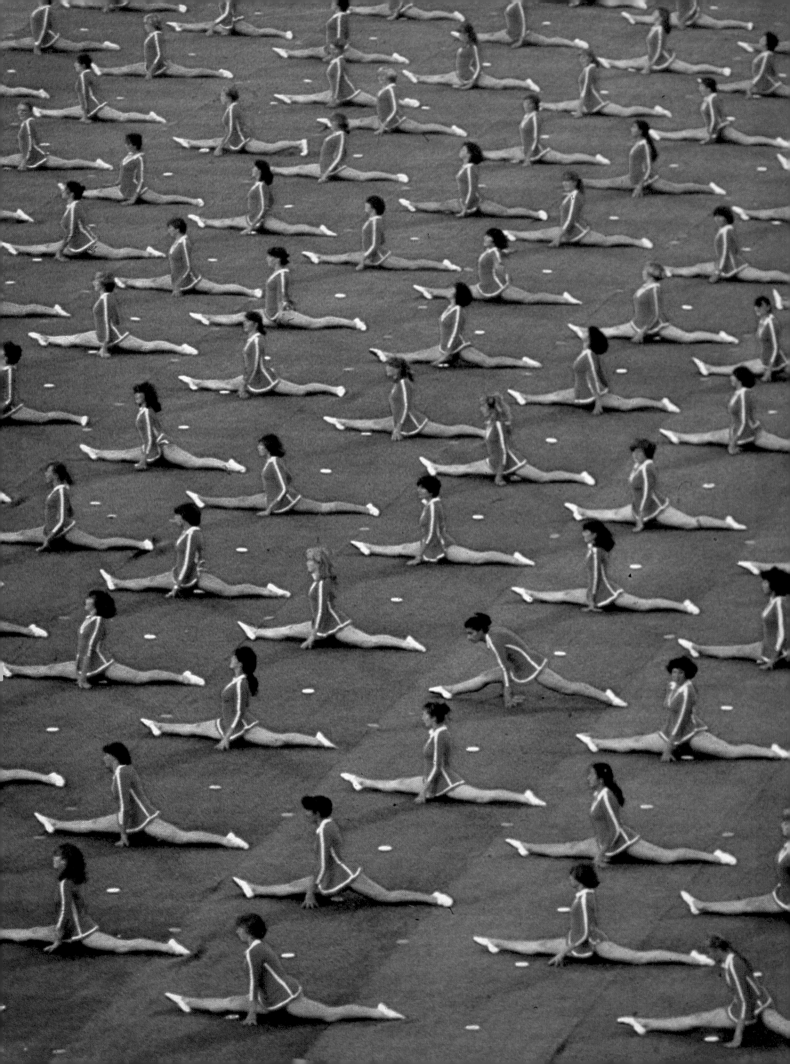

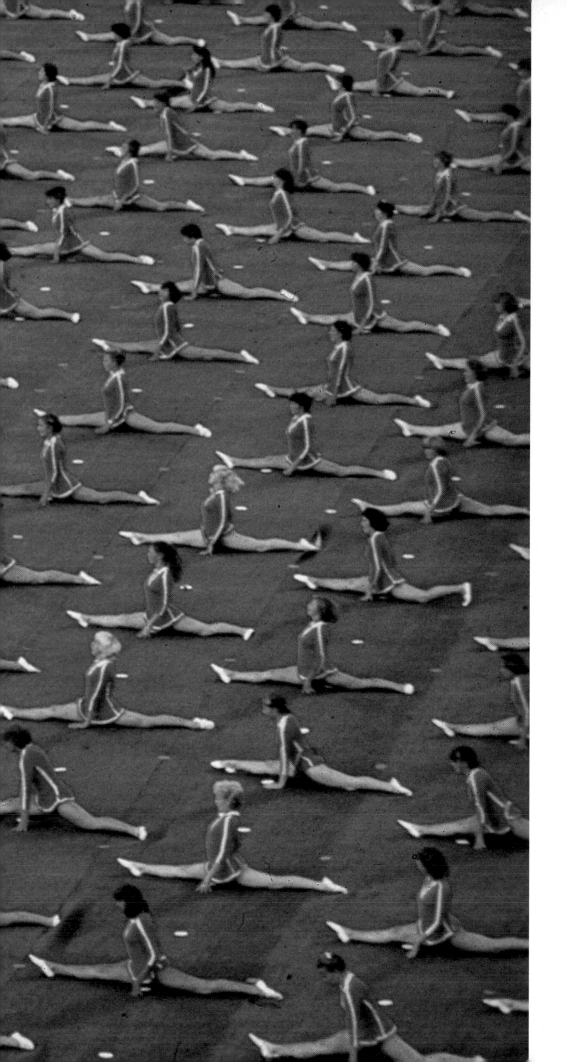

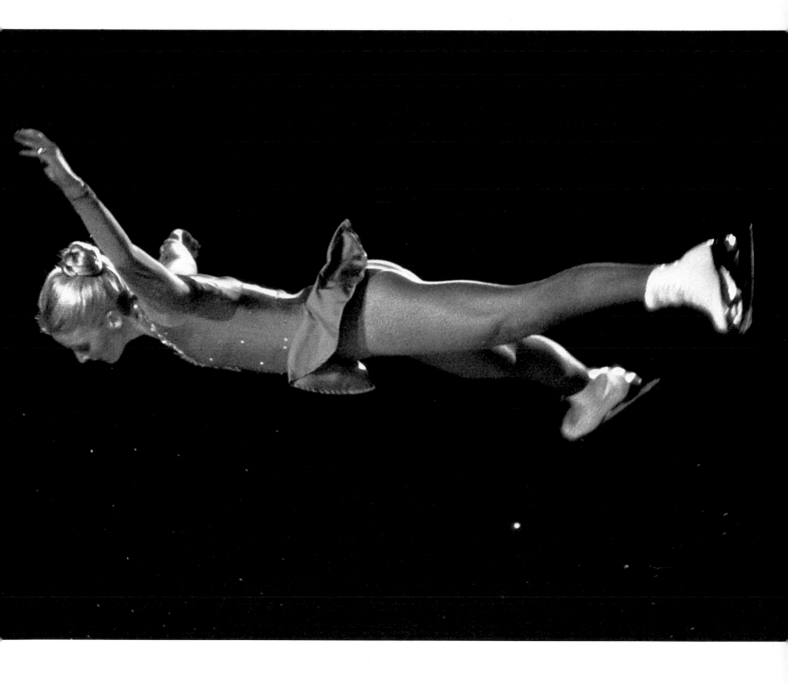

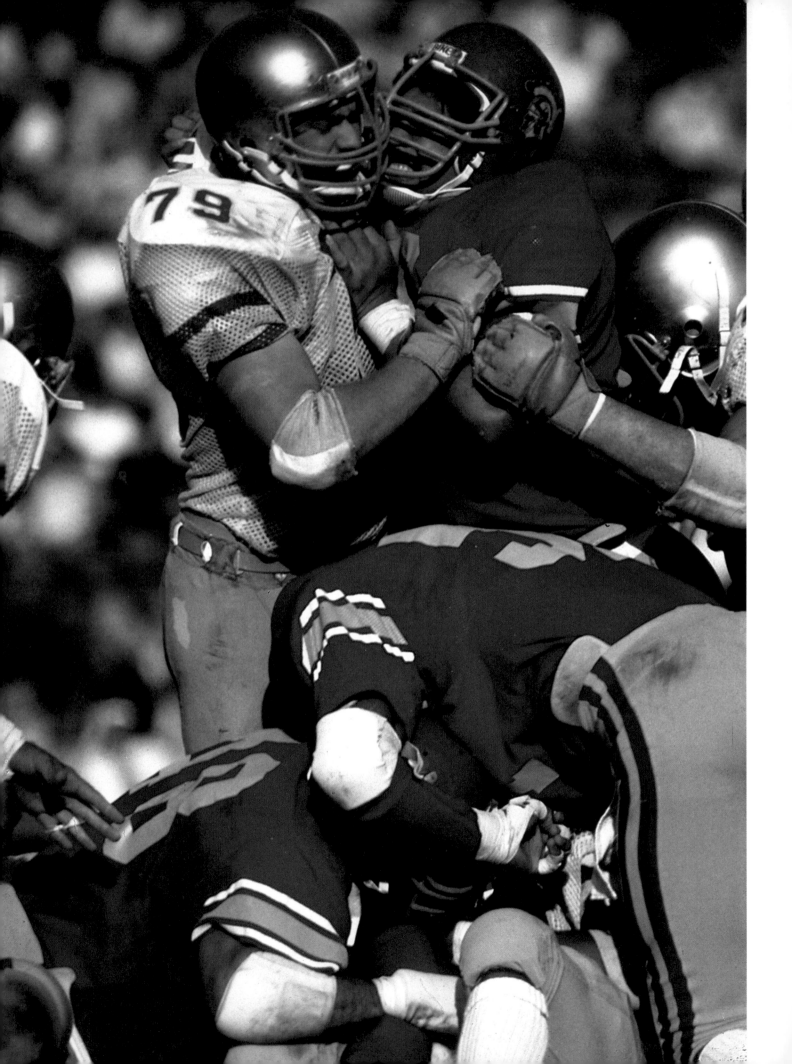

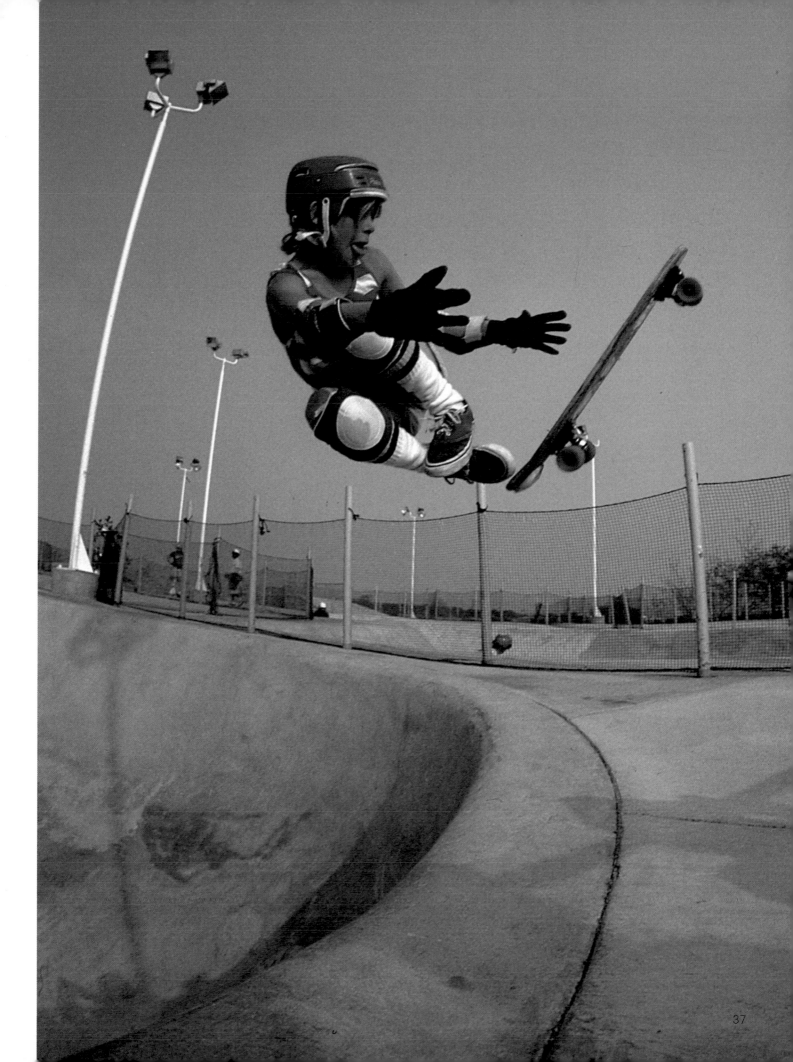

BIOGRAPHY

1937 Born in London
Evacuated to Rochdale during
World War 2
1956/59 Took law degree at
Manchester University
1958/72 Qualified as a chartered
accountant and became a junior
partner with a London firm
1966 Bought his first camera – a
35 mm Voigtländer Vito B
1968 Though unaccredited,
photographed the Olympic
Games in Mexico.
Determined to turn full-time
professional sports photographer
1972 Helped to found and
become a partner in All-Sport
Photographic Ltd
1975 Appointed Managing
Director of All-Sport
Photographic Ltd
1977 Guest speaker at
International Sports Journalists'
Seminar, Djakarta, Indonesia,
organized by AIPS and UNESCO.
Official photographer to
International Amateur Athletics
Federation and also to Fédération
Internationale de Natation
Amateur

AWARDS

1975 Sports Photographer of the
Year – Sports Council and Royal
Photographic Society
competition
1977 1st Prize, *Sport For All*
category – same competition
1975, '77 and '81 1st Prize,
*International Sports Photo of the
Year*, organized by International
Sports Press Association

BOOKS

1983 *Winning Women* (Queen
Anne Press, London; Times
Books, New York)

Starting-gate, Ascot, 1975
pages 26–27
Tony Duffy usually prefers to
shoot from a low angle, partly
because of the inherently dra-
matic viewpoint and partly be-
cause it emphasizes speed and
effort, for example, the height of a
runner's stride. But on this oc-
casion, Duffy stood up to take the
photograph in order to capture
the line of horses' heads.
 He chose a telephoto lens to
frame the subject tightly and to
compress the space. He needed to
use both a fast shutter speed, to
'freeze' the movement, and a small
aperture to get good depth of
field. The light was dull and so he
had to load a much faster film
than his usual favourite, Koda-
chrome 64.

*Equipment – Nikon F2 camera
and f2.8 180 mm Nikkor lens.
Film – Ektachrome 200.*

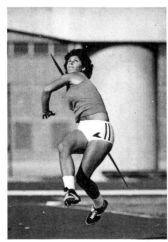

**Fatima Whitbread, Crystal
Palace, 1981** *page 28*
One of the problems of using long
telephoto lenses is their limited
depth of field at wide apertures.
Sometimes, however, this can be
turned to advantage. Tony Duffy
had chosen the camera position

carefully in order to get a
particular shot, but the back-
ground was rather distracting and
so he used the widest possible
aperture to throw it out of focus.
The sharpness of the subject
makes her stand out boldly
against the blurred surroundings.
 The photographer's under-
standing of the sport was crucial
in this instance. He knew that this
moment of action, called the
cross-over, occurs just before the
throw itself and that it can be an
even more dramatic instant. So he
was poised ready to capture it.

*Equipment – Nikon F2 camera
and f3.5 400 mm Nikkor lens.
Film – Kodachrome 64.*

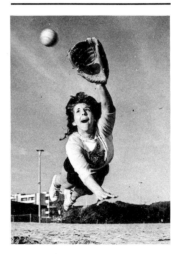

**Janet Pinneau, Venice
Beach, California, 1982**
page 29
Tony Duffy could never have
obtained such a worm's eye view
of U.S. softball player, Janet
Pinneau, in the course of an
actual game. Pictures like this
have to be set up during training
or at special photo sessions, when
the photographer has more
freedom to experiment and more
control of the action.
 Duffy wanted to catch the
girl in mid air and the ball about to
hit the glove. He shot 24 frames
and the ball is well placed in
about half of them. Timing, he
says, is a matter of instinct but
with experience one learns to
sharpen up one's reactions.

*Equipment – Nikon FE camera
and 50 mm Nikkor lens.
Film – Kodachrome 64.*

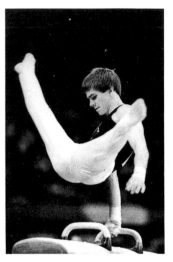

**Kurt Thomas, Fort Worth,
Texas, 1979** *page 30*
Professional sports photogra-
phers cannot simply rely on luck
and quick reflexes. Many of their
finest pictures are the result of
careful preparation. This image is
a classic example.
 Tony Duffy was covering the
1979 World Gymnastics Cham-
pionships and he knew that one
of the favourites, U.S. gymnast
Kurt Thomas, would almost cer-
tainly perform the move that he
invented which is named after
him – the Thomas Flares. The
routine only lasts about 20
seconds and so Duffy studied
Thomas's action, both during
training and in the warm-up
period, before deciding on his
camera position. As a result, his
choice of angle shows the gym-
nast's technique to perfection.

*Equipment – Nikon F2 camera
and f2.8 300 mm Nikkor lens.
Film – Ektachrome 200, 'pushed'
two stops during processing.*

European Swimming Championships, Sweden, 1977 *page 31*
In any sport, the start makes a good picture because this is the moment when athletes, horses or machines explode into action. Duffy noticed the dolphin-like shapes of these bodies and he was lucky in that the girl in the foreground didn't obscure those behind her. He says that a high percentage of failures is inevitable with shots like this but the one that does work makes it all worthwhile.

Equipment – Nikon F2 camera and f2.8 300 mm Nikkor lens. Film – Kodachrome 64. (It was an outdoor event.)

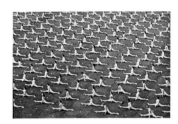

Olympic Games, Moscow, 1980 *pages 32–33*
Professional photographers are always alert to the picture possibilities of strong patterns, such as this gymnastic display at the opening ceremony of the 1980 Olympic Games in Moscow. Working from high in the stands to get an overall picture, Tony Duffy shot first with a wide-angle lens and then changed to a telephoto to accentuate the strength of the design. It was not until the film was processed that he saw the one girl in the middle who was out of step with everyone else. This picture was then cropped from the bottom half of the frame.

Equipment – Nikon F2 camera and f2.8 300 mm Nikkor lens. Film – Kodachrome 64.

Pietro Albertelli, Flying Kilometre, Cervinia, 1978 *page 34*
Taking pictures in the snow calls for special care in measuring exposures, because the strong reflection of light gives inflated readings. Tony Duffy has learned from experience what the correct exposure is likely to be in such conditions, within a certain range, but he is still extra cautious in his calculations.

Even under normal circumstances, he likes to use two meters. First he gets a general impression of the scene by taking an incident light reading, that is, measuring the amount of light falling on the subject rather than being reflected from it. Then he uses a spot meter to obtain precise measurements from his main subject.

Equipment – Nikon F2 camera and f5.6 400 mm Nikkor lens. Film – Kodachrome 64.

Lisa-Marie Allen, Los Angeles, 1979 *page 35*
Skating is normally a difficult sport to cover because of the combination of poor illumination and fast movement over a wide area. During major competitions spotlights are not allowed, though they can be used during exhibitions. This picture was shot during a display by the U.S. champion, Lisa-Marie Allen, with different colour filters being rotated over the hall lights. A low camera angle dramatised this jump and the movement was stopped by a shutter speed of 1/500 second. The fast lens had to be used at full aperture and the film had to be 'pushed' two stops during processing.

Equipment – Nikon F2 camera and f2 135 mm Nikkor lens. Film – Ektachrome Professional Tungsten (160 ASA) 'pushed' two stops during processing.

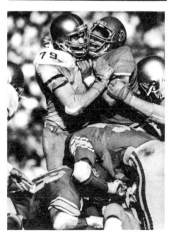

U.S.C. v Notre Dame, Los Angeles, 1982 *page 36*
In order to frame this nose-to-nose clash as tightly as possible, Tony Duffy had to use a 400 mm lens and even then to enlarge from a section of the transparency. This American football match was the last game of the season between two traditional rivals, the University of Southern California and Notre Dame.

Equipment – Nikon F2 camera and f3.5 400 mm Nikkor lens. Film – Kodachrome 64.

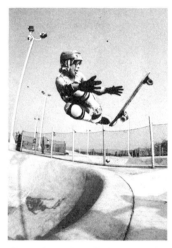

Skateboard park, Los Angeles, 1978 *page 37*
It is not only professional or top amateur sport that makes stunning pictures, as is proved by this photograph of a nine-year-old boy skateboarding in a Los Angeles park. It was not set up. Tony Duffy was lying on the ground photographing another boy, when he saw this lad cross the bowl, leap out of it and land on his feet. The second time he did this, Duffy was ready to shoot it.

Equipment – Nikon F2 camera and f3.5 16 mm Nikkor lens. Film – Kodachrome 64.

Gerry Cranham

His imaginative and technically brilliant work set new standards in British sports photography and won him an outstanding international reputation

Bryn Campbell What were your ambitions when you first became a full-time professional sports photographer?

Gerry Cranham To earn £3000 a year so that I could keep my head above water. We already had three children and I wanted to buy a car and a house.

Most of my work then was for the London evening newspapers – usually stock portraits and features. I had a map of London and I planned my work like a military operation, travelling from one athletics track to another – first on a bicycle and later a small motor-bike – shooting as many as 12 features in a day, working myself to a standstill. But it was basic stuff, mainly pictures of pretty girls – an attractive javelin thrower or an engagement, and so on.

B.C. When did you first realize that you had the talent to take photographs of quite a different quality?

G.C. I didn't have the time to worry about that at first. It was just a question of earning money and improving my technique. I had to learn everything by trial and error. I only had this *Ilford Manual of Photography* to work from.

Perhaps the turning point was when I began to freelance for *The Observer*. They gave me a by-line, the pictures were well displayed and Dennis Hackett, the Picture Editor then, was keen to use new talent. It was about the same time that Don McCullin joined the paper. Jack Esten was there too, just about to retire but still a very fine photographer, especially with long lenses.

I wasn't under any contract and I used to suggest nearly all my own ideas but they used more and more of my pictures. The 'dailies' on Monday morning were also important to me, particularly the *Daily Telegraph* and the *Daily Mail*. Then I was introduced to the *Time-Life* people and my market got wider and wider.

I used to shoot news pictures on Saturday and features on Sunday. The rest of the week was taken up with planning the pictures or selling them. Earlier, as an unattached freelance, I used to have trouble getting into events to take pictures; I had to shoot from the crowd, but it didn't bother me too much. At that distance it was easy to read the action and if I picked a high vantage point, I could simplify my pictures by cutting out the crowd in the background. I only had a Leica in those days and I had to buy a 135 mm telephoto lens in order to cope with all the long shots that were necessary.

B.C. Have there been any photographers who have had a strong influence on you?

G.C. At the beginning I can't really think of anyone who influenced me. Later perhaps Jack Esten to some extent. He was producing different pictures from anybody else when I first worked for *The Observer* and he helped me to realize that there was more to photography than simply taking stock pictures. As I said earlier, he was especially strong with long lenses. I remember that Don McCullin and I had these cheap Hanimex 300 mm lenses that he used to call poor man's Jack Estens.

Mark Kauffman was probably the only really strong influence on me – the dramatic angles, the colour, the strength of his composition, everything in its place like a painting. In fact, painting has probably influenced me more than photography – Monet, Breughel, Munnings – horses are a very important part of my work – and many others.

In all my black and white pictures, the golden rule for me was 'Watch the whites'. The whites were the most important part of the picture. That's something I picked up from my art classes, it was always 'Watch the whites'.

I envied the control that painters can exercise over their work and I was determined to impose what control I could on my own pictures. In my early days, I virtually drew a picture in my own mind of what I was trying to shoot. I had a very clear image of what I was after.

B.C. Were you trained in art?

G.C. My great disappointment was that I didn't go to art school. But I went to evening classes in art at Reading University. And when I worked in the aircraft industry, I used to spend most of my lunchtimes talking with our illustrator.

B.C. How and why did you change from aircraft engineering to sports photography?

G.C. There was a severe recession just as I was finishing my engineering apprenticeship, about 1948, and the firm I was in was close to going bust. I was quite a good athlete – Southern District champion twice in the half-mile and runner-up in the National Junior Championships. One of my athletic club members was a captain in the R.E.M.E. and he suggested that I should join up too and run for the Army. So when I was 19 I signed on for five years. Remember, there was a recession then.

I never won the Army title itself but I was Services Champion in 1952. Then just as I was reaching my peak as a runner, the arch of my foot went and I became so lame I was almost invalided out of the Army. Before long I was in Civvy Street anyway and I started to coach other athletes. A chap I knew at work was a keen amateur photographer and that gave me the idea of photographing the athletes I was coaching, to show them the faults in their style.

I bought a Periflex camera for £40 and then a Johnsons exposure calculator. My friend taught me the rudiments of developing and enlarging and after that it was up to me. I covered my costs at first by selling prints to athletes and by photographing everything from dog clubs to weddings. With my job as a draughtsman and my photography, I was working from 9 a.m. till midnight every day.

Gradually, I improved my technical knowledge, made more money, added to my equipment and began to be published in athletics magazines and then in local newspapers. As I got better, I got bolder and approached the national press. Going full-time was almost forced on me by the sheer pressure of work. It was about 2½ years after I started photography.

B.C. As long as I've known you, over 20 years, you have

always tried to produce original pictures, never playing safe.

G.C. When I could afford to.

B.C. O.K. When you could afford to. But what was it that drove you to take pictures that were so different, to take chances?

G.C. I didn't like the photographs I took earlier but they paid their way. But even when I was shooting stock portraits, I would always take a series of pictures from different angles, instead of just a single shot like the agency photographers. And, whenever I could, I shot colour as well, right from the beginning. I used Agfa CT18 in a 5×4 inch camera with an f4.7 lens. I could shoot at 1/250 second wide-open in bright sun.

I wouldn't be in photography today if I had been forced to go on taking stock pictures. It would be like working on a production line. That is why I have varied the sports that I've covered. Look at Picasso – I was lucky enough to see that huge exhibition of his work recently – he went from one phase to another, working intensely at one thing and then moving on to something else.

In some ways that is what I have done. I get obsessed with a sport, work away at it until I can't do anything better and then I move on. I must have covered about 80 different sports and I still find the subject endlessly fascinating. I've been asked whether I've thought of getting involved in televising sport but I haven't yet come near to fulfilling myself in 'still' photography. The possibilities are endless.

B.C. Has it been any advantage to you as a sports photographer to have been a good athlete yourself?

G.C. Yes, without a doubt, because to begin with I made my name just photographing athletics and I knew the crucial moments, where the pressure came on. It also gave me a sympathy for the athletes. I knew when to keep out of their way both before and after an event, when to approach them and when to stay back and work with a long lens.

Certainly it helps for a photographer to understand the sport he is covering but one doesn't want to get too obsessed about following particular athletes. It isn't always the world champions that make the great pictures.

In general I don't think it is a good idea to over-specialize. It may help to concentrate on perhaps half-a-dozen sports but if you stay too close to one of them, you do tend to dry up.

When I was an athlete I always prepared myself well and it is a habit I have kept up in photography. I arrive early at any event, I've done my homework about what to look out for, and I have a good walk around the course before the competition starts. I know what you get out depends on what you put in.

Most of the best pictures do not happen by accident. Of course, sometimes there is an element of luck, something happening right in front of you. But you should know where things are likely to happen and be prepared for anything that does happen. An outstanding angler knows where the fish may 41

bite and he sets up there. Catching the big fish is largely a question of calculation and skill.

B.C. To what extent do you go to an event with preconceived ideas of the kind of picture you want?

G.C. I used to watch television and see where the best visual opportunities lay. That would give me some idea of where to go and also help me decide what I was after. I would pick my fishing area. Sometimes I would set up quite elaborate shots and that could be so costly that one needed some support from a magazine or newspaper. But whatever plans I've made, I like to think I'm an opportunist and if I see something better, I'll go all out for it.

Staff men are often made to play safe. I feel sorry for them in that way. I've always made myself independent. I've made sure that I'm financially secure and not overcommitted to any single market. It is fundamentally important to me to have my freedom, to be my own man.

B.C. Do you ever get the idea for a picture because of some effect you see through the camera?

G.C. No. I see pictures first with the eye.

B.C. What equipment do you use?

G.C. Mainly 35 mm cameras, Nikon FE's at the moment, but occasionally I do use Hasselblads for studio work and I also own some Mamiyaflexes and a Linhof 5 × 4.

On a major assignment I would probably carry four or five camera bodies, possibly fitted with motor-drives, depending on the particular story. I am always wary of over-shooting with motor-drives. I use every kind of lens from a 16 mm fish-eye to an 800 mm telephoto. If I was travelling abroad, I might save weight by carrying nothing longer than a 300 mm or 400 mm lens, plus a ×2 converter to double their focal length, if this is necessary.

Perhaps the lens I use most is the 85 mm but every lens has its own function and I select different ones for different jobs. They all have something to offer. I often shoot wide-open, to throw everything but the immediate subject out of focus. With black and white film, this may mean using filters to cut back the exposure. I like to use Tri-X because it gives softer gradation in harsh sunlight than slower black-white emulsions. For colour, I prefer Kodachrome-25 or occasionally Kodachrome-64. In extreme conditions, such as using the 800 mm lens in poor light, I have to rely on Ektachrome-400.

I try to keep abreast of the latest technical developments but I think that people become too obsessed with new equipment and really, photography is all about *seeing* pictures. Some of the new cameras and faster lenses do, however, make life a lot easier. The wider apertures help to make the backgrounds fall off more and not overpower the picture.

For measuring exposures I rely very much on experience. I know the materials I use very well and then I just check things with a Lunasix meter. I am more likely to trust the built-in camera meters with black and white film.

B.C. How do you feel about using lenses and accessories that purists might consider 'gimmicks'?

G.C. They all have something to offer if they're used in the right context. It is a question of using them intelligently.

B.C. Do you process and print your own pictures?

G.C. Colour film either goes back to Kodak or an outside lab. The black and white I mostly handle myself. It's almost unfair to expect anyone else to produce a print the way you see it yourself. It is such a personal matter. You have to make the print yourself or supervise the printer very closely.

B.C. You are often called a perfectionist. How true is that description of the way you work?

G.C. I will certainly go to inordinate lengths to get the picture I want. If I can't get it during an event, I am quite prepared to set it up. I have my 'drawings' in my head. I have my standards and my pictures have to live up to that. So many people settle for second best.

B.C. There is a story that you once tried all season to get a particular soccer picture and when it didn't work out, you hired a team to play around a goalmouth while you took the photographs you wanted. Is that true?

G.C. More or less. But it was one of my great failures. I wanted to get a goalkeeper's eye view of an attack right in the goalmouth – all the drama between backs and forwards, with at least a part of the goalie in the picture.

As you said, I didn't produce the shot during the soccer season but a friend of mine was a lecturer at a physical education college and he organized his students into teams to play for my benefit. I put the camera all over the place in the goalmouth, low down, high up, everywhere. But it just didn't work out. Perhaps I knew I had made it too easy and I didn't have the real drive any longer. It taught me that you can't just buy what you want.

B.C. What advice would you give anyone who wanted to break into professional sports photography today?

G.C. I would say it is very difficult. It has become a very overcrowded business. But if you are still determined, first become a good technician. Don't worry about the big events but cover the small amateur meetings to gain experience.

B.C. You emphasize this word 'technician' but isn't it easier than ever today, with all the improvements in equipment, to take technically good pictures?

G.C. Usually everything is O.K. as long as conditions are good. But it is important to learn how to cope with bad conditions, how to improvise when things are not going well.

B.C. What would you tell the amateur photographer to concentrate on?

G.C. Putting over a point in the simplest possible form. A picture's intentions should leap out at you with no confusion of purpose, however subtle its aesthetic effect. Basically it is a question of composition – simplify everything.

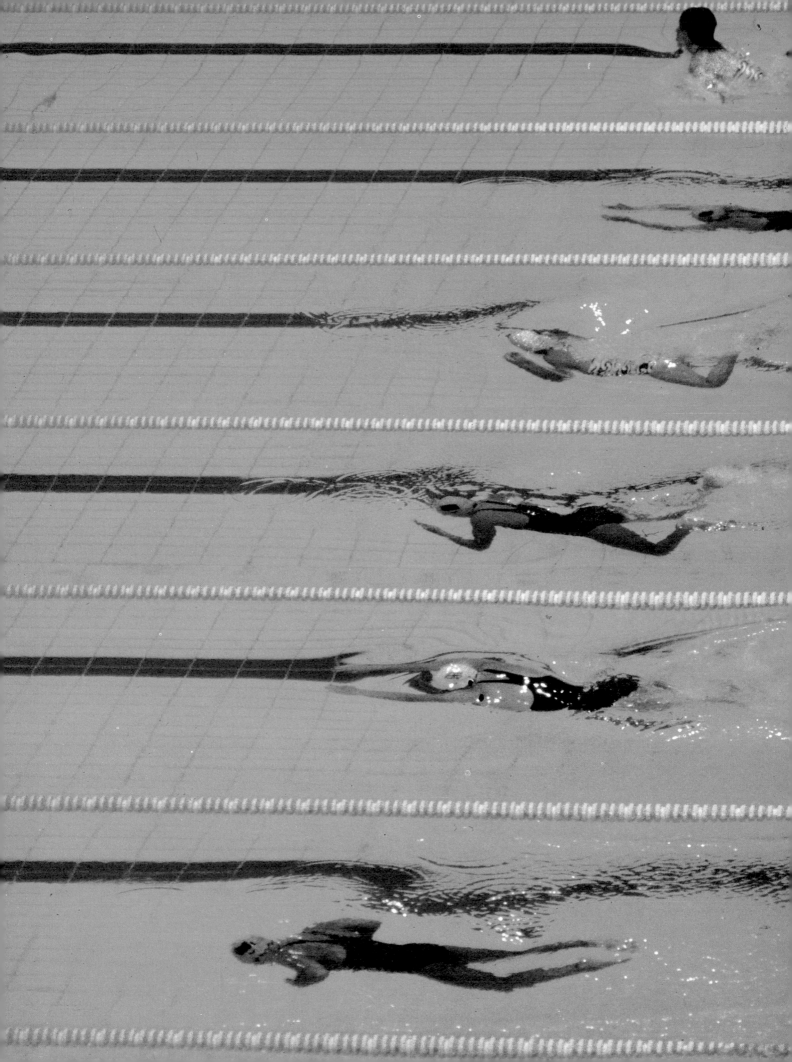

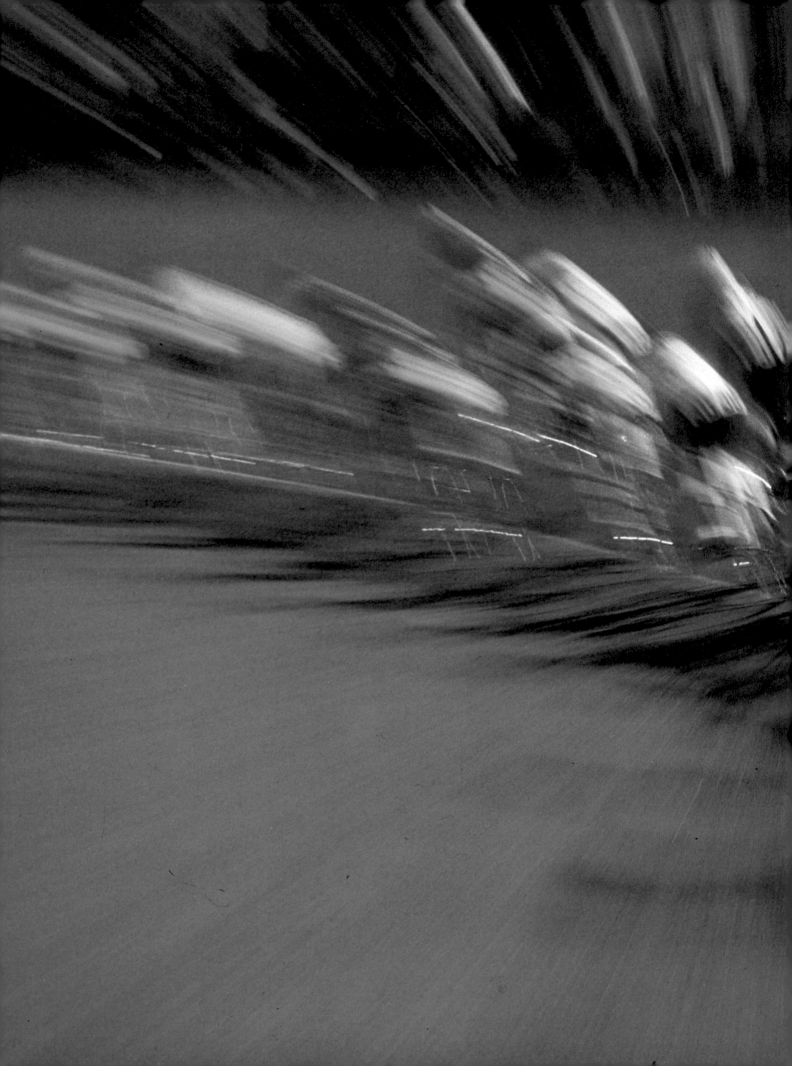

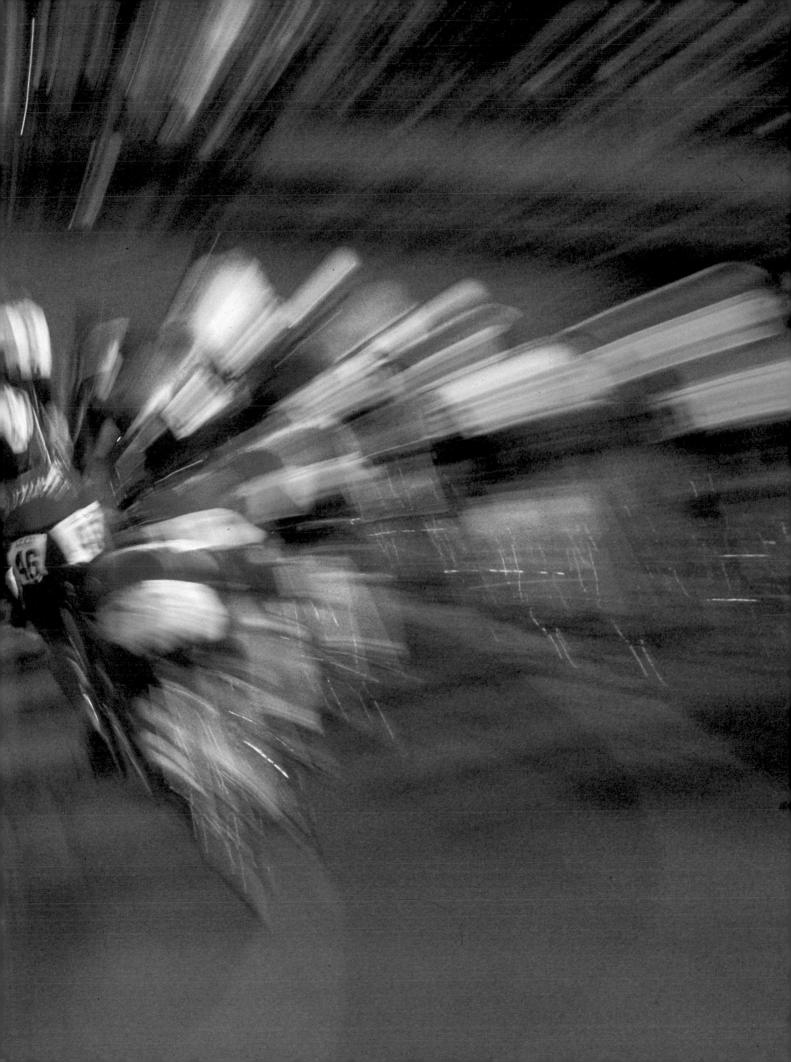

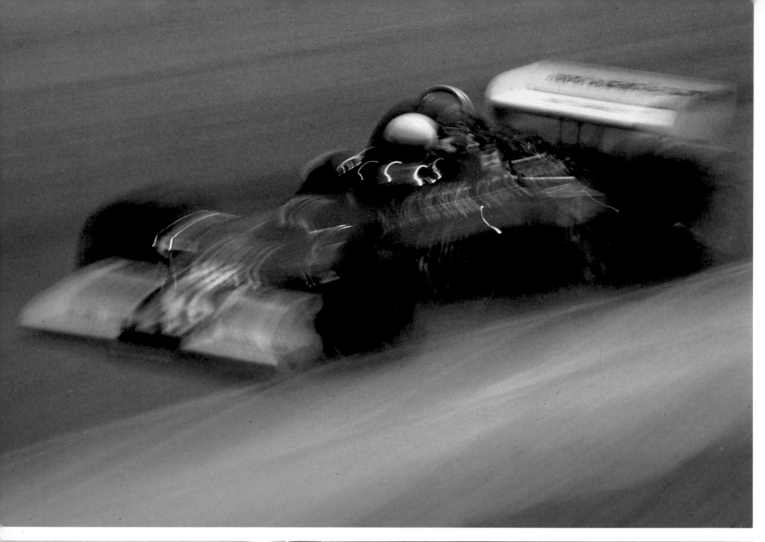

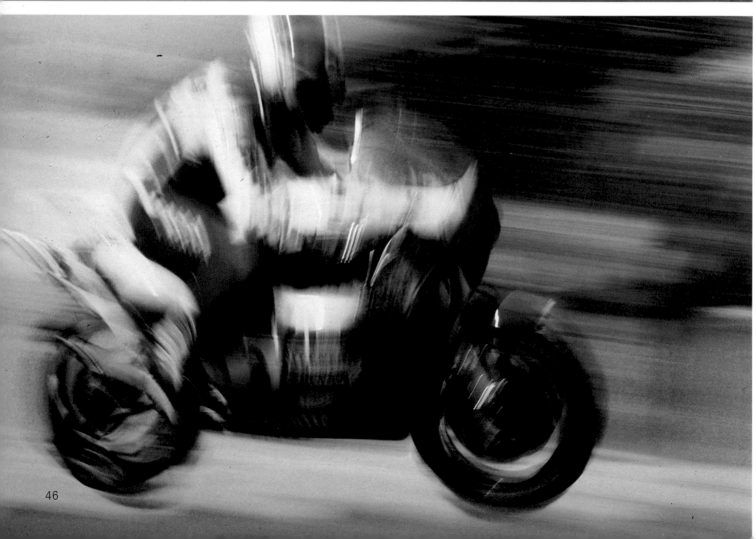

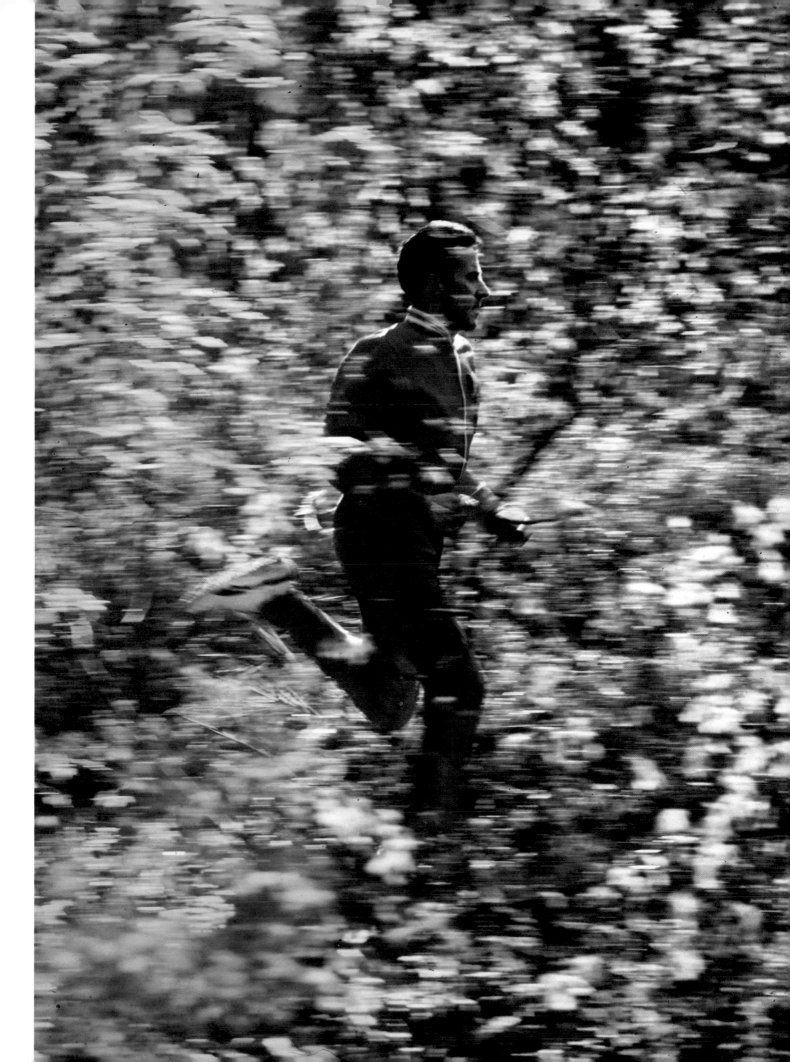

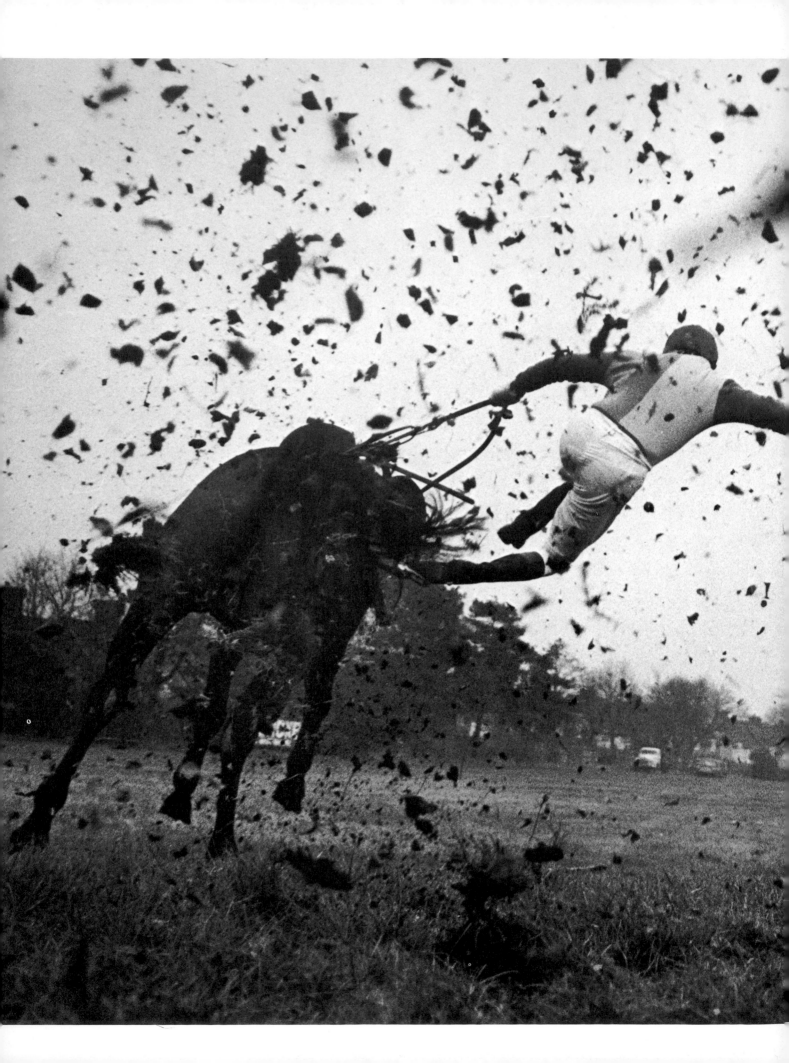

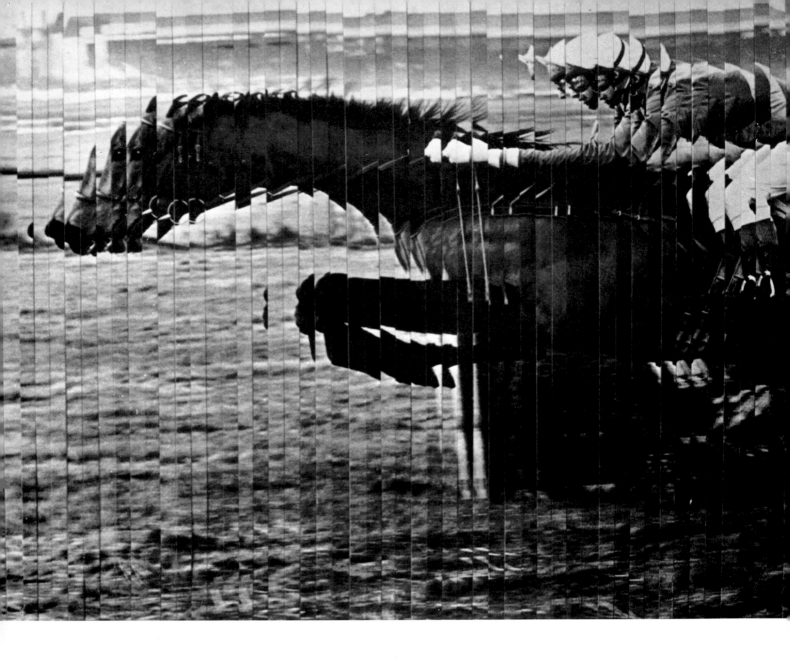

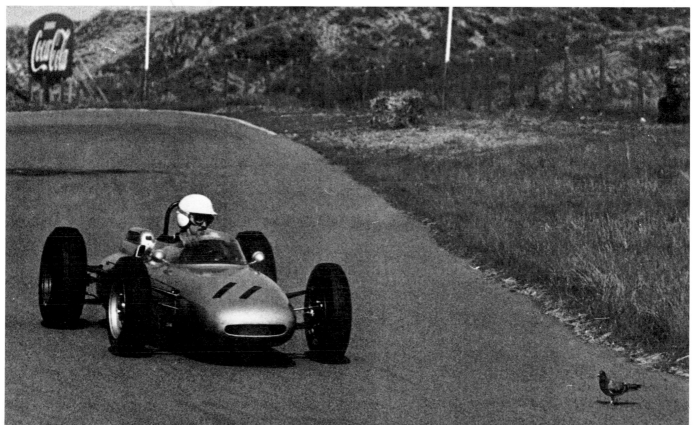

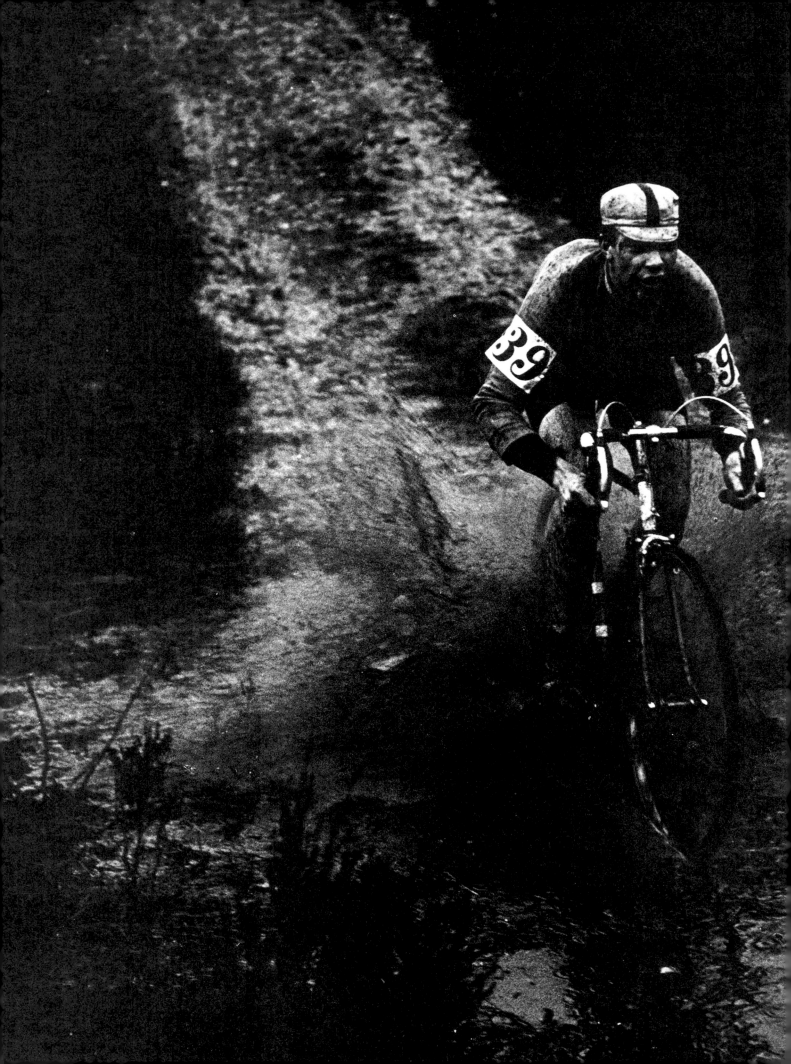

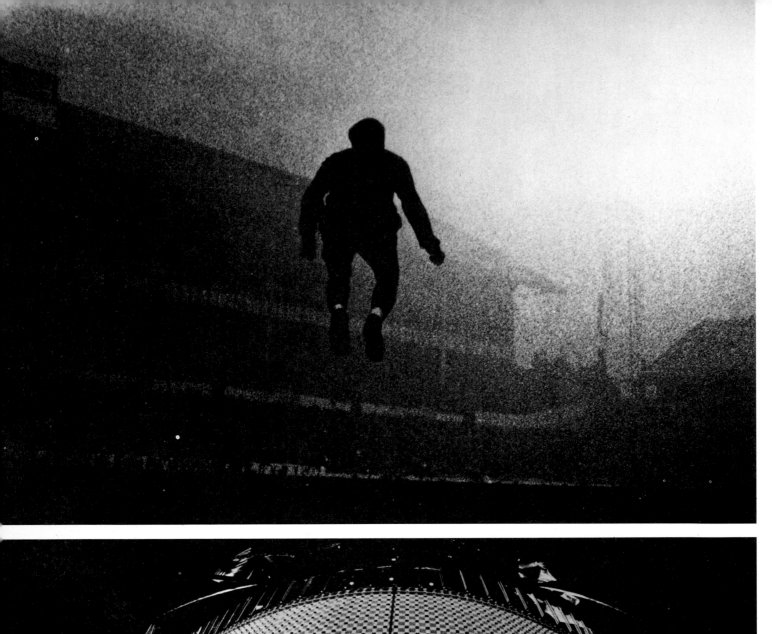

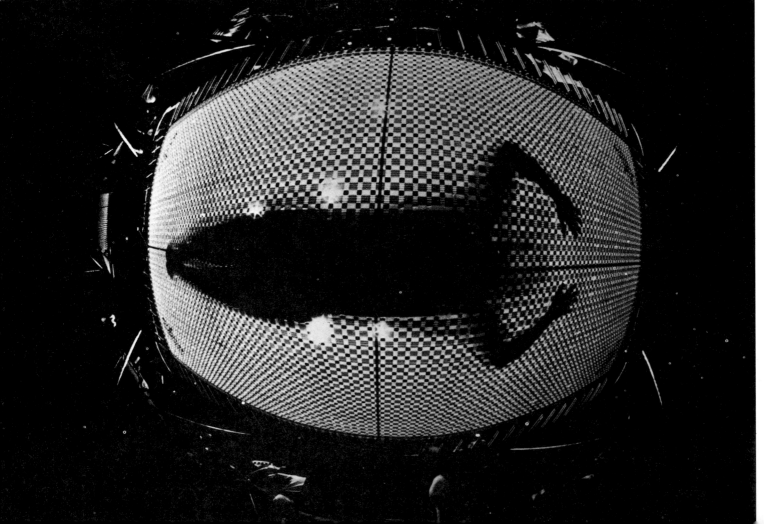

BIOGRAPHY

1929 Born in Farnborough, Hampshire, England
1943/48 Worked as an apprentice in the aircraft industry
1945 and 1946 Winner Southern Junior Half Mile (Athletics)
1948/53 Served as a Corporal with the Royal Electrical and Mechanical Engineers (REME)
1952 Inter-Services Half Mile Champion (Athletics)
1954 Retired from athletics
1954/60 Part-time running coach with Herne Hill Harriers
1957 Took up photography
1962 Major exhibition at Kodak Gallery, London
1962/71 Regular contributor to *Sports Illustrated*
1971 One-man show at Victoria and Albert Museum, London

AWARDS

1972 and 1978 Sports Photographer of the Year – Sports Council and Royal Photographic Society competition
1972 British Racing Photographer of the Year
1974 Fellow of the Institute of Incorporated Photographers
1975 Fellow of the Royal Photographic Society

BOOKS

1964 *The Professionals* with text by Geofrey Nicholson
1977 *100 Years of Wimbledon*
1979 *The Guinness Guide to Steeplechasing,* with text by Richard Pitman and John Oaksey
1980 *Trevor Francis,* with text by Rob Hughes
1983 *The World of Flat Racing,* edited by John Lovesey with text by Brough Scott

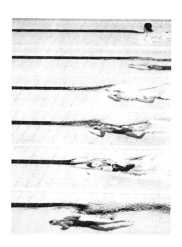

Olympic Games, Montreal, 1976 *page 43*
The shape of the human body underwater has fascinated photographers from André Kertész to David Hockney. This picture was taken just after the start of a women's 200-metre breast-stroke heat at the Montreal Olympics. Cranham's choice of camera angle and telephoto lens isolates the action precisely, drawing a most effective contrast between the formal pattern of the lanes and the movement of the swimmers.

Equipment – Nikon camera and 180 mm Nikkor lens.
Film – Kodachrome 64.

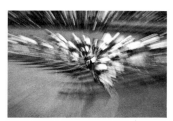

Herne Hill, 1980 *pages 44–45*
This effect is produced by 'zooming' a variable focal length lens during an exposure. In other words, the focal length of a zoom lens can be infinitely adjusted within a certain range (*e.g.* 85–200 mm). If this zoom control is moved while the shutter is open, the magnification of the image will be changed and so details will be recorded as streaks radiating from the centre of the frame.

Equipment – Nikon camera and 85–200 mm Zoom-Nikkor lens.
Film – Kodachrome 25.

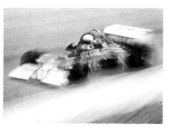

British Grand Prix, Brands Hatch, 1978 *page 46*
The fundamental advantage of a zoom lens is not the special effects it can produce but the convenience of being able to frame a subject quickly and precisely, without changing camera, lens or position. This can be particularly important when ones movement is severely restricted by problems of safety, crowds, regulations and so on.

This photograph was taken with a zoom lens but the blur was caused by a similar technique to the previous picture and not by 'zooming' during exposure.

Equipment – Nikon camera and 85–200 mm Zoom-Nikkor lens.
Film – Kodachrome 25.

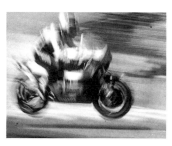

Isle of Man, 1982 *page 46*
Gerry Cranham is always flexible in his approach to a subject, ever ready to experiment with a variety of techniques – changing viewpoints, lenses and exposures. Covering the T.T. races in the Isle of Man, he found a point on the track where the motorbikes leaped into the air. Sometimes he used a fast shutter speed to stop the action and define its every detail. Sometimes, as here, he chose a slow shutter speed, 1/15 second, and panned the camera, producing an evocative blur of movement.

Equipment – Nikon camera and 85 mm Nikkor lens.
Film – Kodachrome 25.

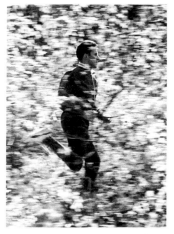

Gaston Roelants, Brussels, 1967 *page 47*
This picture was also produced by panning the camera but using a faster shutter speed of 1/125 second and with a much slower subject than a motorbike or a car. Therefore, the runner is quite sharp but his surroundings are slightly blurred, giving an impression of speed and helping him to stand out against the background. This prominence is aided by the rim illumination of the figure caused by shooting into the light.

Equipment – Nikon camera and 85 mm Nikkor lens.
Film – Kodachrome 25.

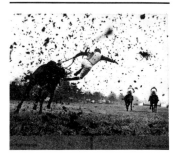

Terry Biddlecombe, Sandown Park, 1970 *pages 48–49*
Gerry Cranham was obviously fortunate in catching a moment like this but it was hard-earned luck. He worked on and off for about four years to create such a picture, setting up four remote-control, motor-drive cameras under and around a notoriously difficult jump at Sandown Park racecourse. The positioning of the cameras was critical, based on his

knowledge of the usual line of approach to this open ditch. In wintery conditions, he had to 'push' his film one stop.

Equipment – Nikon F camera and 24 mm Nikkor lens.
Film – Tri-X, rated at 800 ASA.

Night Nurse, Kempton Park, 1976 *pages 50–51*

This montage is a marvellous example of Cranham's imaginative talent. Inspired by his son's art homework, he experimented with various subjects before deciding on this particular image. It is made from two similar prints cut into thin strips and laminated together, so doubling the length of the horse.

Equipment – Nikon F camera and 85 mm Nikkor lens.
Film – Tri-X, rated at 800 ASA.

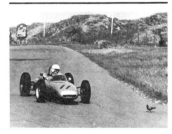

Jo Bonnier, Dutch Grand Prix, 1961 *page 51*

The pigeon, clearly hurt in some way, was fluttering around the edge of the track. Cranham saw the possibility of a picture as a car passed it and he was ready as Jo Bonnier swept by in the new Porsche. Seconds later the bird moved away.

Equipment – Nikon F camera and 85 mm Nikkor lens.
Film – Plus-X.

Cyclo-cross, Bagshot, 1961 *pages 52–53*

Events like cyclo-cross are relatively easy for the amateur photographer to cover, with ample chance of getting close to the action and plenty of dramatic incidents. Cranham himself gained much valuable experience at the start of his career in photographing such sports. This picture was taken in appallingly bad light and the film had to be 'pushed' almost to its limit.

Equipment – Leica M3 camera and 35 mm Summaron lens.
Film – Tri-X, rated at 1600 ASA.

Spurs goalkeeper John Hollowbread, London, 1964 *page 54*

A low camera angle and very foggy conditions helped to produce this very graphic and dramatic image of Spurs goalkeeper John Hollowbread as he jumped for joy when his team scored. Cranham took it lying in the mud behind the goal with his arms up under the net, working with a wide-angle lens on a Nikon fitted with a Remopak, an early type of motor-drive. It is surprising how few exceptional pictures have been taken of soccer, considering its world-wide popularity and how much it is photographed.

Equipment – Nikon F camera and 28 mm Nikkor lens.
Film Tri-X, rated at 1000 ASA.

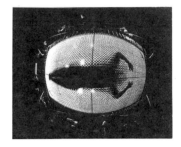

World Trampoline Championships, London, 1964 *page 54*

This photograph exemplifies not only Cranham's visual flair but also the quickness of mind and the creative courage that can inspire him to abandon a carefully prepared plan and seize the half-chance of a better picture.

He was assigned to cover the World Trampoline Championships at the Royal Albert Hall, London, and his idea was to contrast the airborne gymnasts with the richness of the surrounding architectural detail. An elaborate lighting set-up would be needed, together with the cooperation of both the officials and the competitors. At first, the organizers refused him permission to go ahead but eventually, impressed by his persistence and enthusiasm, they offered him a short, special photo session. When he was well into this period, he suddenly noticed the silhouetted image as a competitor landed in the trampoline. Immediately he switched all his efforts to capture that picture instead, placing a camera with a fish-eye lens directly under the apparatus and operating the motor-drive with a long lead.

Equipment – Nikon F camera and original model Nikkor fish-eye lens.
Film – Tri-X, rated at 800 ASA.

Fred Joch

Renowned for his ability to capture the high spots of action. A resourceful and much travelled German freelance

Bryn Campbell As a freelance photographer, what are your usual markets?

Fred Joch Both editorial and advertising. I work for a number of newspapers and magazines on both news and feature stories. Books have been an important outlet for me, I must have produced 50 to 60 of them, the most important ones being on the Olympics and on World Cup football.

Top sports personalities are always in demand for advertising and I've become more and more involved with that area of commercial photography. Also with calendars.

There is a regular flow of archive sales, of course, but I never shoot speculatively, only on direct commission.

B.C. Do you photograph mostly in black and white or do you work mainly in colour?

F.J. About half and half, but I prefer working in colour. In the first place I find it more interesting and secondly, it is far better from a business point of view. Mostly one can only sell black and white pictures to daily newspapers or very occasionally, to magazines, if it is an exclusive story.

B.C. Do you process your own films?

F.J. Only black and white. I send the colour to a lab.

B.C. How did you become a photographer?

F.J. Quite by accident. I was a carpenter for 13 years and the only sport I was really interested in was motor cycling. But a friend of mine worked for a sports magazine in Munich and one day in 1967 he invited me to go along to photograph a football match with him. So I sat behind the goal and took my first pictures with a Leica M2. I remember it was fitted with a Leicavit so one could wind on faster. I've still got it.

After that, I photographed football every Saturday for the next two seasons. Then Axel Springer Junior, Sven Simon, started a new agency in Munich and needed a photographer. My friend recommended me and I got the job.

And so on April 1, 1968, I stopped being a carpenter and became a full-time professional photographer. I was the only cameraman and I worked about 18 hours a day, every day for six months. It was too much for me. I lost 12 pounds in weight and I was a bundle of nerves. My girfriend, now my wife, worked at that time in the darkroom of a magazine group. She said that it was crazy for me to overwork that way and that it ought to be possible for us to freelance. I decided to take the chance.

First I worked for a sports magazine and then for a newspaper as well, that was part of the same group. More and more of my pictures were published, I earned more money and I began to shoot colour using a Praktisix 6×6 cm camera. I was introduced to another agency and through them I was given the job of photographing the Winter Olympics at Sapporo in 1971, as part of a colour pool of five photographers. Everything has developed from that.

B.C. What decided you to make the break from carpentry after doing that job for all those years?

F.J. Photography, for me, seemed so much more interesting and somehow I had the false impression that sports photographers only worked for 1½ hours or so at a football match or for 2 hours at a Grand Prix and that they had the rest of the time free. The joke was on me. I didn't realize that in my first job in photography I was going to be working 18 hours a day and turning into a nervous wreck. But photography also offered me the hope of visiting other countries, of getting away from Munich and seeing other places.

B.C. Which photographers have influenced you?
F.J. I can't think of a single one.

B.C. Unlike most sports photographers today, why do you prefer working with a large format camera – relatively large anyhow, compared to 35 mm – the Pentax 6×7?
F.J. When I started photography I always wanted a Praktisix. The large negatives gave such beautiful quality – so little grain and needle sharp. But working for an agency on news stories, the Praktisix was too slow and so I had to switch to 35 mm. I chose the Leica because I think it is the most precision-made instrument available and also the most robust. You can almost knock in nails with it, it is so strong.

Later, I was able to go back to the Praktisix and I only abandoned it in 1971 when I was in Sapporo to cover the Olympics. I replaced it with the Pentax 6×7 which was 50 per cent cheaper in Japan than in Germany.

I must be the only photographer in the world who uses Pentax 6×7 cameras and Leitz lenses – the long ones, that is, 400 mm, 560 mm and 800 mm. The Leitz people at Wetzlar have been incredibly helpful to me, adapting these lenses, which are normally intended for use with their 35 mm cameras, to fit my rollfilm models.

I still work with Leicas occasionally, I have eight to ten bodies and various lenses, but the Pentax 6×7 suits my style better. As I said, it gives me the image quality I want and for my kind of picture, I don't need to shoot off dozens of frames and switch quickly from lens to lens. What I am looking for is the high point of an event – that is how I have made my name, by catching that specific moment of action. If I used a motor-drive on a 35 mm camera, I might get the instant before and the instant after but miss that special moment itself. No, I prefer to wait, to be certain of capturing the picture and to be sure of that large format quality.

The Pentaxes have through-the-lens metering and I always use this system for measuring exposures. I do own a separate light meter but it's stayed in my cupboard for the last 10 years.

As far as film is concerned, for black and white I use Tri-X – though recently I've been testing a new Fuji 400 ASA film that I like very much. For colour, I prefer High-Speed Ektachrome or Ektachrome 200 ASA. Occasionally, for special jobs, I also use Ektachrome 100 ASA.

B.C. Do you prefer to work with any particular lens?
F.J. Yes, the 560 mm. It gives me the magnification I need and yet it is not too bulky. Leitz adapted it specially for me. I found the ordinary focusing mechanism rather slow and so Leitz fitted it instead with a Novoflex focusing grip.

B.C. Would you elaborate on what you were saying about capturing the high point of an event?
F.J. That is the real challenge of sports photography for me, catching that precise moment when the competitor is poised for achievement or failure. For example, with a long jumper it is not during the run-up but the instant he launches himself off the ground. That is the moment I want to highlight, a moment that the television viewer is hardly aware of because it is part of such a fast, continuous motion. I can capture and hold this split-second of movement, so the viewer can study and enjoy it fully.

B.C. Is it important to understand a sport in order to be able to photograph it well?
F.J. It is absolutely essential to understand a sport, in order to photograph it as I want to. One has to know where and when the high point of the action is going to occur, so that one can place oneself in the right position and anticipate that moment.

B.C. Do you plan your photographs in advance?
F.J. Not usually, though sometimes, of course, one has to. In general, I tend to respond to events as they happen, rather than setting up pictures. But as I said, experience teaches one where to stand and what to look for.

B.C. Do you have a favourite sport to photograph?
F.J. I don't know that I do, but perhaps winter sports. I enjoy photographing them, even though my hands and feet are frozen. Perhaps that's the challenge. Also I like the freedom to move around. I'm not confined to one position as in a stadium.

B.C. Why do you like photographing sport and not, for example, landscape or something else?
F.J. I have no talent for photographing landscape and I have never learned how. For me, the ultimate has always been sports photography, this high point of action that is there for me to seize and reveal.

B.C. Do you ever photograph anything but sport?
F.J. Yes, architecture. Remember I was a carpenter once and I still have my contacts from that period of my life. I sometimes photograph buildings and interiors for specialist magazines.

I have a good head for heights, perhaps because of my previous experience, and so, among other things, I was able to photograph the construction of the famous television tower in Munich, even at a height of 290 metres. I won a photographic competition with the results.

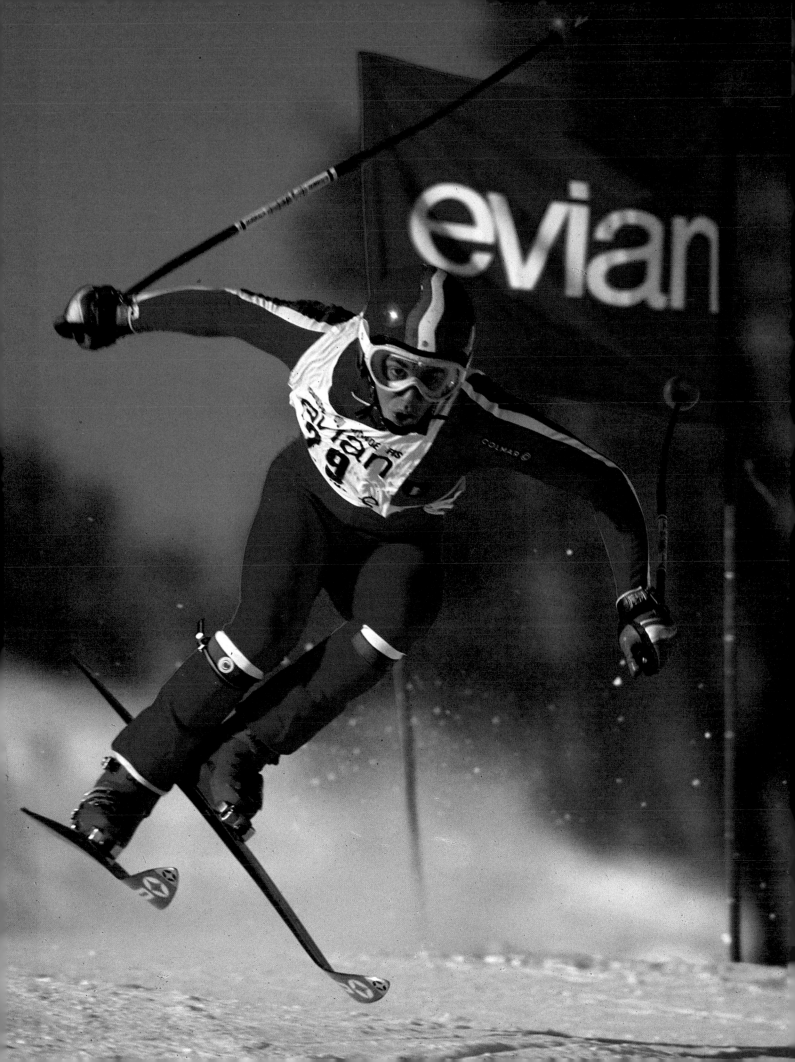

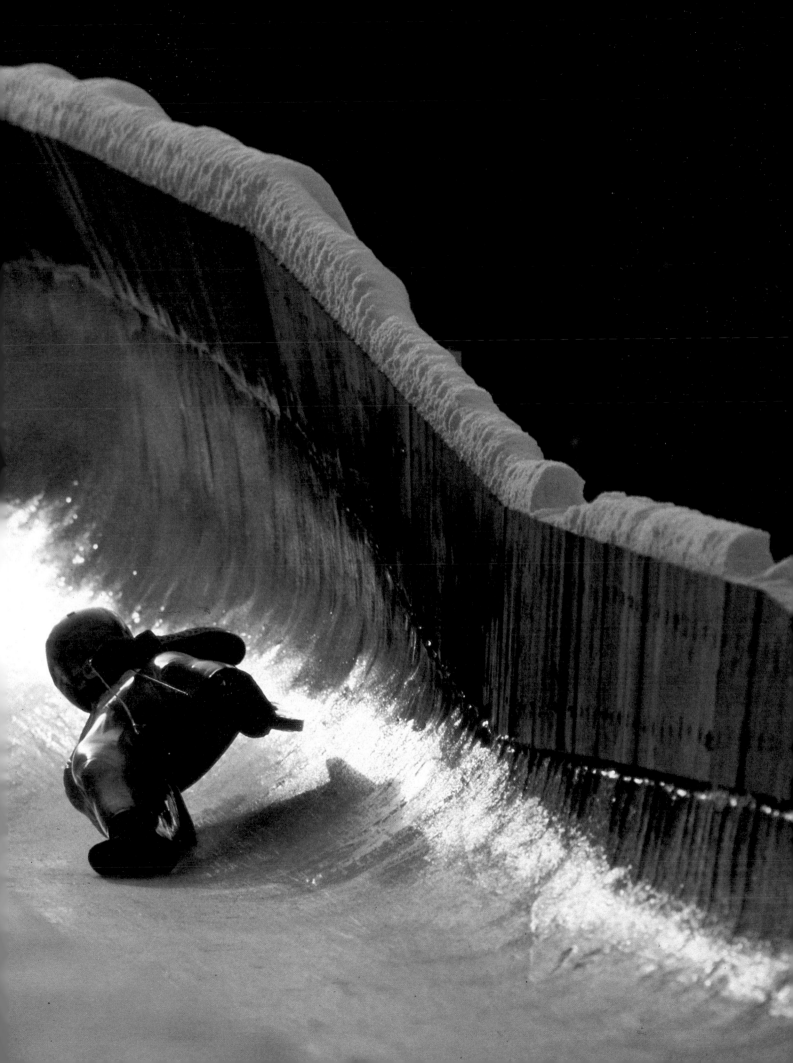

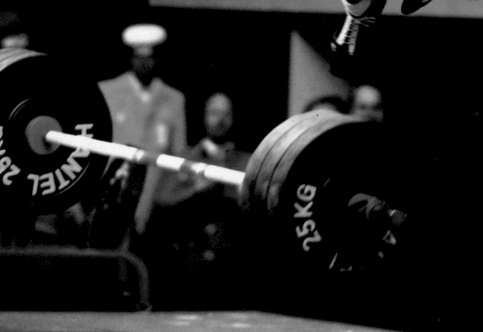

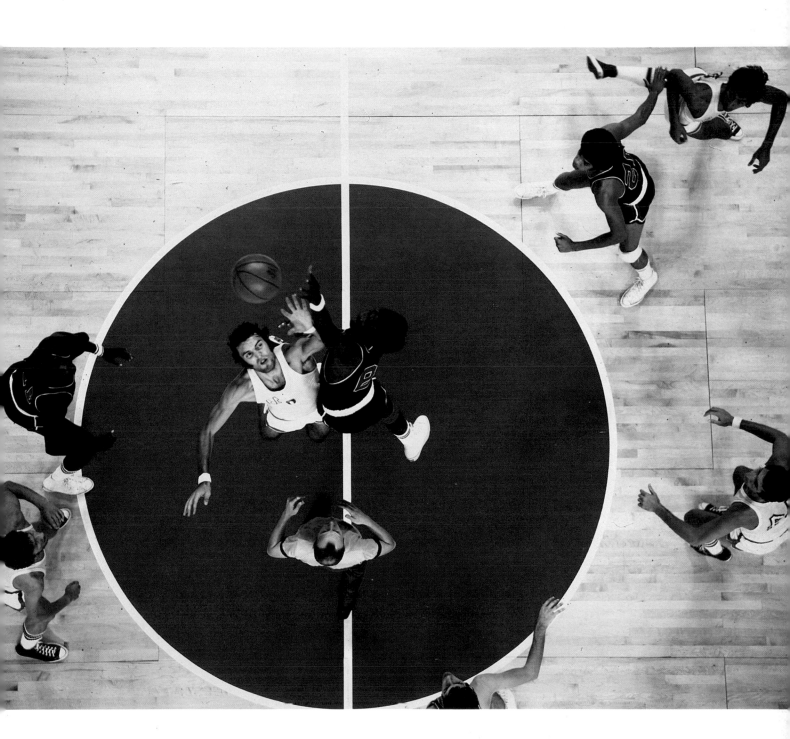

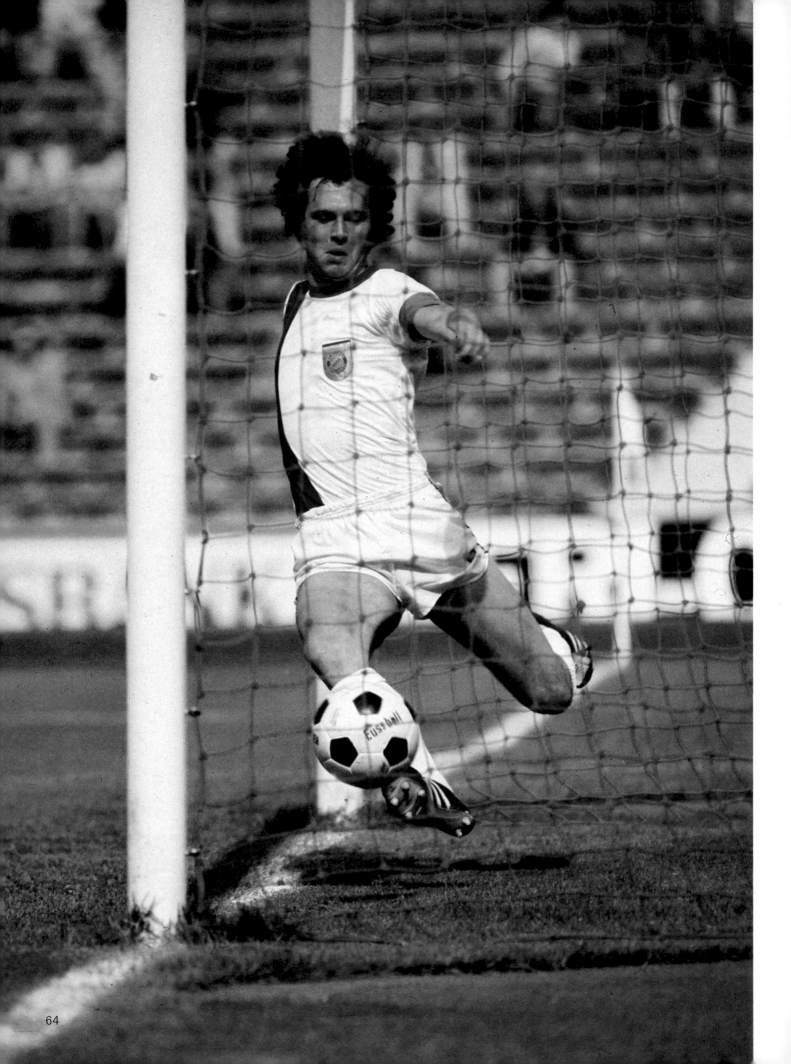

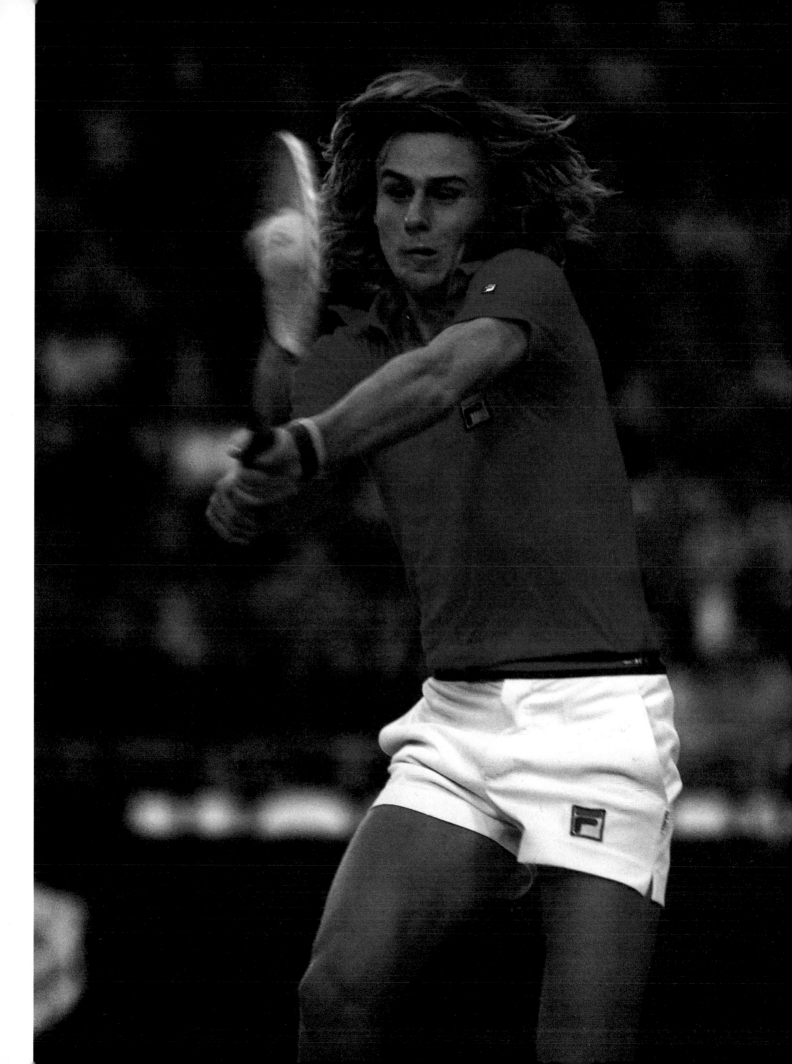

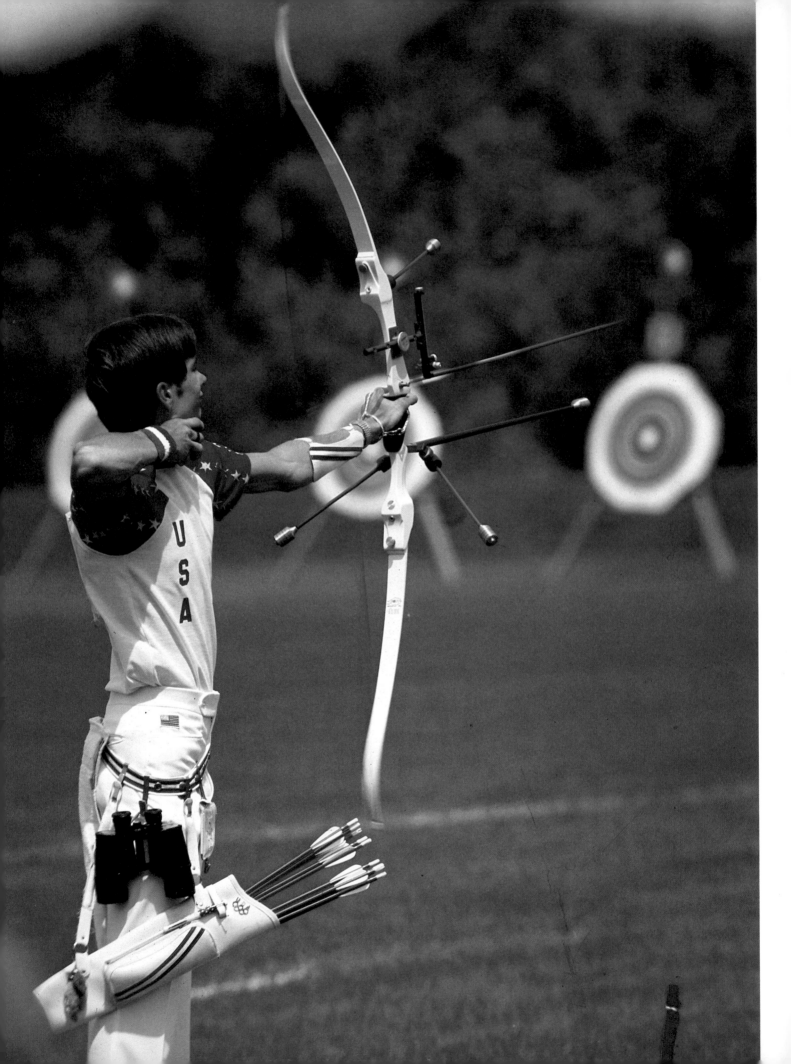

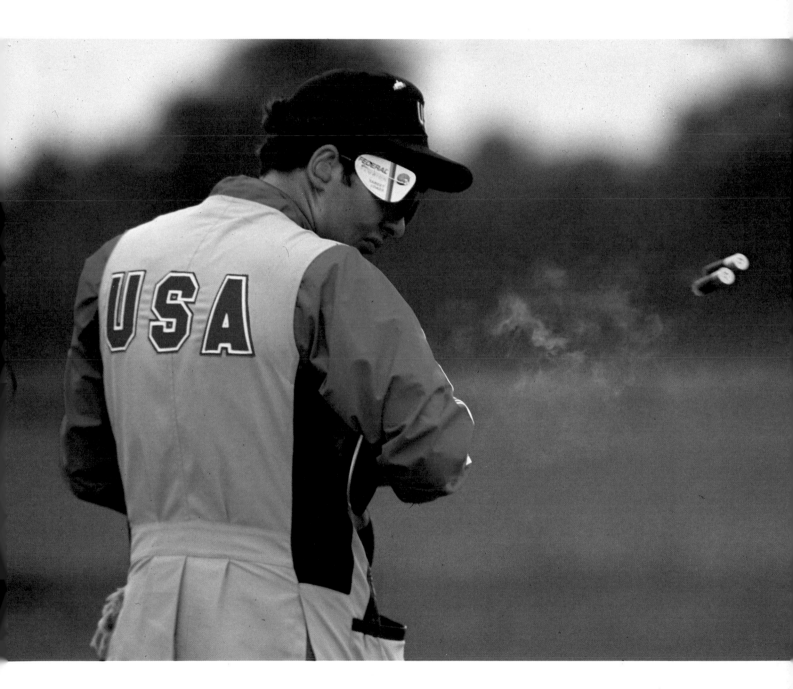

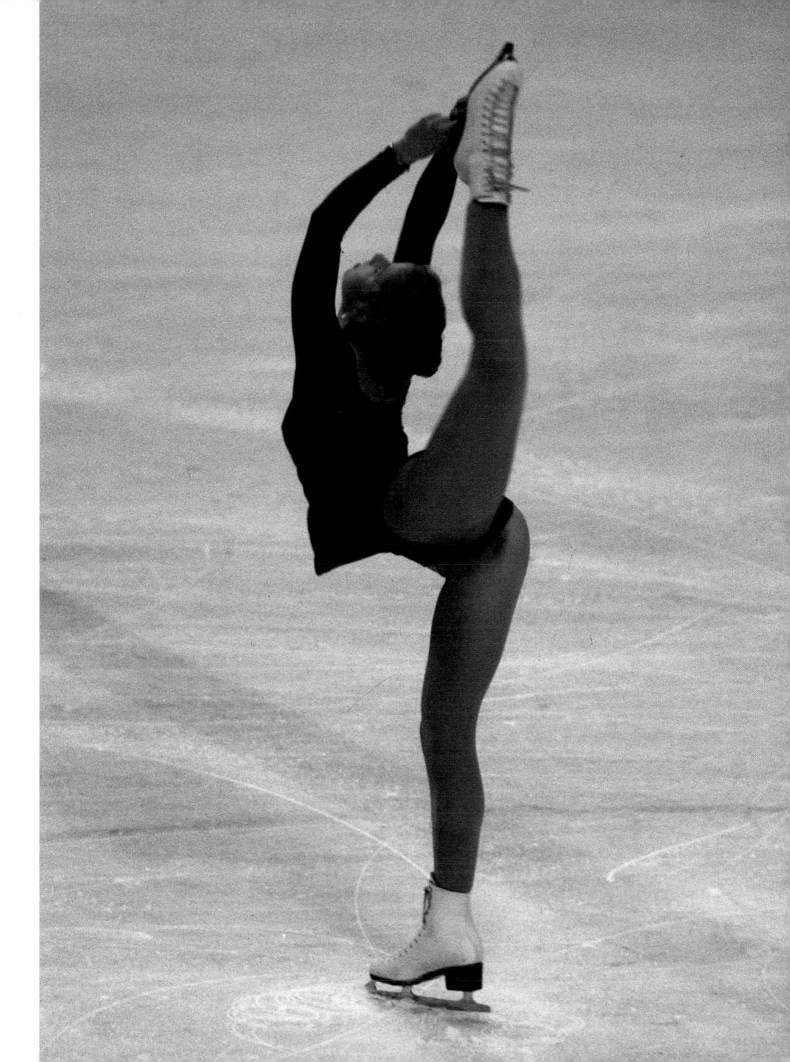

BIOGRAPHY

1941 Born in Praskowitz, Czechoslovakia
1948/55 School in Munich
1955/58 Apprenticeship in carpentry
1958/68 Worked as a carpenter
1958 Interest in photography as a hobby began
1968 Became a full-time professional photographer. Worked for the Sven Simon agency from April to September and then began his career as a freelance.
Since then he has covered a huge variety of national and international sporting events, including Winter and Summer Olympics and World Cup football
1983 Exhibition of colour photographs at Leitz, Wetzlar

AWARDS

Has won several prizes in national contests, also 1981 2nd Prize, Special Olympic Games Award (Colour) – International de la Meilleure Photo Sportive

BOOKS

Has collaborated on more than 50 books, the most important being on the 1972 and 1976 Olympics and on football's World Cup – 1974, 1978 and 1982

F. Marconi (Italy), Val d'Isère, 1978 page 59

By using a fast shutter speed to 'freeze' the action and a low camera angle to dramatize it, Fred Joch produced this picture that sums up the skill, dash and courage of the downhill racer. We can study this fixed moment at our leisure, observing detail that could never have been absorbed while watching the actual event.

Equipment – Pentax 6 × 7 camera and 800 mm Leitz Telyt-S lens. Film – Ektachrome 200 ASA.

Olympic Games, Lake Placid, 1980 page 60

As is so often the case with great sports photographs, more effort went into creating this picture than is obvious. The light only caught the slope in this way for about 10 minutes a day and once he saw the effect, Fred Joch went back to the same spot four days running, until he was confident he had made the most of the situation with this shot of the women's luge event.

Equipment – Pentax 6 × 7 camera

and 560 mm Leitz Telyt-R lens. Film – Ektachrome 200 ASA.

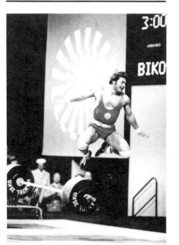

Jordan Bikow (Bulgaria), Olympic Games, Munich, 1972 page 62

Today, the lighting at most major indoor sports competitions is remarkably good, but to catch a moment like this in colour calls for a fast film – perhaps to be 'pushed' in processing – and a wide-aperture lens, so that one can use a fast enough shutter speed. Fred Joch shot with his telephoto lens wide-open at f4 as Jordan Bikow dropped the weights and jumped for joy after winning an Olympic gold medal.

Equipment – Pentax 6 × 7 camera and 300 mm Pentax lens. Film – High-Speed Ektachrome.

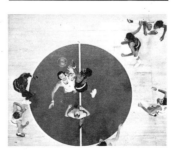

Italy v U.S.A., Olympic Games, Munich, 1972 page 63

An unusual camera angle is a sure way of creating some element of visual surprise. It is not often one gets the chance to shoot directly down on the play in any sport, especially at an Olympic Games,

and Fred Joch made the most of his opportunity to photograph this basketball match between Italy and the U.S.A. from high overhead. He was especially lucky because security precautions were strict at Munich, but because he knew the hall manager, he and one other photographer were given special permission to work from that position for just a single game. The viewpoint brings out the pattern of play with remarkable clarity.

Equipment – Pentax 6 × 7 camera and 150 mm Pentax lens. Film – High-Speed Ektachrome.

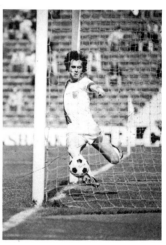

Franz Beckenbauer, Munich, 1973 page 64

Fred Joch concentrates on catching what he calls the 'high point' of sporting action: this picture is a classic example of what he means. Franz Beckenbauer just failed to stop the ball going into the net and so his team, Bayern Munich, lost by the only goal in the match against F.C. Cologne. If the photograph had been taken a split-second before or after, the full tension and significance of the moment would have been missed completely.

Equipment – Pentax 6 × 7 camera and 560 mm Leitz Telyt-R lens. Film – Ektachrome 200 ASA.

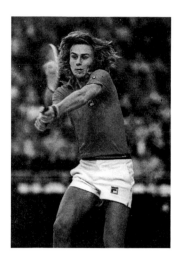

Bjorn Borg, Munich, 1975
page 65
The light was so poor when Joch photographed a young Bjorn Borg playing in a W.C.T. tournament in Munich, that even his fast colour film had to be 'pushed' two stops. With good timing and good luck, in whatever proportion, he caught the instant the racket connected with the ball.

Equipment – Pentax 6×7 camera and 300 mm Pentax lens.
Film – High-Speed Ektachrome 'pushed' 2 stops.

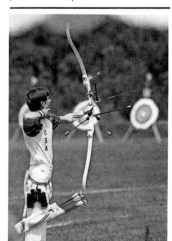

Darrell Pace (U.S.A.), Olympic Games, Montreal, 1976 *page 66*
Again, timing and luck combined to 'freeze' an even rarer image, the very moment an arrow sped from the bow of Olympic gold-medallist, Darrell Pace. Joch took 10 pictures of the young

American as he competed at Montreal, trying to bring off this shot. His choice of viewpoint and lens made the tightest possible clear grouping of archer, arrow and target.

Equipment – Pentax 6×7 camera and 560 mm Leitz Telyt-R lens.
Film – Ektachrome 200 ASA.

Bradley Simmons (U.S.A.), Olympic Games, Montreal, 1976 *page 67*
With a subject this subtle, the reader's attention has to be totally concentrated on the specific point of interest and so Joch used a telephoto lens to close right in on the action. He saw this incident happen once, as Bradley Simmons (U.S.A.) ejected two spent shotgun cartridges, and he was ready to photograph it when it occurred again.

Equipment – Pentax 6×7 camera and 560 mm Leitz Telyt-R lens.
Film – Ektachrome 200 ASA.

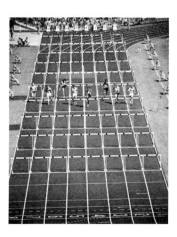

110 metres hurdles final, Olympic Games, Munich, 1972 *page 68*
Photographers often say that if you can't get close enough to the

action, you can't take good pictures. This is largely true but, as this photograph shows, not invariably so.

Fred Joch was unable to work from what was apparently the best camera position because of the limited space available and the sheer number of photographers. So he moved high up into the stand and framed the entire length of the 110 metres hurdles track. The intercrossing lane markings and the lines of hurdles formed a strong pattern and he was able to photograph different stages of the race, producing both a number of effective individual shots and an interesting series.

Equipment – Pentax 6×7 camera and 560 mm Leitz Telyt-R lens.
Film – Ektachrome 200 ASA.

4×100 metres relay final, Munich, 1982 *page 69*
The qualifying stages of any event are useful times for photographers to shoot stock pictures of competitors and to watch for picture possibilities that they may be able to take advantage of later. Fred Joch decided to go for this particular photograph after covering the first heat of the 4×100 metres relay in the German National Championships. He shot the baton change in each of the four heats, panning the camera at 1/60 second and so blurring the background and the runners' feet. In the final race, everything fell into place as he had hoped and he made this picture.

Equipment – Pentax 6×7 camera and 400 mm Leitz Telyt-R lens.
Film – Ektachrome 100 ASA.

Olympic Games, Lake Placid, 1980 *page 70*
Fred Joch used a telephoto lens to isolate his subject – a competitor in the women's luge event at the Lake Placid Winter Olympics – against a plain background and to take advantage of the way in which it appears to compress *space, producing a striking effect.*

Equipment – Pentax 6×7 camera and 560 mm Leitz Telyt-R lens.
Film – Ektachrome 200 ASA.

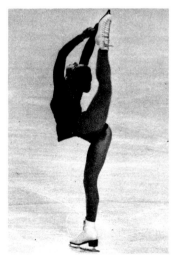

Denise Biellmann, Olympic Games, L. Placid, 1980 *page 71*
When working in poor light, photographers who prefer medium or large format cameras are often at a disadvantage compared to 35 mm camera users because of the relative slowness of their lenses. Here, Joch worked with his telephoto lens wide-open at f5.6 and by 'pushing' the fast colour film two stops.

Equipment – Pentax 6×7 camera and 560 mm Leitz Telyt-R lens.
Film – Ektachrome 400 ASA.

Neil Leifer

Internationally famous American photographer, acclaimed for his strikingly original work for magazines such as Sports Illustrated and Time

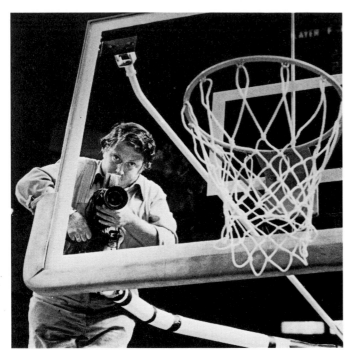

Bryn Campbell Did you start out on your photographic career by taking sports pictures?

Neil Leifer Professionally, yes, but as a kid I loved photographing Navy ships. One of my greatest thrills was photographing the battleship *New Jersey* for *Life* magazine and then doing two books on it.

Photography was my ticket to the world. I don't come from a rich background – I was born and raised on the Lower East Side of New York. I'm a sports fan, I like taking pictures and I love seeing them published. It dawned on me very early that people were paying me to do what I wanted to do. How else could I get a front row seat for the Ali v Liston, or Ali v Frazier title fights? Someone is paying me to do what I enjoy and putting me in the best seat in the house.

When I began, in the late Fifties, if you were young, bright and competitive, you had plenty of space in the market. Most intelligent, capable kids were going on to college to be doctors, lawyers and engineers. They were not becoming photographers. There were many more markets and competition was not that keen.

In the late Sixties and early Seventies, photography became something of a glamour profession and as the big magazines like *Life, Look* and *Saturday Evening Post* ceased to publish, suddenly there were fewer markets and many more photographers around.

B.C. Since you left *Sports Illustrated* in 1978 and joined *Time* magazine, have you continued to photograph sport?

N.L. We cover all the major events and I still photograph all the top sports personalities but now I also photograph Paul

Newman or the Mayor of New York. I just did a sitting with President Reagan in the Oval Office. It was a thrill, no doubt about it. *Time* offers me that extra opportunity, a fresh range of subjects to cover and I find that so exciting and satisfying. I've never had a better job.

People used to ask me if one wouldn't get bored doing just football games or just sport, and I'd say no. But in fact you do. I'd done every Super Bowl, every title fight. I worried about burning out or about losing my enthusiasm. *Time* allows me to photograph only those sporting occasions that I am wildly enthusiastic about. I've always been a great boxing fan and since I've been with *Time*, there isn't a major fight that we haven't covered. I'm having a good time with sport but I don't have to photograph it every single week.

I've always had interests in other things and now I have the chance to explore them. For the last 5 years, I've been trying to tell people that there is more to Neil Leifer than just sports photography. I love my job here and I've also fallen in love with the movies. I made one film and I want to make more.

B.C. Do you put a different value on your recent work, such as the picture essay on American prisons, than on your sports photography?

N.L. I'm very proud of my sports pictures and I don't attach any less importance to them than to my other work. And my approach is remarkably similar. For instance, the cover picture for the prison story was a remote control shot with the camera set up above an inmate's cell, just as once it sat above the ring when Ali fought Cleveland Williams.

B.C. What photographers influenced you in the beginning?

N.L. When I started to submit pictures to *Sports Illustrated*, they had four great photographers – John Zimmerman, Mark Kauffman, Hy Peskin and Marvin Newman. Peskin and Newman mostly covered news events and they did it better than anyone had ever done before. Zimmerman also tackled some hard news but primarily he was producing essays, taking themes and ideas and expanding them into major photographic features. This was infinitely more appealing to me. Mark Kauffman intrigued me in a different way. He had the quality that I knew I lacked most – sensitivity. For instance, I admired the way he could light a portrait.

The other strong influence on me, who was being beautifully published at that time, was George Silk. He comes somewhere between Zimmerman and Kauffman, both technically superb and sensitive. I like eliminating luck and when you see Silk's pictures, you know he wasn't going to miss. He took the first photographs with the camera mounted on a racer's skis and also on the starting gate at the Kentucky Derby. He did it first and he did it best.

As the four great *Sports Illustrated* photographers left in the early Sixties, the new generation of photographers like Walter Iooss, Jim Drake and I had our chance.

B.C. Has anyone influenced you significantly since?

N.L. Not really. The more you're influenced by other people, the more sub-consciously you begin to copy them. I would like to think that my best ideas were original, that they came from my head, that they were fresh.

B.C. What do you think constitutes a great sports picture?

N.L. To me it is the same as what makes a great picture, period. I judge photographers by the pictures they have taken that I remember. You mentioned Cranham to me just now; I can remember a dozen of his pictures just like that, his steeple-chasing essay is one of the finest set of photographs I've seen.

You can't get away from the element of luck in sports photography, but what makes a great sports photographer is that when he gets lucky, he doesn't miss. Of course, you can't always get it exactly right, but more often than not, you will.

B.C. How would you describe your own sports pictures?

N.L. I hope now that they are really simple. That is something else that I liked about Kauffman's work, its simplicity, and that probably influenced me. I enjoy working on pictures that are technically interesting to do but turn out looking clean and straightforward. But so much these days my accomplishment is not in the quality of my photography but in getting personalities to pose for pictures, to cooperate.

My best sports pictures have been really good execution when a great moment happened – like Secretariat crossing the finish line and the jockey looking straight at me. Luck, of course, but I was working tight with a 300 mm lens and I held the point of focus, I didn't miss.

I think I'm not naturally gifted, I have to work hard at it. I don't have the instinctive genius of someone like Walter Iooss. My strength comes from a lot of hard work, a little research and thinking out my pictures. I execute the technical end of photography very well and I light my pictures very carefully. I would like to think I'm valuable because of my versatility and because of how hard I work.

I'm honest with myself about my pictures because I know what went into them. I've been praised by senior editors for pictures that I knew were not very good. And conversely, I've been criticised for what I've turned in on a job when everything that could go wrong, went wrong and the editor was just lucky I was there to be able to produce a decent image at all, given the difficult circumstances.

As your reputation grows, people go out of their way to help you when you turn up on a job. It is easier for me to do good work now than when I started, because people put out the red carpet and if I need an extra hour, I am more likely to get it.

B.C. What kind of control have you been able to exercise over the selection and use of your pictures?

N.L. Over the years you get more respected in terms of your opinion being listened to, but realistically, I have no say on the subject. The Managing Editor of the magazine is paid to make those decisions. We happen to have a very good one and so more often than not, I'm happy about what goes in.

When I'm really confident of a situation, I don't give them a choice of what I shoot. I'll provide four different versions of the same thing. I also edit my own pictures, 99 per cent of the time. And I edit very tightly. I influence decisions by choosing carefully which pictures I show the editors.

One of the reasons I want to make movies is that I want to be the person who makes that final choice.

B.C. How has the development of television sports coverage affected your work?

N.L. Enormously, in many ways. On a purely practical level, it creates serious problems. For example, at a title fight, the new hand-held TV cameras are all over the place, shooting preliminaries, action and so on. Wherever you look, one of them is in the way. Secondly, they light everything and they light it flat, so that you lose the drama. The lights used to be 40 to 50 feet over the ring and so the boxers stood out against a black background. Today, the lights are low and ugly and the physical appearance of the arena has been changed to meet television's needs. And they don't like the strobe lights that gave us such terrific quality.

Television has also fundamentally influenced our approach to photographing an event. Again, take a title fight as an example. People see it live on TV; it is on the news shows later that night together with slow-motion replays; the newspapers next day are full of pictures taken by the guys who were right next to you at the ringside. Why should you want to look at *Sports Illustrated* almost a week later? That was our challenge – to produce pictures that were worth waiting to see. Whenever possible, I didn't position myself with the other photographers and I always tried to do something different.

In a number of areas, sports photography is not what it was. Look at Hy Peskin's pictures taken 30 years ago of Sugar Ray Robinson fighting Carmen Basilio. They were better than anything taken today. The flash units he used were high power but very short duration, 1/10,000 sec. or 1/20,000 sec. They stopped the action totally. We don't have such strobes any more; they don't exist.

When we used to light an arena for *Sports Illustrated*, it took a truckful of equipment to do the job and it took us a day just to set it up. The condensers weighed 80 pounds each and I remember it took 40 of them to light Madison Square Garden for some pictures that John Zimmerman did. The total value of the equipment was about 40,000 dollars. Magazines won't pay that kind of money today but in those days it was a necessity.

It is one thing to light an arena with strobes so you are able to shoot at f5.6. It's another matter to do it creatively. Today, the routine is that you arrive half an hour before a hockey game, for example, and get yourself ready. It used to take 3 days to prepare, to fix up the lights and check them. Something would always go wrong. Perhaps you would be using radio remote control and some policeman's walkie-talkie would be firing off 75

your lights. You would have to change your frequency and so on. We might be stuck in the arena until 4 am trying to find out what was wrong with one of the power packs. It was expensive of time and money but it was very satisfying when you managed to bring it off successfully.

B.C. Is a good knowledge of cameras and equipment still important to your work?

N.L. Very important. So much of my photography involves coming up with the right answer to a technical problem.

B.C. What equipment do you use?

N.L. From the time I started, I've always used Nikons. In the studio I use Hasselblads and I've used a variety of cameras for special purposes but at least 90 per cent of my work is with Nikon equipment.

Because of the kinds of sport that are most popular in the USA, we have to rely a lot on long lenses. In a baseball game, for instance, you are anything from 75–200 feet away from the action. When I was with *Sports Illustrated*, I used my 400 mm lens 10 times as much as my 50 mm lens.

B.C. Do you ever have equipment specially made or adapted for your own personal use?

N.L. Definitely, all the time. Not as much as John Zimmerman, but still quite a lot. Al Schneider of the *Life* photo lab has helped me enormously with remote control devices and other special rigs, like the strip camera made from a 250 exposure Nikon that I used for the car racing picture and in other sports. It was similar to one built years ago for George Silk, but he wanted to create more bizarre images than me.

It's an intriguing bit of equipment, rather like a photo-finish camera – the film and the subject move across a slit in opposite directions. The film's speed of travel has to be adjusted relative to the speed of the subject, if one wants to avoid distortion. Too slow and the subject is elongated, too fast and it is compressed.

The important thing is to test out this kind of equipment thoroughly, so that you sort out all the problems before you use it at a major event. I experimented with this camera over and over again before I even took it to France for the race. Then during practice I shot some black and white film, processed it quickly and checked the results. As I said before, I try to minimise the element of luck involved in photography.

Another specialised piece of equipment that I have enjoyed playing with now and again is the Hulcher camera. It can operate at up to 50 frames a second. The Hulcher people have been very helpful to me.

B.C. Do you prefer shooting black and white or colour?

N.L. When I was putting together my book *Sports,* I thought I would include some black and white but then I realised how little of it I had shot over the years. By the mid-Sixties we weren't shooting any black and white for *Sports Illustrated* and today colour is where it's at.

I prefer shooting Kodachome 64 but often I've had to use Ektachrome just for speed of processing. I check exposures with a Minolta Flash Meter III.

B.C. How did you get involved with making movies?

N.L. I began taking still pictures as special photographer on feature films, mostly with sport themes. It was a nice way of earning some extra money. I always used to think of film as being essentially collaborative and I valued the individual accomplishment of still photography – my pictures were my idea and the camera was in my hands.

Someone told me once that when you watch a film being made, one of two things happens: you fall asleep out of boredom or you fall in love with the process. The more I watched, the more I fell in love. If you're involved, you're not going to fall asleep – if anything, you'll want more time.

It isn't surprising really that I was ready for a change. I had spent about 17 years with *Sports Illustrated* and I had over 150 published covers. Back in the late Fifties when I started, the photographers on *Life* and on *Sports Illustrated* were the visual giants. Now, one could make an argument for the fact that the giants are Stephen Spielberg, Francis Coppola, George Lucas and so on. Movies are so much more challenging in many ways.

My most satisfying pictures as a photographer were the ones that came from my head, for example, the shot of Ali v Cleveland Williams. After that was published, at the next fight 10 photographers were competing to get their camera in the centre spot where nobody had ever put one before. I did that. That was my idea.

Now I've got someone writing a treatment for a screenplay from a poem about basketball that I bought. It's my idea. What a thrill to sit at the back of an audience one day and know that the film on the screen came from my head. Can you imagine what Spielberg must feel like when he sits down and watches *E.T.*? In terms of the competition, movies today are so much more challenging than photography.

I've directed one film, called *Yesterday's Hero,* dealing with soccer. It was an English movie produced by Elliott Kastner. He'd seen my still photographs and I submitted a script to him. He didn't like the script but he liked me. The movie was released in 1979 and it was moderately successful.

It's difficult to move on from there. Someone has to believe in you to the tune of six or seven million dollars. I'm talking to the right people but they haven't said 'yes' yet. But they will.

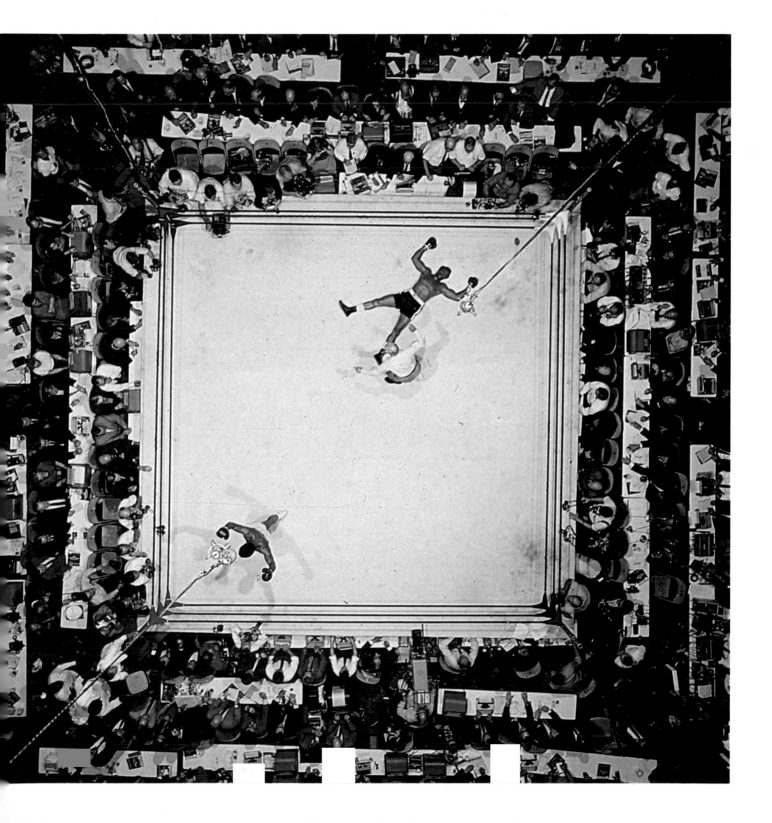

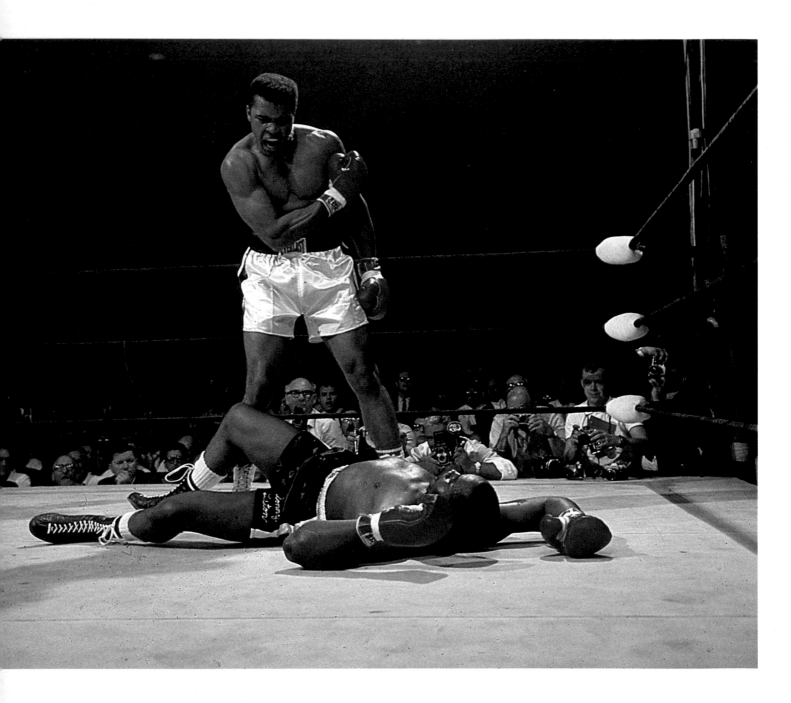

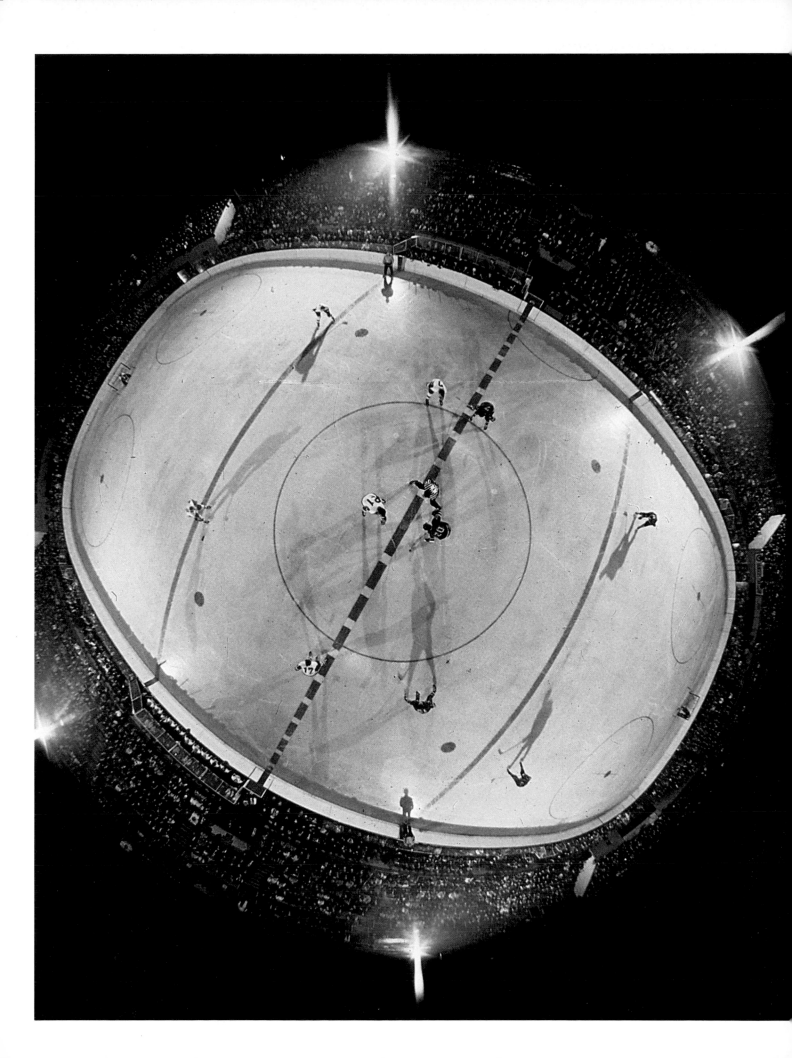

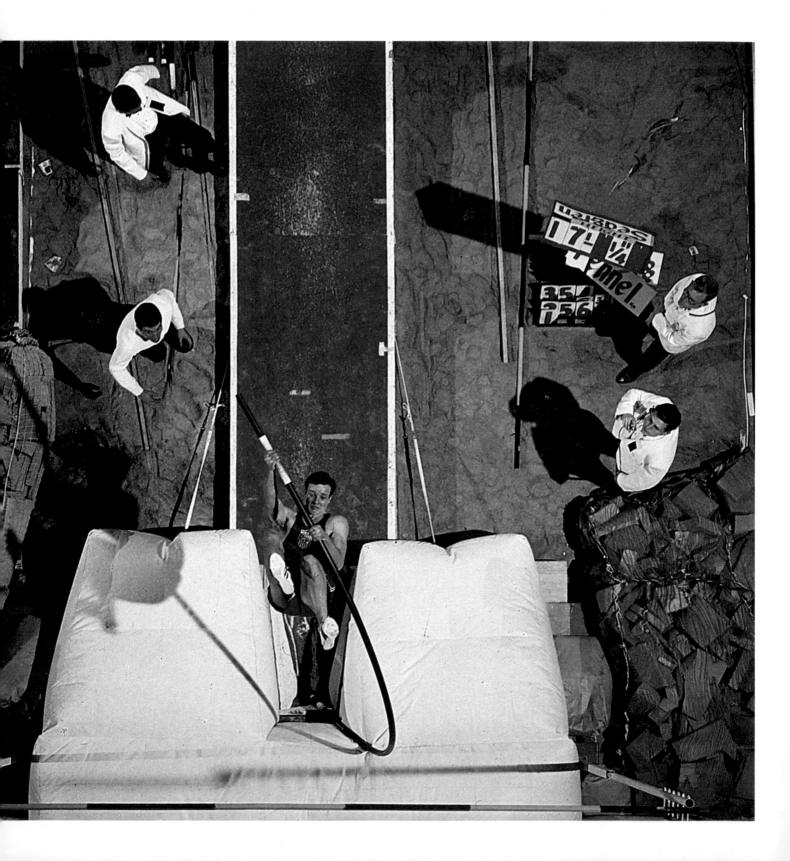

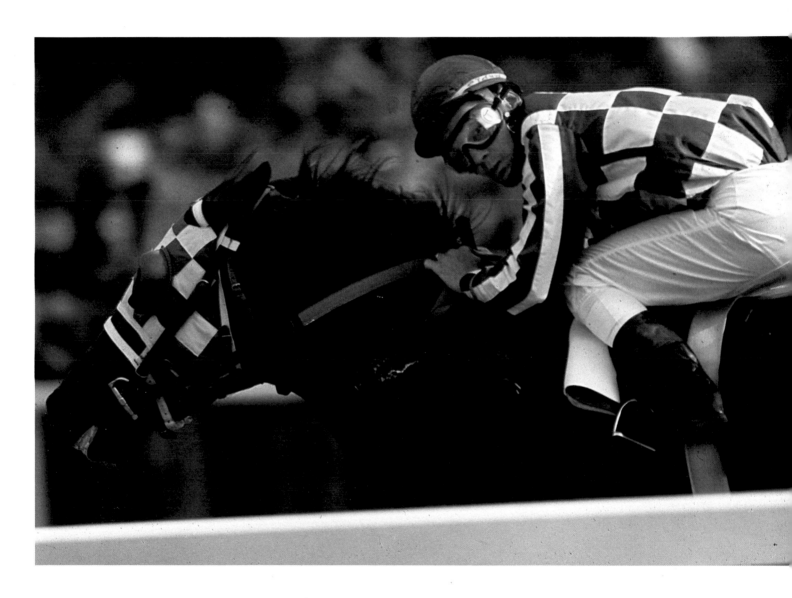

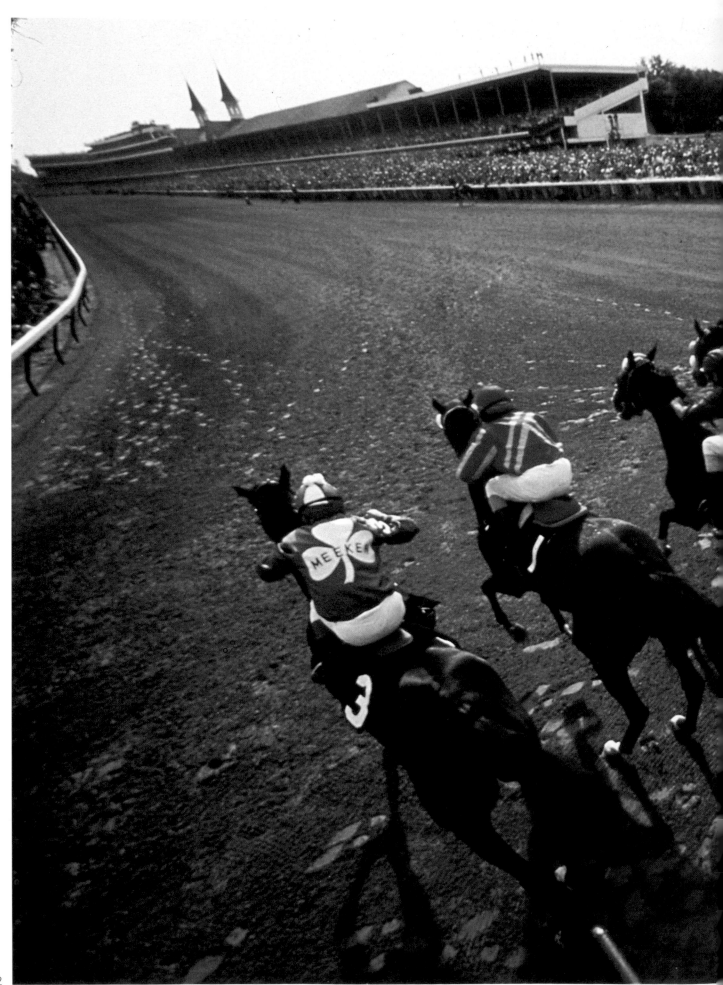

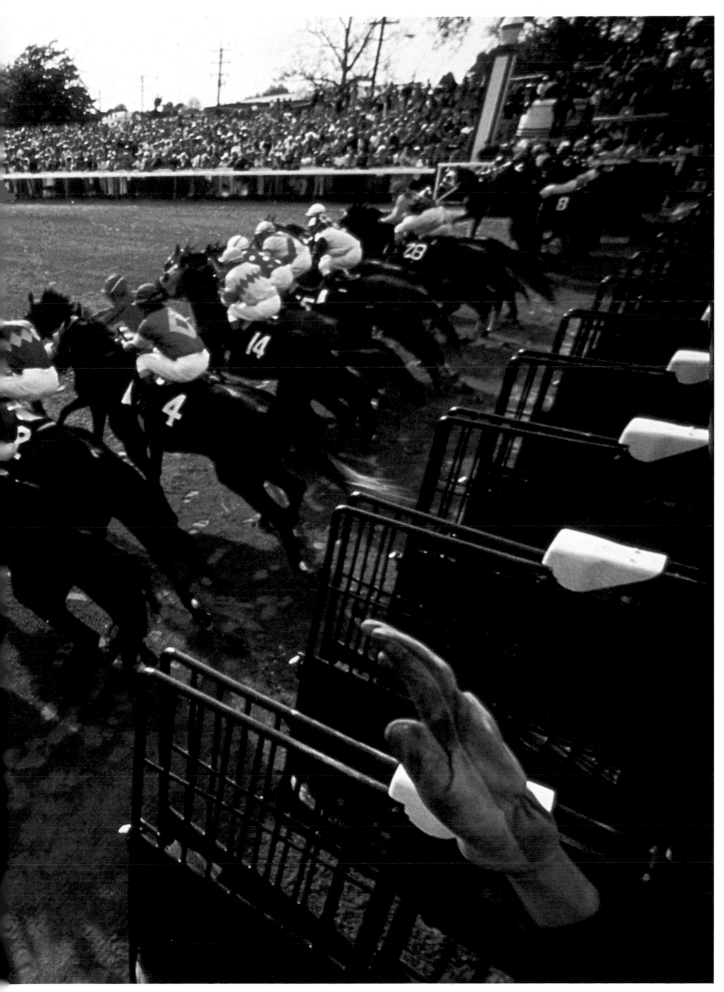

S'AFETY

FILM

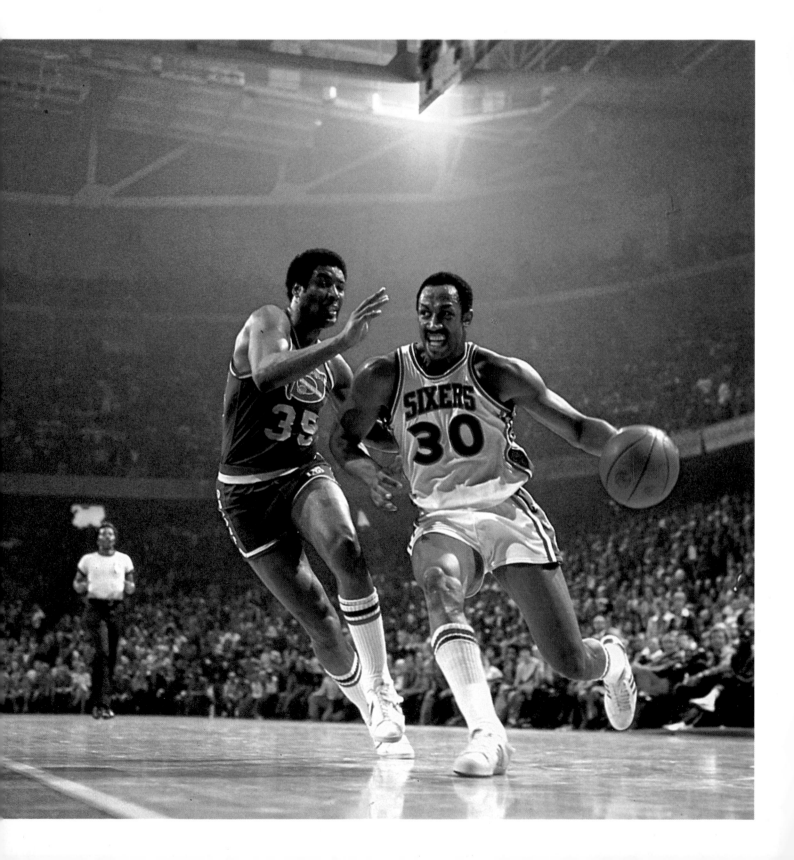

BIOGRAPHY

1942 Born in New York City
1960 First colour photograph
published in *Sports Illustrated*
1961 Established as freelance
photographer. Produced first
two cover photographs, in
consecutive weeks, for *Sports
Illustrated*
1972/78 Staff photographer
with *Sports Illustrated*
1978 on Staff photographer with
Time magazine
1978/79 Directed film
Yesterday's Hero, written by
Jackie Collins and produced by
Elliott Kastner

BOOKS

1969 *Dreadnought Returns*
1970 *Dreadnought Farewell*
1975 *Muhammed Ali*, with text
by Wilfrid Sheed
1978 *Sports*, with text by George
Plimpton

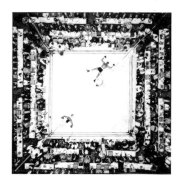

Muhammed Ali v Cleveland Williams, Houston Astrodome, 1966 *page 77*

This picture is the result of
an astonishing combination of
imagination, application and good
luck. Neil Leifer lowered a special
rig, containing a motorized
camera fitted with a wide-angle
lens, from the roof of the Houston
Astrodome, until it was about 50
feet above the centre of the ring.
The camera was wired up to elec-
tronic flash units and fired by re-
mote control. When Ali knocked
out Williams in the third round,
Leifer had to pick his moment
carefully because the flash re-
cycled relatively slowly. The com-
position could scarcely be more
perfect and neither of the boxers
is at all obscured by the
suspended microphones.

*Equipment – Hasselblad camera
and 50 mm lens.
Film – Daylight-type Ektachrome
64 ASA.*

Muhammed Ali v Sonny Liston, Lewiston, Maine, 1965 *page 78*

As Neil Leifer himself has said,
you cannot take the luck out of
sports photography, but when it
breaks well for a great photo-
grapher, he doesn't miss. Herb
Scharfman, the other *Sports Illus-
trated* photographer covering this

fight, can be seen through Ali's
legs. He was bound to get a rear
view of the action. Leifer was per-
fectly placed and in a one-shot
opportunity, he made the most
of his good fortune. The picture
was taken using an overhead elec-
tronic flash unit.

*Equipment – Rolleiflex Wide-
angle camera
Film – Daylight-type Ektachrome
64 ASA.*

Madison Square Garden, New York, 1963 *page 79*

The fish-eye lens acquired a
certain notoriety for some years
after its introduction, because, so
very often, it was badly or
frivolously used. But it is a photo-
graphic tool like any other lens
and in the right hands it can pro-
duce superb images that would
otherwise be impossible to
achieve. For this shot of an ice-
hockey face off, Leifer suspended
a camera fitted with a fish-eye
lens about 50 feet above the
centre circle at the old Madison
Square Garden and lit the entire
stadium with eight banks of elec-
tronic flash.

*Equipment – Nikon camera and
original Nikkor fish-eye lens.
Film – Kodachrome.*

Bob Seagren, Albuquerque, New Mexico, 1966 *page 80*

An unusual angle can bring fresh
excitement to any subject and
Neil Leifer is very fond of an over-
head perspective. He perched
himself on a catwalk in the rafters
to photograph Bob Seagren
setting a new world record for the
polevault of 17 ft $\frac{1}{4}$ in., as shown
on the scoreboard at the top right
of the picture.

*Equipment – Hasselblad camera
and 150 mm lens.
Film – Ektachrome.*

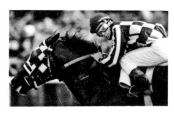

Ron Turcotte winning Belmont Stakes on Secretariat, New York, 1973 *page 81*

The longer the focal length of a
lens, the less the depth of field,
and the more skill it takes to keep
a fast-moving subject in focus.
Using a 300 mm telephoto, Leifer
had Secretariat and its jockey,
Ron Turcotte, tightly framed as
they won the Belmont Stakes in
1973, the first Triple Crown
winners in over 25 years. As they
crossed the finishing line,
Turcotte looked towards Leifer
and the shot was in the bag.

*Equipment – Nikon camera and
f2.8 300 mm Nikkor lens.
Film – Ektachrome.*

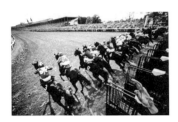

Start of Kentucky Derby, 1974 *pages 82-3*

Special events demand special pictures and for the 100th running of the Kentucky Derby, and the largest field in the race's history, Leifer mounted a camera on the starting gate, just above the stall of the first horse. The photograph shows the entire field of runners and the famed spires of Churchill Downs are visible in the background.

Equipment – Nikon camera and f5.6 15 mm Nikkor lens.
Film – High-Speed Ektachrome.

Dick Butkus, Chicago, 1969 *page 85*

A long lens makes it possible for you to concentrate attention on your subject by filling the frame with it and also by throwing other areas of the picture out of focus, as can be seen in this photograph of Chicago Bears linebacker, Dick Butkus. Leifer wanted to capture the feeling of playing against Butkus and so he used a long lens to ·isolate him and to give the reader the effect of being the person about to be tackled.

Equipment – Nikon camera and f5.6 1000 mm Zeiss mirror lens.
Film – Kodachrome 64.

George McGinnis, Philadelphia, 1977 *page 88*

The choice of camera angle very much affects one's impressions of a subject, as can clearly be seen from studying this portfolio of photographs. A high viewpoint can help to emphasize the overall pattern and a low viewpoint can add a touch of drama to the action. Here, the camera was used at court level to accentuate the power of the player's drive towards the basket. The court was lit by electronic flash overhead.

Equipment – Hasselblad camera and 80 mm lens.
Film – Ektachrome.

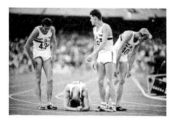

U.K. 4×400 m Relay Team, Olympic Games, Mexico, 1968 *page 84*

'Defeat lends itself almost as well as victory to good photographs', said Neil Leifer and his point is made in this picture of an exhausted and well-beaten U.K. relay squad in the Mexico Olympic Games.

Equipment – Nikon camera and 300 mm lens.
Film – Ektachrome.

French Grand Prix, 1973 *pages 86-7*

Technical ingenuity has been a valuable asset to many sports photographers, notably George Silk and John Zimmerman. Neil Leifer has followed very much in this tradition but with a more restrained and precise style. As described in the text, this picture was taken with a specially adapted camera, that 'froze' the movement of the car, travelling at about 180 mph, but blurred the race track.

Equipment – Nikon camera with 250 exposure back and 105 mm lens.
Film – Kodachrome.

Walter Iooss jr

Admired by fellow professionals for the range and sensitivity of his talent. One-time Sports Illustrated staff photographer, now busy freelance

Bryn Campbell Other photographers have told me that you are especially good at working with long lenses. Do you think of that as a major characteristic of your sports photography?

Walter Iooss Jr It certainly was characteristic of my work once, but not so much any more.

The very first lens that I owned was a 300 mm. Instead of learning with a normal lens, which would have been easier, everything I shot for the first few years was with this telephoto.

I was 15 years old at the time and this piece of equipment was owned by my father. He had an Asahi Pentax and an f4 300 mm lens – this was about 1957, pretty avant-garde equipment in those days. He was an awfully good photographer. My parents were divorced and I would see my father on Sundays. We both loved sports and we went to the New York Giants football games – he had season tickets. He would have the camera with him and shoot a few pictures now and again. It didn't interest me much, I was too busy watching the game.

I was obsessed with sports, especially football and baseball. I was always fascinated by form and by the grace element of sport. I used to try to draw these things. Then one day I looked through this camera lens and took some pictures of the game. We went home and developed them, and that was the end of the camera for my father.

I had very sharp eyes and I had no problem focusing the long lens. I changed from the 300 mm to a 135 mm and then back up to a 400 mm, but I didn't even know how to use wide-angle lenses until about the mid-Sixties.

In so many sports you have to work far away from the action, but you can pull the play into you with a long lens. It also increases the dynamic qualities of the image and throws the background out of focus so that it is less distracting. For years, my standard lens was a 600 mm, the old f5.6 600 mm Nikkor. Then my vantage point changed. You can't just keep doing the same thing over and over again for 20 straight years without getting bored. Hopefully, you mature into something else. I use wide-angle lenses constantly now but they have to be handled carefully. You can't let them distort too much. But use them with the right perspective and things start to happen.

B.C. When did you join *Sports Illustrated*? Was it the first job you had as a professional photographer?

W.I. It was the only job I ever had as a photographer. I called them up one day when I was still in High School and arranged to show them some of my pictures. The picture editor liked one of them and he told me to stay in touch and to show him that picture again in August. I did and they bought it. It was one of the first games I ever photographed on the field and they paid me 150 dollars. I was just a kid, and to get this cheque and to be published in the greatest sports magazine in the world. . . .

I was so naïve in those days. I didn't know what I was going to do. All my uncles and relatives had gone to Ivy League schools. Now all my friends were going to college and I was still living at home. All I cared about was baseball: 10 months out of every twelve, baseball. I was still a kid.

My mother said, 'What are you going to do with yourself?' and I said, 'I'm going to be a photographer, Ma.' 'How gauche,' she said, and walked out of the room. Of course, now it's all wonderful. Life was pretty lean then for the first two years.

When my father and I used to go to these games together, we would see this punky little red-haired kid on the field – that was Neil Leifer. I wondered how that little guy got his credentials. I was too shy to ask him myself so my father did. Neil and I met at the Time-Life building; it was about 1961.

I started to work one day a week for *Sports Illustrated*. The assignment fee then was 100 dollars to cover a football game. My friends couldn't believe that I was getting that much money to work 2 hours a week going to a football game. It was completely incredible.

First I worked for *Sports Illustrated* as a freelance, then I went on to contract and finally joined the staff for about 8 years. It's been a great relationship. There are always problems wherever you go, but Time Inc. is a beautiful company.

I left in June 1982 to freelance and to do a tremendous assignment for Fuji film, documenting the American athletes, leading up to the Olympics and through them. We'll put out a big colour book – 120 pages – and there is going to be an exhibit that will travel through 25 cities. It's not just action photography, it's doing the things I like to do so much, the softer, quieter moments that often show more of the character of a person than the event itself; trying to create dramatic images that go beyond sport – like the National Anthem picture.

B.C. After 20 years as a pro, do you still get a kick out of photographing sport?

W.I. I was getting a little tired of the general action but the more I do these advertising jobs, the more I realise how special sport is to me. The Fuji project keeps me in sport, and track and field is something I haven't covered that much, so it's fresh to me; I'm still learning who the athletes are.

I love photography but I couldn't go out week after week doing routine games any more. I know one of the reasons I stayed at the magazine so long. Neil and I suffered a lot in the beginning. To the New York Press we were the new generation and they didn't know what to make of us, young and aggressive with our 35 mm cameras. They were there with their Speed Graphics and knowing everybody. I would buy a ticket, go to Yankee Stadium and they would throw me out. The Press guys would get Neil and me thrown out by the ushers. We had to fight all the way. I suppose I wanted to take full advantage of what we had achieved.

B.C. What is it that still excites you in photography?

W.I. Anything that is visually appealing excites me. I always thought that my photography had a sensitive edge to it but I don't have a general philosophy. If it's appealing, I shoot it.

I'm an expert at locations. If you want something shot in a studio, don't hire me. I've been trained to go out in any conditions and try to make a good picture. I'm always looking, always searching. I don't think a lot of guys do see and look. They just go to events. If I was the picture editor of *Sports Illustrated*, I would take every photographer off assignment for two weeks in turn, send them to events without a camera and tell them just to walk around and look.

B.C. To what extent do you previsualise your photographs?

W.I. Most of my best pictures are things I just happened to see but I have occasionally set up shots that I like, the basketball picture, for instance.

B.C. How important is it to you to keep abreast of new cameras, lenses, films and so on?

W.I. Technical apparatus has never been of any importance to me. I see equipment through the other guys. They always have it first.

I used Nikons for years but not any more, for various reasons. When they replaced the old 300 mm, 400 mm and 600 mm lenses with new internal focusing models, I couldn't focus them. I had 10 or 12 years' experience with the old f5.6 600 mm lens and I knew what to do with it. The new f4 is a great lens, but I just cannot focus it as well.

Then the Nikon F2 camera was discontinued for the F3 and they introduced plastic focusing screens. The lenses didn't pop into focus any more, you kept having to focus back and forth. Perhaps, too, my eyes lost a slight edge. I started to lose confidence in my focusing. I didn't know what was going on.

Canon asked me to do a couple of TV commercials for them. I tried out their equipment and began to like it. I found it easier to focus and that was a good enough reason for me to start thinking seriously about changing. The one thing that stopped me switching sooner was that I felt they didn't have a really professional camera. Then they brought out the new F1 and now their system is totally pro. I changed over and I think it's some of the best equipment there is.

Obviously these days I know Fuji film a lot better. They have a new 50 ASA film that's not on the market yet but it's unbelievably good. Their 400 ASA film is the best in the world and they have a new 100 ASA film that is excellent. But this 50 ASA material is mind-boggling; the colours are so beautiful. A little grainier than Kodachrome but the colour is spectacular.

B.C. How much equipment do you carry when you go out on a major assignment?

W.I. Much more today than I ever did. Commercial jobs are so much more complicated than editorial ones.

But with sport, let's say a big football game, I would carry three motorised Canon F1 bodies and 17 mm, 24 mm, 50 mm, 200 mm, 400 mm and 800 mm lenses, and a Minolta Flash Meter III – the best exposure meter in the world.

I used to carry my good 600 mm lens when I worked with Nikons but now, with everybody using 600s, I carry an 800.

I've always been a wanderer, a loner. I keep away from the other photographers at an event. When John Dominis was picture editor, he would assign everybody else positions and

then tell me to go where I wanted. I would always find new angles. So many guys go with all the other photographers. It's mass journalism; they might as well have one cable release and shoot the same picture. It's so crowded that if all the lenses go to the right, you can't even go to the left. You've got to swing in unison, it's like the Rockettes. I'm not interested in working like that. I'd rather not be there.

One reason I originally liked long lenses was that they made it easier to work away from the other photographers. Time Inc. own an f5.6 1000mm Zeiss lens that they had specially adapted to fit the Nikon. It cost about 25,000 dollars. Nobody else seemed to use it but me. Maybe because it weighed about 50 pounds and the depth of field was minute. But, for me, it was so much more dynamic than any other lens – one of the greatest lenses on earth.

It's a mirror optics lens and you get these huge blobs when something is out of focus. I would move around looking for the most abstract background. I'd be at the other end of the field, perhaps 150 yards away, and I'd look for the area that had the best colours or walls or angles, so I could play with the background. The depth of field was an inch or so. But even a player just walking off the field had a dynamic quality because of what this lens did to space.

At the end of the game, one of my eyes would be so out of focus that I could hardly see out of it. The concentration had to be that hard. You could throw away half your take the moment you started editing: they were out of focus. But the pictures you gained were well worth the trouble.

B.C. What interest do you have in photography as a whole, as distinct from sports photography?
W.I. I'm no historian by any means but I admire many photographers. Robert Frank's *The Americans*, for example, is a phenomenal piece of work.

B.C. Did any of these photographers influence you?
W.I. No.

B.C. Did any sports photographers influence you?
W.I. Zimmerman, no doubt. Hy Peskin and the other guys who worked at *Sports Illustrated* in the Fifties. But I never tried to copy people. Maybe they inspired me, rather than influenced me. Jay Maisel is a guy who has inspired me a lot. He was one of my heroes.

B.C. Do you ever work at anything other than sports photography or have you ever wanted to?
W.I. Some commercial jobs, especially recently. And sports fashion photography.

At times I wish there were other things I could work on. I doubt that I'll ever be as good at anything else as I was, or am, in sports work.

B.C. Have you ever thought of making movies?
W.I. My interest is strictly in still photography. I've a lot more to do. I haven't reached the end of the line by far. I love it and I don't want to leave it.

B.C. What makes a great sports photograph?
W.I. Emotion. The greatest pictures always have a feeling of emotion. A simple image, not too many people in it and you can see their faces. The face mirrors the pain and intensity of the game. That is one of the reasons I liked long lenses, to see the faces. It is also why I never liked auto racing, because I couldn't see the faces.

B.C. How do you see your sports photography developing in the immediate future?
W.I. What I really want to do for Fuji is to take an athlete like Carl Lewis and not photograph him at track meets but to have him work at something over and over for me, where I can be anywhere I want, have him in any uniform I want, and take pictures without any restrictions because of meet directors or other photographers. So I can take the quintessential picture of Carl Lewis, if that is possible. I want to work with all the athletes just like I did with Julius Irving. But I still get my greatest thrill when I just cruise an area looking for pictures. Essays are so fantastic to do because they develop in your head as you go along. I still love working on them as much as I did 15 years ago.

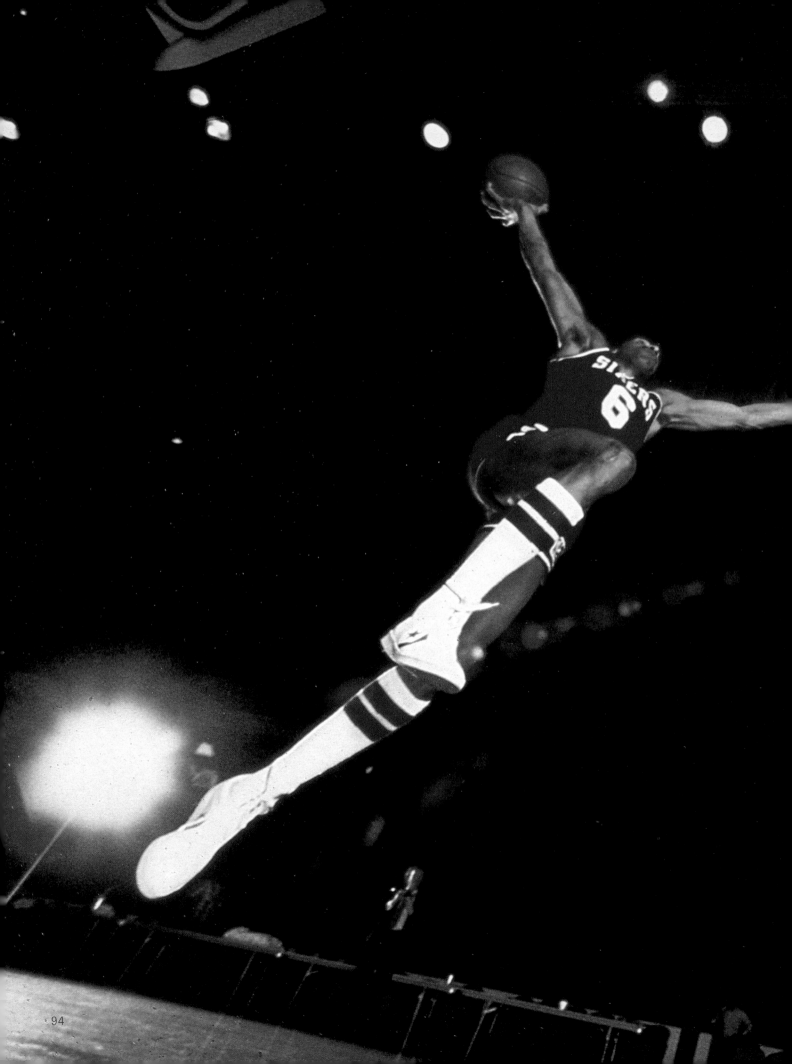

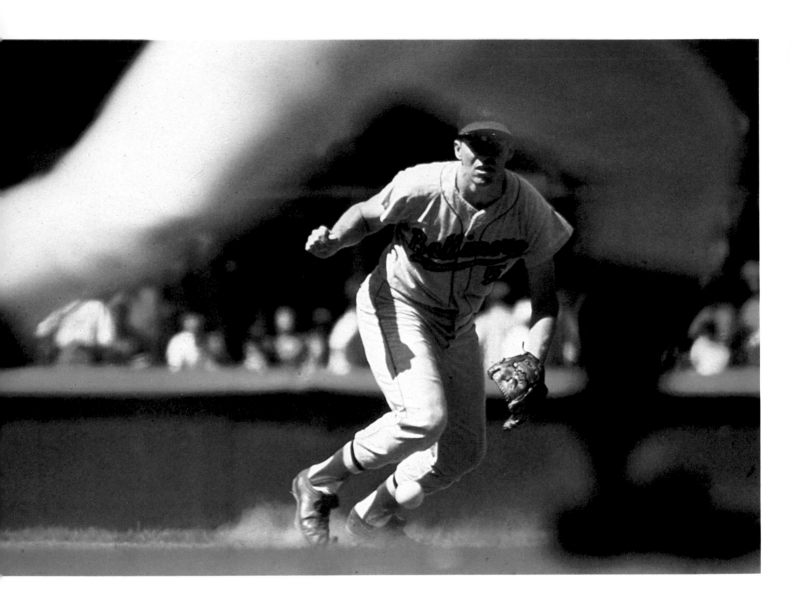

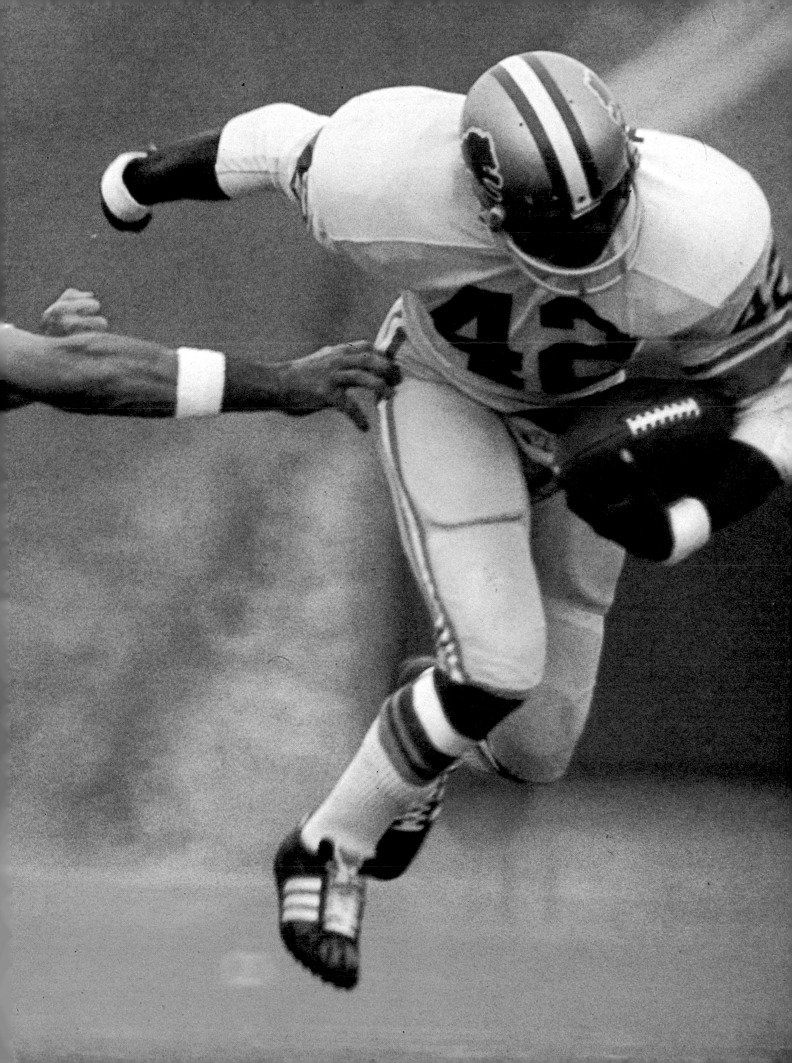

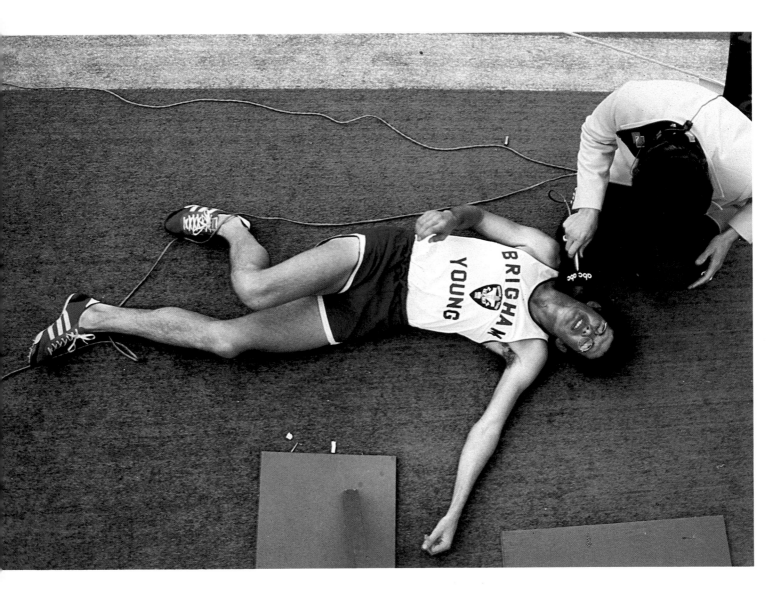

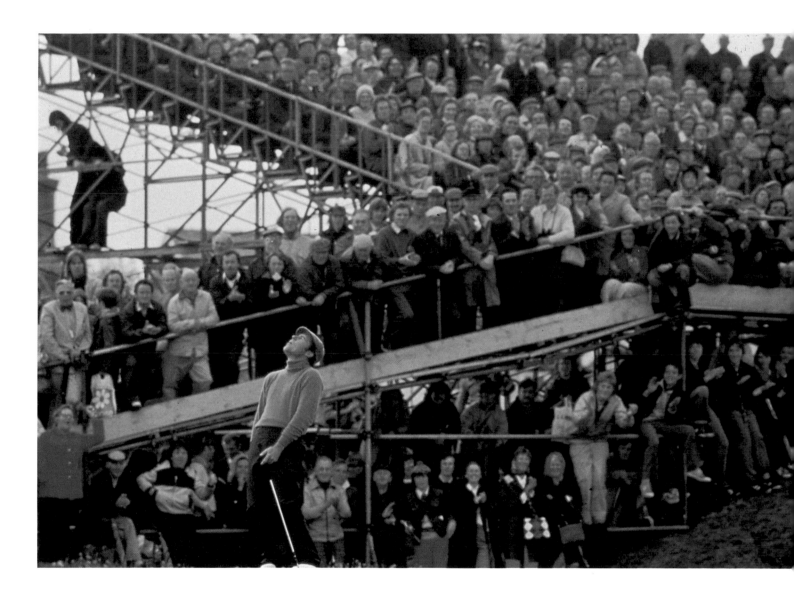

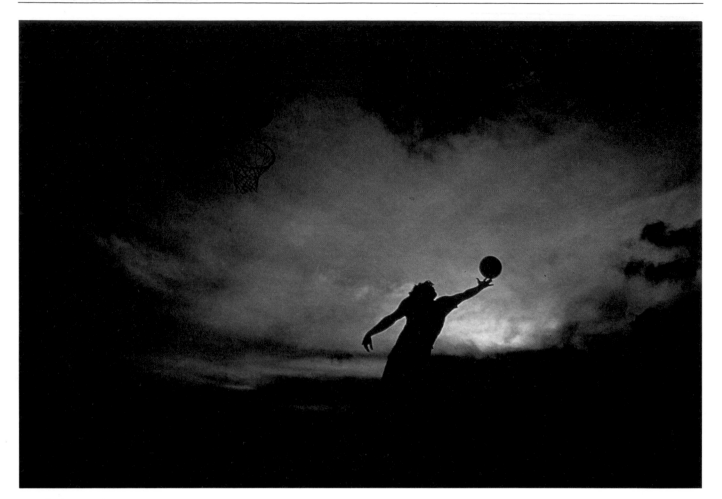

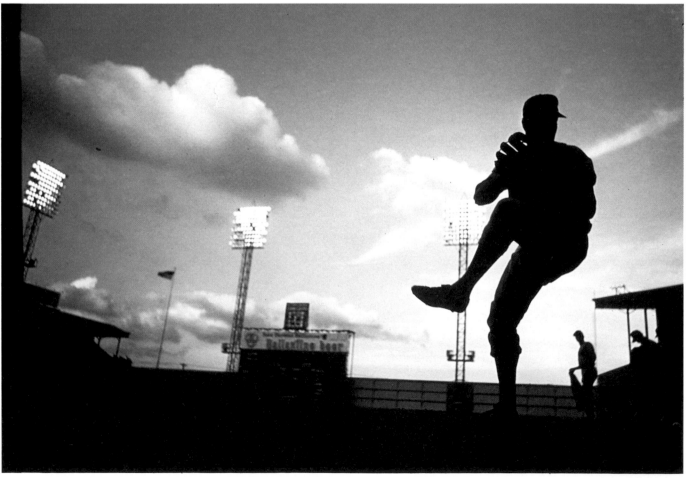

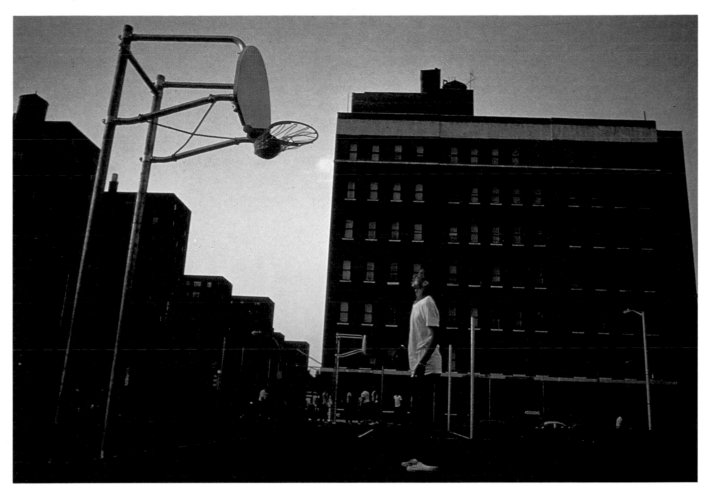

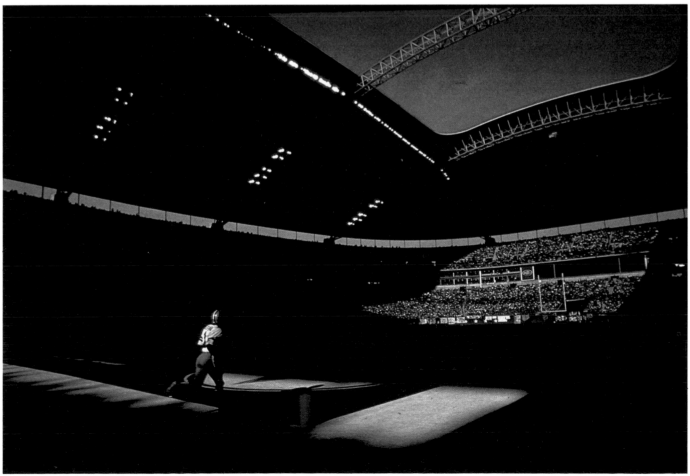

BIOGRAPHY

1943 Born in Temple, Texas
1961 Sold first photograph to *Sports Illustrated*
1962 Named as contributing photographer on masthead of *Sports Illustrated*. First and only teenager ever to achieve that distinction
1967 Represented in *Man In Sport* exhibition
1974/82 Staff photographer with *Sports Illustrated*
1982 Represented in *Champions of American Sport* exhibition

AWARDS

1979 Photographer of the Year, National Football League Photo Contest

BOOKS

1964 *Paper Lion*, with text by George Plimpton
1973 *Rockin' Steady* (about basketball)

Julius Irving, New York, 1981 pages 94–5

Shooting a photograph like this during play would be next to impossible. It was difficult enough to take even with complete control and the full cooperation of the subject, Julius Irving – 'Doctor J'. Iooss wanted to show the player's soaring leap and his ability to do anything with the ball, and he explained his idea very fully to him. A low camera angle and a very wide-angle lens created a dramatic perspective and the picture was lit by a 15-foot bank of electronic flash veiled with diffusing tissue.

Equipment – Nikon camera and 18 mm Nikkor lens.
Film – Kodachrome 64.

Surfer, Kauai, 1968 page 96

The emphasis in sports photography is so often on filling the frame with the action that a touch of understatement makes a refreshing change. Sport sometimes takes place in the most beautiful locations and it was this aspect of surfing that Iooss concentrated on in a *Sports Illustrated* essay. The picture was taken from a helicopter and the colour is natural, not filter-induced.

Equipment – Nikon camera and 85 mm lens.
Film – Kodachrome 64.

Barry Lerch, Los Angeles, 1979 page 97

The quieter moments of sport can yield very telling images, especially when combined, as here, with an intelligent use of colour. Iooss had tried unsuccessfully several times to photograph a blue-uniformed player against a blue wall – the kind of half-idea that a photographer often has at the back of his mind. One day, during the playing of the National Anthem, he turned around and saw what he later described as 'Almost like a Norman Rockwell characterization of the American scene', the red cap standing out against all that blue.

Equipment – Nikon camera and 20 mm lens.
Film – Kodachrome 64.

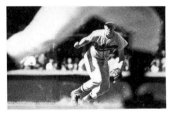

Brooks Robinson, Detroit, 1966 page 98

Framing one's subject is a classic photographic technique but the odds against getting this picture must have been enormous – Brooks Robinson, the premier 3rd baseman of his time and one of the greatest fielders in the history of the game, framed between the running legs of the player who has just hit the ball, itself in shot.

Equipment – Nikon camera and f5.6 400 mm Kilfitt lens.
Film – Ektachrome.

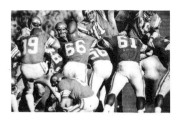

U.C.L.A. v U.S.C., Los Angeles, 1975 page 99

'Colour has its own priority', a well-known saying in photography, is perfectly illustrated in this picture, in which the action, exciting though it is, is overwhelmed by the vivid colours of the players' uniforms.

Equipment – Nikon camera and f5.6 1000 mm Zeiss mirror lens.
Film – Ektachrome 64.

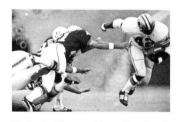

Detroit Lions v New England, Foxboro, Mass., 1971 pages 100–1

One of the advantages of a long telephoto is that one can take head-on shots of the action even at a considerable distance, as can be seen from both this and the next photograph. Iooss says that he particularly likes this picture because it really doesn't matter who the subjects are, it is just such a characteristic moment of American football.

Equipment – Nikon camera and f5.6 1000 mm Zeiss mirror lens.
Film – Ektachrome 200 'pushed' to 400 ASA.

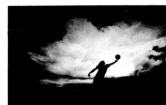

Austin, Texas, 1974 *page 102*
A quick-thinking change of angle made all the difference to this funny-sad picture of an exhausted runner being 'interviewed' by an over-eager reporter. Iooss saw the situation and leaped up the steps of a stand to shoot down on the scene, so picking out the figures against an uncluttered background and getting a better view of the athlete's face.

Equipment – Nikon camera and 28 mm lens.
Film – Ektachrome 64.

Los Angeles, 1971 *page 104*
One effective way of photographing action in poor light is to shoot for a silhouette. The basic idea is to pick a camera angle that sets your subject against the brightest part of the scene – for example, the sky – and then to expose only for this highlight area. This allows you to make the most of the available light and to choose a faster shutter speed than would be possible if you wanted to record shadow detail. The clearer and more dramatic the outline of the movement, the more successful the silhouette.

Equipment – Nikon camera and 28 mm lens.
Film – Kodachrome 2.

New York City, 1971 *page 105*
Amateur sport often lends itself to a powerful contrast between the game and the surroundings in which it is being played.

Walter Iooss says that in basketball, one of the best sounds in the world is the swish as the ball goes through the net. That is what this particular picture represents to him.

Equipment – Nikon camera and 28 mm lens.
Film – Kodachrome 2.

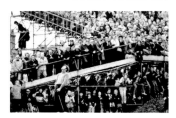

Gary Player, British Open, Lytham St. Annes, 1974
page 103
Interesting background shapes can often be turned to good advantage, as also can crowd reactions. Iooss composed this picture carefully to relate Gary Player to his surroundings, instead of trying to separate the two elements as people often do.

Equipment – Nikon camera and 180 mm lens.
Film – Ektachrome.

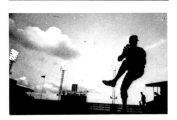

Philadelphia, 1964 *page 104*
It can be difficult to shoot pictures from a very low angle using a normal pentaprism viewfinder. Faced with this problem, Iooss simply rested the camera on the ground, removed the pentaprism and looked directly down into the viewfinder screen. The photograph was taken during the warm-up period immediately before a baseball game.

Equipment – Nikon camera and 28 mm lens.
Film – Kodachrome 2.

Texas Stadium, Dallas, 1981
page 105
Compare this photograph and the previous one as studies of a sport and its environment. The strength of this image is in the balance of light, form and colour. The single figure gives scale to the structure, a touch of humanity and a suggestion of the attention and the pressure that can be focused on the individual player. Iooss tried for this kind of picture many times, before succeeding here.

Equipment – Canon camera and 17 mm lens.
Film – Kodachrome 25.

Chris Smith

Award-winning 'all-rounder' now specializing in sport. One of the most experienced and respected British Press photographers

Bryn Campbell How long have you specialized in sports photography?

Chris Smith As a complete specialist only for the last 7 years, since I joined *The Sunday Times* in fact. I shot a great deal of sport when I was with *The Observer* for the previous 7 years, but I also worked regularly on news stories and features.

My early training was in general Press photography, with a small local newspaper, then I moved on to a national, the *Daily Herald*, again covering a wide variety of subjects including a little sport, before changing to *The Observer*.

B.C. I believe your first awards were for news photography?

C.S. Yes, the disarming of a gunwoman who had shot a policeman in north London. Then, the following year, for a general portfolio of news, features and sports pictures.

B.C. When did your interest in sport begin?

C.S. I was always interested in sport as a kid and I was happy enough photographing it on the local newspaper every Saturday. Nobody else wanted to do it so I would be sent off to a football or rugby game.

I continued to photograph sport spasmodically on the *Daily Herald*. Nobody there specialized in sports photography in those days and when a sports job came up I quite enjoyed doing it. But it was at *The Observer* that I began to be seriously involved with the subject.

B.C. Was there a basic difference in the approach to sports photography between the daily and the Sunday newspapers?

C.S. The main difference was that on the daily paper, they

wanted the news angle covered – the goal that clinched the game, or the try that won the match, regardless of whether it made a good picture or not.

The marvellous thing about *The Observer* and *The Sunday Times* was that their paramount interest was in a good photograph and if it happened to be of the winning goal, well then that was a bonus. If they liked a picture, they would design a page around it. But on the *Daily Herald*, because of the pressures of time and space, your picture had to fit the shape that was available on the page. The pictures were just cropped as necessary and often the best photograph was never published because it wouldn't fit.

Also on the Sunday papers, there was time to prepare. For a start, you knew what was in the diary for the week, so you could be specific about which jobs you wanted to cover, which was not the case on a 'daily'. And you could look at an event in the context of producing a good picture, rather than of it being the sports news of the week.

B.C. Were you able to suggest any ideas for pictures?

C.S. Generally on a daily paper, you were just assigned. If your number came up for a certain event, off you went. There was very little in the way of discussion. But on the two Sunday papers, there was much more flexibility, you could actually talk about what might come out of an assignment. Clearly, it was much more agreeable to work like that and if you had a specific idea that you wanted to shoot, they were much more receptive to accommodating you.

B.C. Could you influence the choice and use of your pictures at all with the Sunday newspapers?

C.S. To some degree. The reason for going to newspapers like *The Observer* and *The Sunday Times* was because you had a sympathy for the work that they used. Similarly, the pictures you wanted to shoot. they liked to use: it worked both ways. That was why I was drawn initially to *The Observer*, because I liked shooting their kind of pictures.

B.C. How do you feel now about specializing in sport instead of covering a much wider range of subjects?

C.S. I enjoy it. I don't think there is a limitation with sport, it includes such a huge variety of activities, and so you are using different techniques all the time, it is never boring. All I don't like is doing too much of one thing, week after week. But think how many different games are covered by this one word – sport – and they are all so dissimilar.

B.C. Has your varied photographic experience helped you in your sports work?

C.S. Yes, particularly having gone through training in the darkroom and also the breadth of experience in local journalism, everything from weddings to gold watch presentations. It was a marvellous background for learning such fundamentals as how various developers affect films, and about dealing with people. I used to mix the chemicals for the other photographers – so

much metol, so much hydroquinone, so much sodium carbonate and so on. It was very useful training.

Then on the *Daily Herald*, you had to be prepared for anything. You were expected to produce the goods every time on a news story and it was very competitive. If you had an eye for movement or people, you might be able to add something to what might otherwise be a very ordinary picture. And you have got to be able to anticipate movement in sport, I don't think you can handle it otherwise.

B.C. Have you been influenced by any other photographers?
C.S. Gerry Cranham certainly, from the beginning. And when I was working on a daily paper, Terry Fincher, who is such a marvellous all-round photographer, with an unquenchable thirst to take pictures. Going back further, the old *Sports Illustrated* people and George Silk. But also great photographers outside sport, people like Ansel Adams, Eugene Smith and, of course, Cartier-Bresson.

B.C. What did you draw from them?
C.S. The way they saw shapes, or expressions, or the way they handled movement in general, their ability to catch moments. If you can translate that into sports photography, you're getting somewhere.

B.C. You have been a staff or a contract photographer all of your career. Have you ever been tempted, like so many other photographers, to turn completely freelance?
C.S. There is obviously a great attraction in the idea of being a totally free agent but I wouldn't be on the staff of a newspaper if I didn't have the freedom to work on the pictures I like taking.

It is incredibly helpful to have a newspaper behind you, to know that someone will provide passes, organize transport and so on, especially bearing in mind the work load that you carry.

B.C. All your newspaper work has been in black and white but you have shot a great deal of colour for other publications. Do you have a strong preference either way?
C.S. I much prefer shooting in black and white. It may be partly traditional, I was brought up with black and white, but I find it allows me more control. For instance, if I am after a particular shape, I can burn out a part of the subject both by the original exposure and in the printing. As long as you know beforehand the effect that you want, you have a control with black and white that you can't exercise with colour.

B.C. Do you work heavily on a print, either yourself or by directing someone?
C.S. Sometimes, yes. But first it is seeing the picture before you take it, knowing what you want. Then backing it up with your knowledge of printing and exploring the exact photographic effect that you are after.

B.C. Do you print your own work?
C.S. I enjoy printing very much and do a lot of it. The ideal for me is to see the whole process through from the planning and taking of a picture, to the developing of the film, the printing and even the retouching. But it is almost impossible to do that, working for a newspaper. Much of the time, you're not even processing your own film. You're sending it back by a messenger, it goes through the darkroom and is printed without you seeing it. I have to accept that, it would be impracticable to work otherwise. But I still think the ideal is to do the whole operation yourself.

Most of my printing is for special purposes and not everyday work. I like Agfa Record Rapid paper. You can use different developers to produce different tones with it, from warm to cold. I find that very useful. Some subjects lend themselves to a warm tone, a portrait of Muhammad Ali, for instance, and others look better with a cold tone, like winter sports.

B.C. What film do you use?
C.S. Ilford HP5 film. I've used it for years and I know what I can get out of it, how much I can 'push' it and how much I can cut development for certain effects.

I made the mistake once of changing to a slow film because I realized that the light was going to be so good where I was to work. But because I wasn't too familiar with that material, I didn't make too good a job of it. So now I've standardized on HP5. Basically I rate it at 400 ASA and develop it in D.76 or ID-11, which are more or less the same. If I 'push' it one stop to 800 ASA, I'll stay with D.76 but beyond that I'll use Acufine.

B.C. Technically speaking, is black and white easier to work with than colour?
C.S. Probably you can be a bit looser about exposure but I tend not to be. I try to be as accurate as possible, to get the absolute optimum from the negative. That is the way you're going to get the best print.

B.C. Do you often enlarge from just a section of the negative?
C.S. Ideally, I compose for the whole frame because in the end your quality will be better, but it is not always possible.

B.C. Is your instinct to play safe or to take chances?
C.S. I find that the best pictures happen when you take fliers but, working for a newspaper, you obviously have to keep their interests in mind. You cover yourself and then go for the risky shots. For instance, the picture I particularly like in this portfolio is the one of the blurred rowing eight. I covered the event conventionally and then decided to go for something extra. That was the result.

B.C. What makes a really great sports picture?
C.S. To capture the whole flavour of an event; to catch a marvellous moment in sport and to produce an image that is also outstanding in photographic terms. An incident on its own does not necessarily make a great picture and neither does great technique on its own. You have to combine the two, but those occasions are rare.

B.C. To what extent do you previsualize your pictures?

C.S. Quite often, but there are only a few times when I've set off to an event with a specific idea and come back with that picture. Conditions often force you to change your plans.

Realistically, I go along to take a good dramatic picture and to try to impose what skills I have on the subject, to interpret the event. If you just record something and it's dull, you end up with dull pictures. You have to impose your own visual ideas on the subject if necessary.

When possible, I put in a fair amount of preparation and research. I like to arrive at events a couple of hours early and walk around looking for picture ideas. At an athletics meeting, I may not take any photographs the first couple of times a pole vaulter, for example, tries a jump. I just watch and decide when and how to go for a picture. You work around these concepts and hope that you're not so rigid that you're going to miss any nice incidents that might happen.

B.C. Do you see your best pictures as photographs in their own right and not just records of incidents?

C.S. I would like to think that. I hope that the best images stand up years later, regardless of the personalities involved or any news value. They are so much concerned with ideas rather than with incidents.

B.C. One of the strongest characteristics of your work is its apparent simplicity. Is that deliberate?

C.S. I'm not sure that it is deliberate but it is there and it is a quality that I like.

B.C. How important is it to you to keep abreast of developments in equipment?

C.S. I don't bother with it too much. I keep an eye on the development of wide aperture long lenses, internal focusing, and so on, but I'm not a lens freak, I don't have to have the latest lens or accessory.

B.C. What equipment do you use?

C.S. I've used Nikons for a very long time; first the F, then the F2 and now the F3. I've always found the motor-drive indispensable, not just to blast away but to provide a way of transporting the film without having to take the camera away from the eye, so you can concentrate totally on the subject. It's really a sophisticated winder that simplifies camera operation.

As regards lenses, I have a 16 mm fish-eye, 24 mm, 28 mm, 35 mm, 50 mm, 85 mm, 135 mm, 180 mm, f2.8 300 mm and f3.5 400 mm, plus both ×2 and ×1.4 converters. This is my standard kit, it goes everywhere with me. Occasionally I hire an f4 600 mm lens.

I did own zoom lenses in the past but after using wide aperture telephotos, I find them a little dark for viewing and focusing. They were useful with colour for special effects, but I have little use for them now.

B.C. Do you make use of the automatic exposure control on the Nikon F3?

C.S. Never. I use the through-the-lens metering but not on automatic. In sport you can't always be certain to keep the metering area over the right part of your subject and if it's centred on a highlight, you're going to underexpose. So I work with the T.T.L. metering, but make adjustments as necessary as I go along. I own a Lunasix meter, too, but I haven't taken it out of my bag for months.

B.C. Do you often work with filters?

C.S. Yes, for instance, with both the silhouette pictures, a red filter made the sky more dramatic and the figures bolder.

In the other horse-racing picture, with the thin line of runners against a white background, they were actually in front of a grassy bank and I lightened this by using a green filter and also over-exposing. Then it was printed on a very contrasty grade of paper and any detail coming through was held back. That's the kind of thing you couldn't do with colour.

It was a picture I planned for some time. I watched a race one day and suddenly thought how effective it would be if one could just show the horses and jockeys and bleach out the rest. There was only one specific racecourse that I could think of where that might be possible, because most courses have a background of running rails which would be very obtrusive. So I planned that picture for a particular meeting, using the technique I just mentioned.

B.C. Is there such a thing as a Chris Smith style?

C.S. In a way I would like to think so but on the other hand I would hate to be stereotyped into a given pattern. It's a two-edged thing.

B.C. Do you still really enjoy sports photography or do you need fresh challenges?

C.S. I still get a terrific kick out of it because there is such variety in sport. It is totally different from one day to the next.

B.C. Do you shoot anything other than sport at the moment?

C.S. Recently, someone at *The Sunday Times* looked at my work and asked me to do some features from time to time. I've done a couple of them, for instance, to illustrate our serialization of a Truman Capote book. It was very satisfying to have someone enjoy my sports pictures as photographs and not just as snapshots of sport.

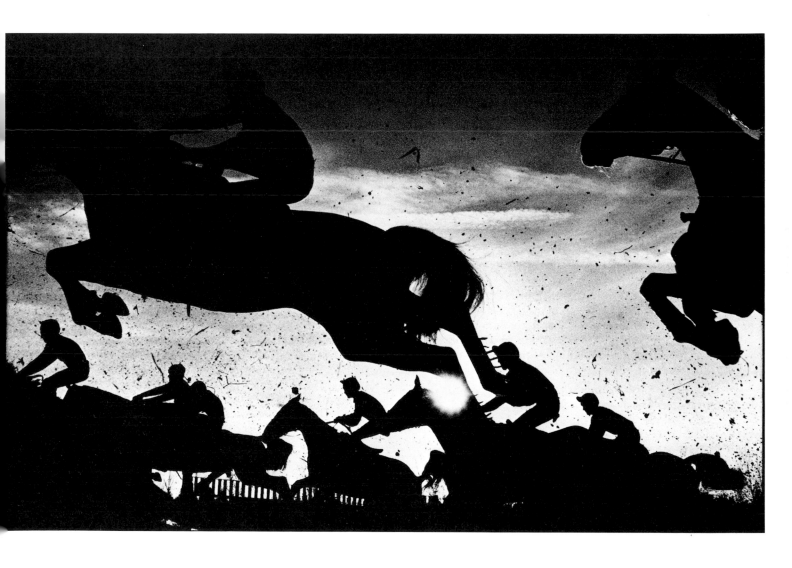

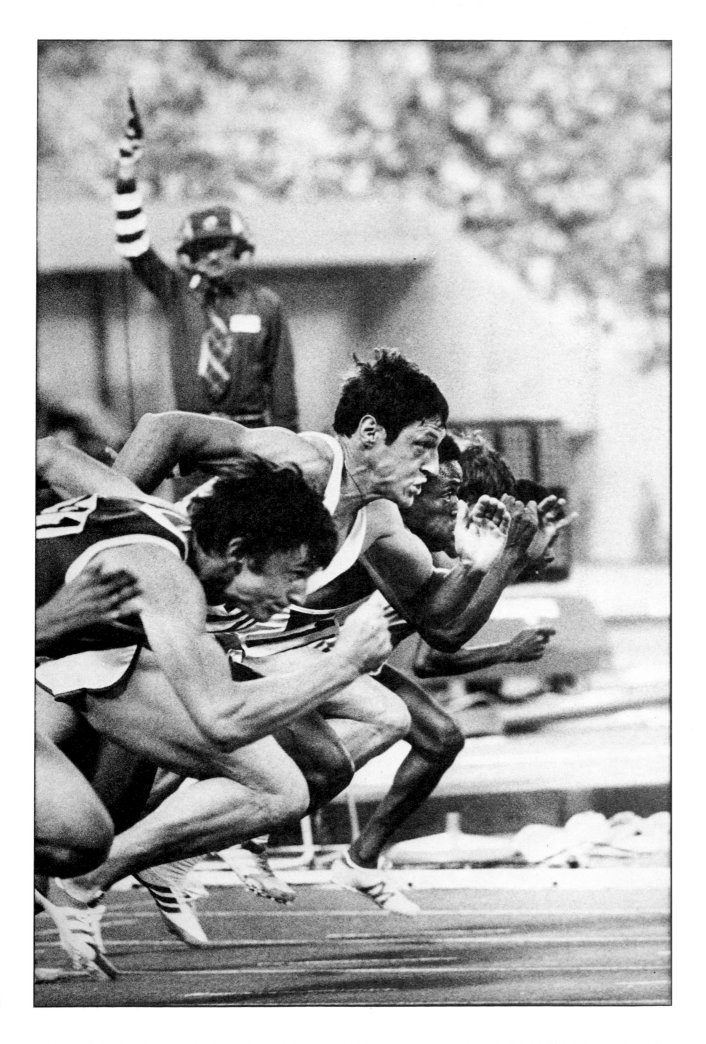

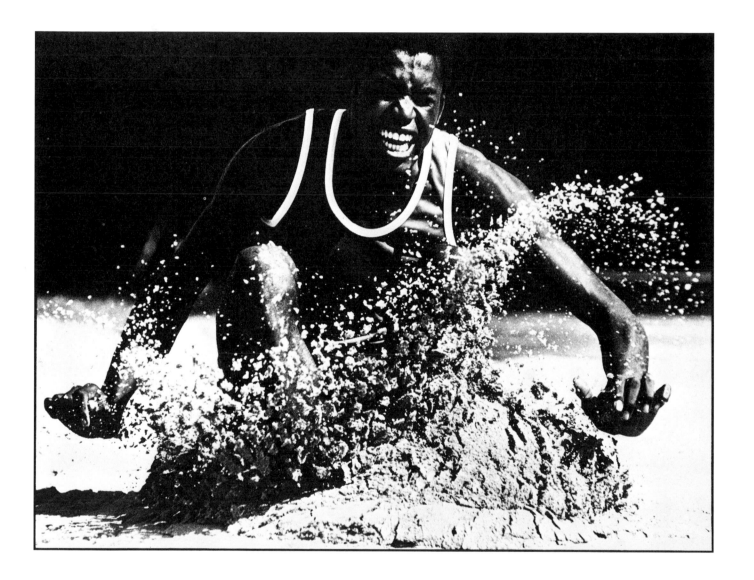

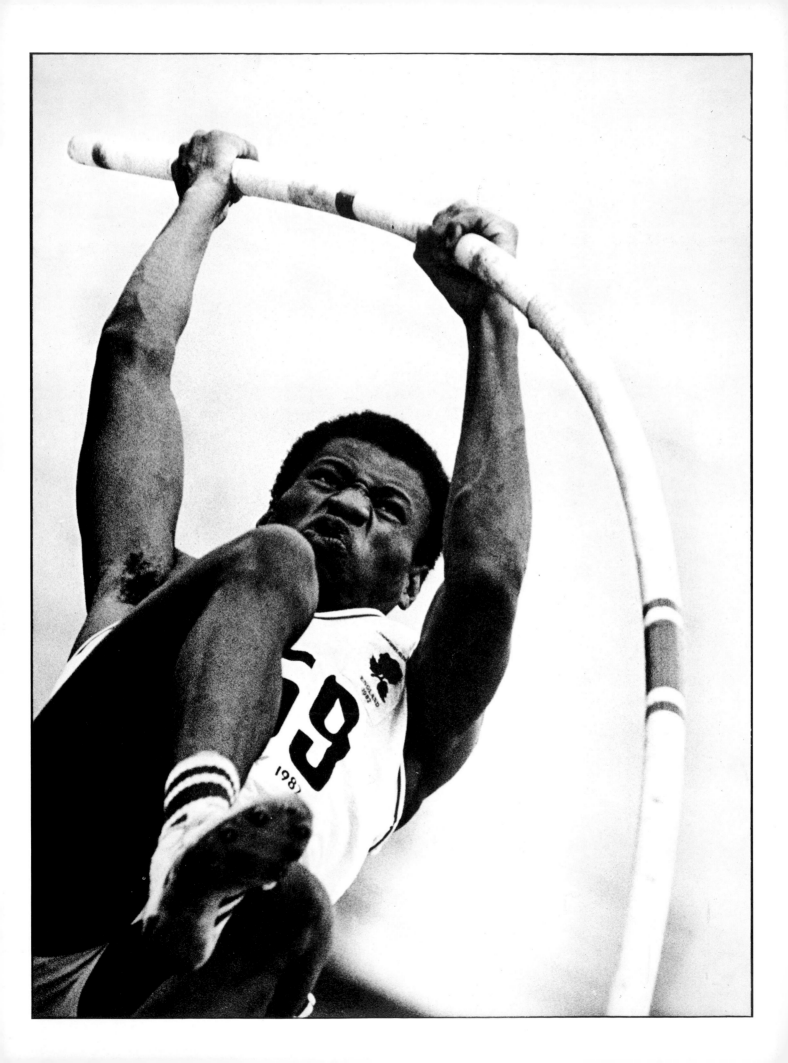

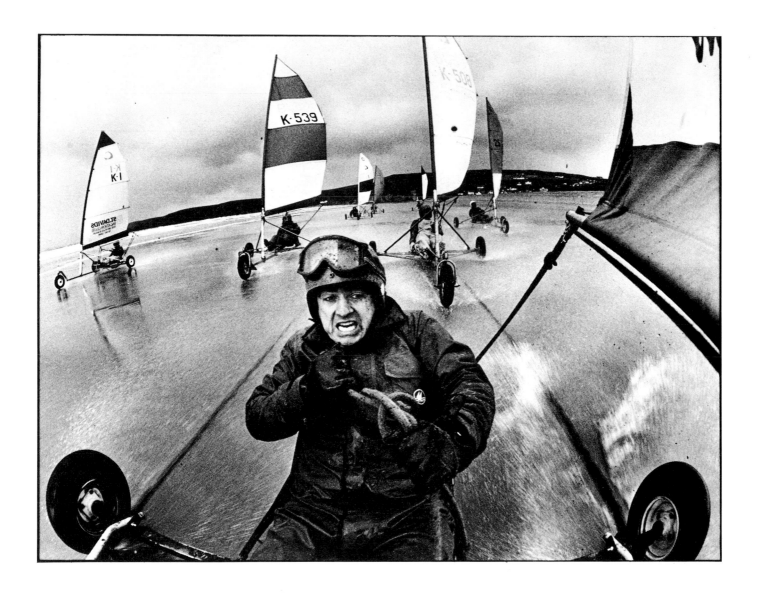

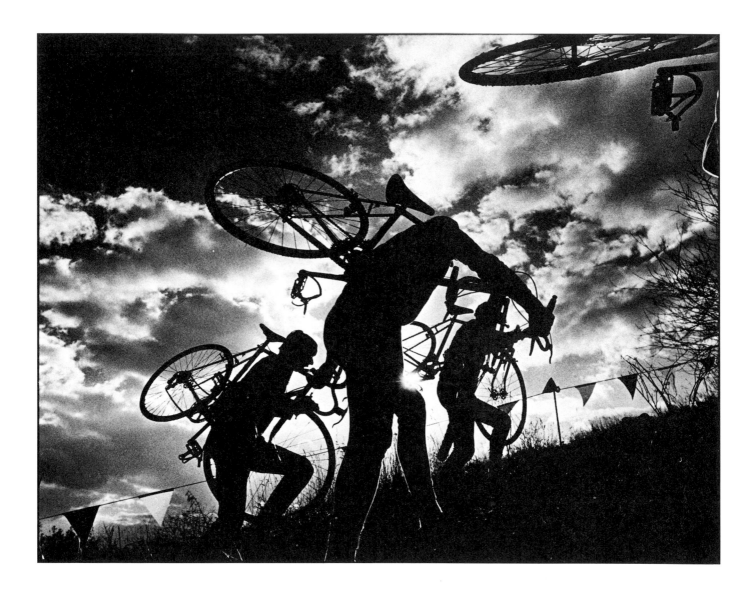

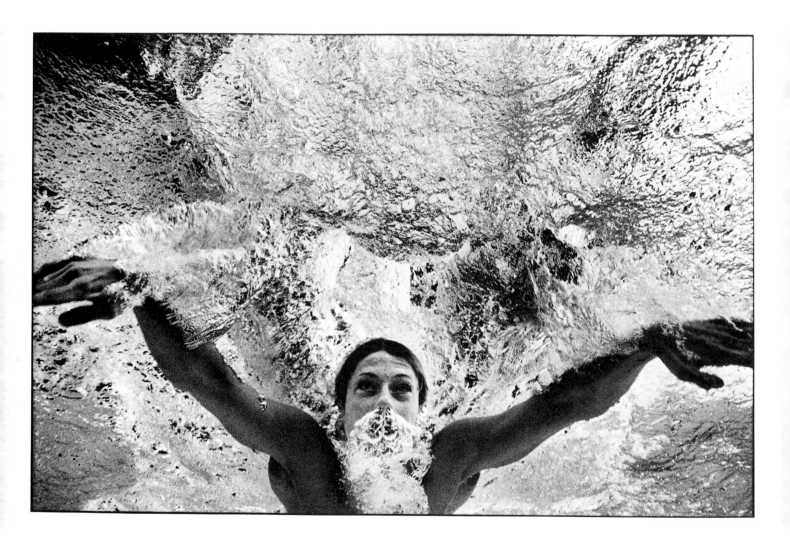

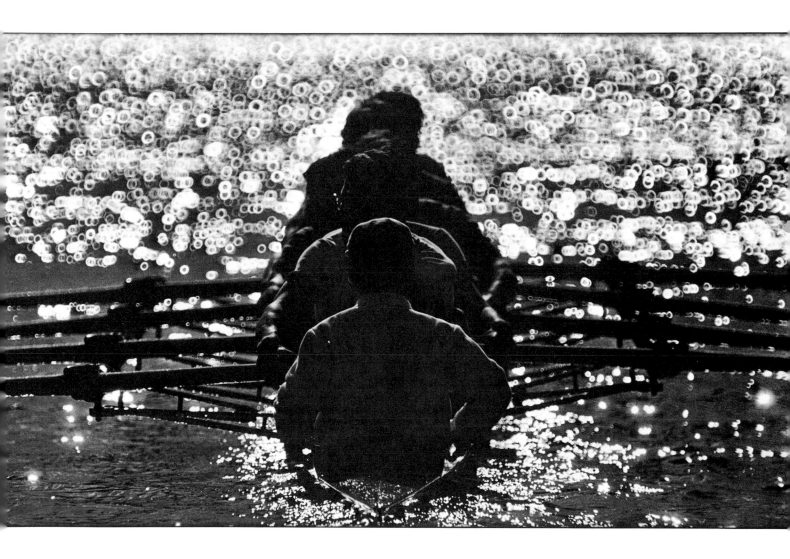

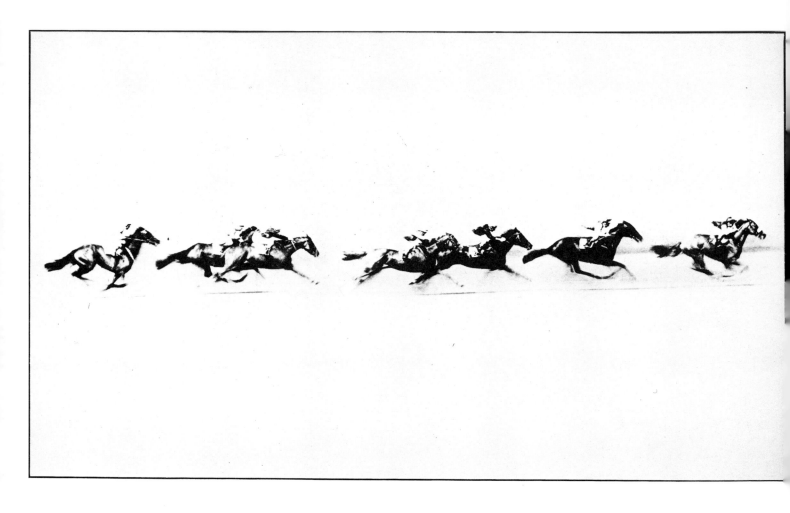

BIOGRAPHY

1937 Born in Hartlepool, Co. Durham, England
1953/56 Trainee photographer with *Northern Daily Mail*
1957/59 National Service with Grenadier Guards
1959 Rejoined *Northern Daily Mail* as staff photographer
1960/68 Staff photographer with *Daily Herald*
1968/76 Freelance contract with *The Observer*
1976 on Freelance contract with *The Sunday Times*

AWARDS

1965 News Photographer of the Year (British Press Pictures of the Year Competition)
1966 Press Photographer of the Year (ditto)
1969 Racing Photographer of the Year (Tote sponsored competition)
1976, '80 and '82 Sports Photographer of the Year (R.P.S. and Sports Council Competition)
1980 Sports Picture of the Year (ditto)
1980 1st Prize (Portfolio), the Olympus Professional Sports Photographers' Competition

Newbury, England, 1976
page 111
Chris Smith dramatised this situation, firstly by his choice of a low viewpoint and a wide-angle lens, secondly by shooting it as a silhouette, thirdly by using a red filter to emphasise the sky tones and finally by printing on a high contrast grade of paper. The camera was set up on a low tripod and fired by a long extension cable release.

Equipment – Nikon camera and 24 mm lens.
Film – Ilford HP5.

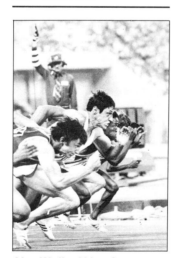

Alan Wells, 100 m Start, Olympic Games, Moscow, 1980
page 112
One of the most basic choices for the photographer is how much of the scene to include in the frame and the more definite you are about your precise subject, the easier it is to make consequent decisions about camera viewpoint, choice of lens and the timing of the exposure. Chris Smith wanted to give prominence to Alan Wells and yet bring out the urgency and atmosphere of the moment, so the picture was carefully angled to allow for the surge forward of the sprinters and to include the starter in the background of the image.

Equipment – Nikon camera and 85 mm lens.
Film – Ilford HP5.

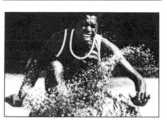

Commonwealth Games, Brisbane, 1982 page 113
Compare this photograph with the one by Erich Baumann on pages 10–11. The different effects of colour and black and white with a very similar subject can be clearly seen. Notice how Chris Smith makes use of contrast to increase the graphic strength of the image. It was the jumper's expression that first caught his attention as he watched earlier rounds of the competition. The speed of Ilford HP5 (400 ASA) allowed him to use a very fast shutter speed, 1/1000 sec., and also to stop down to f5.6 in order to gain depth of field.

Equipment – Nikon camera and f3.5 400 mm lens.
Film – Ilford HP5.

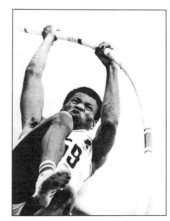

Fidelis Obikwu, Brisbane, 1982 page 114
As with the previous picture, Chris Smith watched this event progress for some time before actually taking photographs. He decided what moment of the action he wanted to capture and how to go about it. Even though this shot was taken with a long telephoto, it was still necessary to enlarge this image from a small section of the negative.

Equipment – Nikon camera and f3.5 400 mm lens.
Film – Ilford HP5.

Sand yachting, Pembroke, Wales, 1982 page 115
A fish-eye or ultra wide-angle lens takes in so much of a scene that the photographer has to compose a picture extra carefully in order to balance all the various elements. Notice how well this photograph is constructed: the exact placing of the wheels in the foreground, the care in avoiding undue distortion, the central figure kept separate and yet relating neatly to the mass of background detail, everything concentrating attention on the driver's expression. All this was happening at speed and with Chris Smith tied onto the sand yacht itself.

Equipment – Nikon camera and 16 mm fish-eye lens.
Film – Ilford HP5.

Cyclo-cross, Crystal Palace, 1973 *page 116*
Chris Smith is very fond of the silhouette technique and uses it powerfully. As in his steeplechase picture, a ×2 red filter dramatised the sky as a background for the clearly defined shapes of the foreground subject.

Equipment – Nikon camera and 24 mm lens.
Film – Ilford HP5.

Muhammed Ali, Miami, 1971 *page 117*
Words can be a useful element in a picture not merely because of their message but also for their graphic interest. Chris Smith emphasized the connection between the phrase and the personality, by simplifying the composition and by isolating the subject against a completely plain background.

Equipment – Nikon camera and 180 mm lens.
Film – Ilford HP5.

Steve Grossman, Crystal Palace, London, 1971 *page 118*
Set-up photographs often develop from a fairly broad original concept. Chris Smith wanted to shoot some unusual pictures of swimming and so organised a session where he could work underwater, wearing mask and weight belt, and using a Nikonos camera. The bonus came when the swimmer broke into a butterfly stroke, exhaling clouds of bubbles. The picture was carefully printed to bring out the full texture of the water.

Equipment – Nikonos 2 camera and 35 mm lens.
Film – Ilford HP5.

Oxford and Cambridge Boat Race, London, 1967 *page 119*
One characteristic of the mirror lens is that it records out-of-focus highlights as doughnut-shaped rings, an effect that sometimes distracts from the principal subject. But Chris Smith decided to use these rings as a prominent feature of the image. He was following one of the crews in practice and as they rowed into the sparkling sunshine, the picture looked to Chris like a bubble bath. It was so bright that he knew it would be advisable to curtail development and after shooting about 8 frames, he changed the film in order to keep it separate for special treatment.

Equipment – Nikon camera and f8 500 mm Nikkor mirror lens.
Film – Ilford HP5.

Newmarket, England, 1970 *page 120*
To take this picture, Chris Smith used a filter to lighten a major area of the scene and not as in the silhouette photographs, to darken part of the subject. The technique is explained fully in the interview and in Techniques and Equipment (pages 143 to 158).

Equipment – Nikon camera and 85 mm lens.
Film – Ilford HP5.

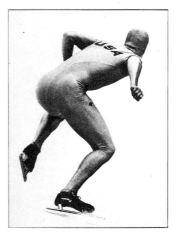

Eric Heiden, 1500 m Start, Winter Olympics, Lake Placid, 1980 *page 121*
A good sports photographer is constantly on the lookout for different angles and a fresh approach. Chris Smith was not too happy with his early pictures of Eric Heiden at Lake Placid – the head-on shots were altogether too conventional, and so he walked around trying to find a better position or some kind of inspiration. By choosing a slightly elevated viewpoint behind the start, he was able to define this muscular and somewhat bizarre shape against the plain background of the ice. A contrasty grade of paper and careful printing removed any unwanted surrounding detail.

Equipment – Nikon camera and f2.8 300 mm lens with ×2 converter.
Film – Ilford HP5.

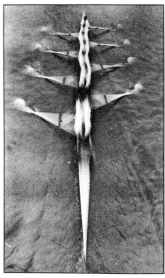

Oxford and Cambridge Boat Race, London, 1969 *page 122*
Shooting down from a bridge over the river created an unusual perspective on this Boat Race crew and a slow shutter speed of 1/15 sec. produced just the right degree of motion blur.

Equipment – Nikon camera and 24 mm lens.
Film – Ilford HP5.

Andy Hayt

A major new talent in American sports photography. In his early twenties, he is already on the staff of Sports Illustrated

Bryn Campbell How would you describe your particular kind of sports photography?

Andy Hayt I don't really think of myself as having a strong individual style, but most of my pictures are shot with long lenses, have limited depth of field and are very dominated by the subject. I try to shoot moments of action and also moments when people are just being themselves, capturing a slice of life, you might say.

There is a lot to be said for photographing the big play of the game, but there is even more to be said about the expression on the face of the person doing it and maybe the exuberance he feels when he has completed it. Sometimes that is a more telling picture than of the event itself. I'm after some kind of emotional involvement, to show the reader something about a person that they wouldn't normally see. Those are the images that usually linger in people's minds.

B.C. What about other elements of photography like colour, form and shape?

A.H. What often happens is that once you've gone through a very journalistic approach to photography, you start to become very aware of the aesthetics. I find now it is becoming more and more a part of my work. You can't really learn it, it just happens to you, an increased awareness of your surroundings, of how people appear in their surroundings and how this setting can sometimes contribute so much to a picture.

When I'm at an event, I'm not forever watching the play through the camera, I'm making myself aware of other things too. I'm thinking *that* will make an interesting background,

those colours will work well out of focus and so on. I look at situations and do the framing in my head before I start to raise the camera.

One of the things people do wrong is to keep the camera up to their eye for too long a period. What is important is not *how long* you keep the camera to your eye but *when* you do it. You see the composition in your head and then you use the camera to translate what your're seeing.

B.C. What fascinates you about sport?

A.H. It is high drama and yet a total diversion from anything else in life. Most people's lives are pretty routine and they are looking for diversions. In the United States, sport is one of the most popular of them. And photographically, you never feel as if you might run out of opportunities – unless you stop thinking.

I don't have any desire to cover spot news, I had my fill of that with the newspaper. I've had my share of covering disasters. You become very aware of how fragile human life is. Recording it is a tremendous rush of adrenalin and if you make a good picture it can be very telling but it is not a part of the human condition that I want to spend my life covering. My curiosity is about the more pleasant things in life.

B.C. What are the major pressures on you as a professional sports photographer?

A.H. Getting to and from the event. And that's half serious.

The one thing I worry about most is whether I've covered the key moments in an event. You can tell how you're doing, and if you're having problems and miss a big play, you know it. I worry about missing important parts of the story.

B.C. Does shipping your film to *Sports Illustrated* in New York for processing make it difficult for you to keep in touch with what you are producing, to understand how your work is progressing or what is going wrong?

A.H. After a while, what begins to happen to you in this business, if you're honest with yourself, is that usually you know after an event what you have on film and it just comes down to the technical question of were you in focus or was your timing right. After you've shipped your film, you hear from the picture editors how the actual product turned out. Their judgement is pretty good, they don't miss that much.

What I do is to call the individual person who is editing my story and talk to them about it. Then I don't worry too much because the editorial process is such that it is really out of your hands afterwards. Most of the time, you're so busy moving on to the next job that you don't have the chance to savour anything too much or worry about possible problems.

B.C. Do you shoot much material just for yourself?

A.H. Yes. I used to shoot a lot more when my schedule was a little freer, probably one event a week just for myself, just for the fun of it. Now maybe twice a month I go out and experiment, try different lenses and different angles, and just have a good time with no pressure. Then I edit my own film so that I can see how 125

an entire take will look to me, where I need to improve and sharpen up.

B.C. Are you very aware of technical developments in photographic equipment?

A.H. I try to keep up with what is new in the industry, but I'm not obsessed by the technical aspects of photography, simply because I enjoy shooting pictures so much. What I do is to look at equipment and wonder how I can use it to my advantage.

B.C. What equipment do you use?

A.H. Nikons, mostly the F3. I think it's great. I use my cameras very heavily and I've had no real problems with them at all. The F3 has tremendous motor-drive speed and accurate shutter speeds, even at 1/500, 1/1000 and 1/2000 sec., because they're electronically controlled. The metering system is quite good and perhaps my only criticism would be of the viewing system which is not as bold and clear as it was in the Nikon F2. What I've done is to take the viewing screens from my F2's and put them in my F3's.

I always keep motors on my cameras because one of the real crimes in this business is not to be ready for a picture. Many people think of a photographer who uses motor-drives as someone who just holds the button down and lets the camera do the work for him. But I use the motor-drive more than anything else as a winding mechanism, just to keep me ready for the next shot. Probably 75 per cent of my pictures are shot single-frame.

Some photographers say that their F2 will do 4 to 5 frames a second. Well I've never owned one that would do faster than $3\frac{1}{2}$ f.p.s. and that's really not all that fast. This new F3 motor does a true 4 f.p.s. and up to 5 f.p.s., when you have fully-charged batteries. That is a real advantage. Once you use this camera for a while, it fits in your hand a lot better than the F2. It doesn't have so many sharp corners on it, it's lighter and altogether more comfortable to handle.

I never use the automatic exposure control. I've never used it once. You only have one chance in this business to get a picture and you had better have your metering right and you had better have your focusing right. You do not have time to worry about whether the metering area in the centre of the viewfinder is in the proper position to make an accurate exposure of your subject. That is too distracting. It is easier to take your light readings and then make whatever adjustments are necessary as you go along, as you see what changes are happening. Then you can be certain that you are in complete control of what is going on.

One of the mistakes some people make is to let the camera do the work for them. This business is one of great unknowns – you don't know where the action is going to happen or what the subject is going to do. So if you don't know what your camera is doing, that is yet another unknown and you can do without that. If you are in complete control of your cameras, your mind is free and clear to concentrate fully on your subject.

B.C. But isn't the automatic exposure system useful when the subject is moving quickly from one light condition to another, for instance, from bright sunshine in the middle of the field into the shadow of the stand? The camera can quickly compensate for that, without you having to worry.

A.H. That is true, up to a point. In the sun you would be shooting at 1/500 sec. at f4 but, on the same film, you would have to work at 1/125 sec. in the shadows, and so the action would be blurred. If you are going for colour quality, you need a slow film for the bright part of the field and a fast film for the shadows. So in that kind of situation, I keep two or three camera bodies with me, loaded with different types of film, and I try to have a camera set up for each area.

B.C. What kind of exposure meter do you use?

A.H. Mostly a Minolta Spot Meter II. I always carry two of them in case one gets damaged. I also use the Minolta Flash Meter III to take general readings or if I don't trust the reading I'm getting from the Spot Meter.

B.C. What equipment do you carry on a major assignment?

A.H. I try to think beforehand what I need to do the job properly. I don't want to take so much equipment that it becomes a burden to me. Some photographers take all the gear they own with them to every job and that can be a phenomenal amount. I try to pack per job.

Usually if it is an outside assignment, I'll take a 600 mm, 400 mm, the f2 200 mm, and then nothing more up to the f1.4 35 mm, f2 28 mm and f3.5 20 mm. Most people think that there is a tremendous gap in the middle range but the way I like to take pictures, there are no lenses between 200 mm and 35 mm that I want to use.

I'll carry four motorized F3 bodies and one Nikon FE-2 to use as a flash camera. It synchronizes at 1/250 sec., so you can use fill-in flash easier outdoors and it reduces the risk of ghost images indoors if the available light is too bright. Before the FM-2 and FE-2 came along, we often used Hasselblads under those conditions, for example, for photographing basketball and ice-hockey. We could synchronize the Hasselblad shutter at 1/500 sec.

I'd pack the Minolta meters, of course, and also a Gitzo monopod to use with the long lenses. I always try to shoot from a fairly low angle because in so many of our sports the athletes wear helmets and you need to shoot up into them if you want to show their eyes.

One of the things that I think is so important in sports photography is what is going on in the subject's face. People are drawn to the eyes faster than anything. They are looking for the expressions and the emotion. That is what you are really trying to show – what is going on with the athlete.

B.C. How often do you work indoors with flash?

A.H. This year, half of the material I've done has been shot indoors with strobe lights. It is quite a different type of shooting. It requires a lot more discipline in a sense, because you can't

really work with the motor-drive and you have to pick and choose your pictures. It is very good for your timing as well as the technical skill of working with lights.

You have to position the lights carefully so you don't have problems with flare or with uneven illumination. We light up the entire arena using strobe lights mounted in places like the catwalks. These strobes are very high powered and we wire them all together, then run a drop line down to the floor of the arena to connect to the camera. What we do fundamentally is to turn the stadium into a giant studio with consistent, even photographic lighting.

B.C. Who sets up this lighting?

A.H. We have technicians who do this for us because it involves a tremendous amount of equipment, perhaps 16–20 cases, each weighing 75–100 pounds.

The technician will go in and basically do the entire set-up. He is responsible for contacting the building people and making sure that we have proper electrical power, so that we will not have power surges or an inadequate supply. The photographer will show up on the day of the event or the day before, and shoot Polaroid tests. Then he will re-aim the lights where necessary and tell the technician to wire parts of the building where he wants outlets that he can plug in to.

B.C. Do you ever have problems with other photographers or with television people because of your lights?

A.H. There have been problems and to some extent there still are, but they have been minimized. We have been very involved in the development of high-power, short-duration flash and the newest types are not as bothersome for the T.V. people. They do not cause video disturbance like the old units and, of course, the television crews are using better equipment themselves today. It has been a real breakthrough.

Photographers using available light might think that there is a strong risk of our flash being recorded on their film but this is very unlikely because the timing is so split-second.

As for problems with other photographers using flash set-ups, the most critical factor is that the equipment is properly wired so that no electrical current cross-feeds into another system, causing it to trigger.

I don't like working with radio remote-control to trip these strobes because other sound frequencies nearby may cause a disturbance and then you have synchronization problems and, sometimes, misfires.

We use Spedatron equipment, 2400 watt-second power packs with a quad head – 4 tubes that discharge from one head. In most buildings we would set up four of these units.

An amateur could work with a similar set-up on a smaller scale, using high powered portable strobes fixed on light stands. I did this when I worked for a newspaper, lighting a small area of a field or of a basketball court. You can get quite successful results in either black and white or colour.

B.C. How did you get your start as a newspaper photo-grapher and later with *Sports Illustrated?*

A.H. In my early teens, I was not a good student but I did a lot of drawing and thought of being an artist. I never played sports and my only interest in them was in motor sports, which I started to photograph to provide reference material for my drawings. Eventually, the photography consumed me more than the actual artwork and I began to shoot more and more pictures unrelated to motor sport. In my senior year I landed a part-time job on a small local newspaper, shooting high-school sports and professional games.

I looked around for a university where I could take a journalism course and eventually ended up at Arizona State University where one of the professors, Cornelius M. Keyes, took me under his wing and greatly increased my awareness of why you take pictures and how to get a message across. I also worked as a stringer for Associated Press and United Press and had a part-time job with a local newspaper in Phoenix.

In my third year, the *Los Angeles Times* approached me. They had seen my pictures, and I had also been recommended to them by Mr. Keyes, who had joined the paper himself. It is the second largest newspaper in the United States and I was one of a picture staff of about 55 people. I shot news, features and sports, gradually specializing more and more on the latter. It was a tremendous experience to work for a large city newspaper. If you can retain your creative drive under such pressure and not be disillusioned, you may well go on eventually to be a very good photographer.

During the baseball World Series in 1979, John Zimmerman introduced me to John Dominis, then picture editor of *Sports Illustrated.* A few months later, the magazine bought an exclusive picture from me and I followed up by showing John Dominis a colour portfolio that I had put together in my own time. He used me for one or two assignments a month for about 5 months and then invited me to go to New York for a trial period of two months. After my return to California and a few more assignments, he offered me a small contract. The following year I joined the staff.

B.C. Why do you prefer being a staff photographer rather than working on a freelance basis?

A.H. It takes so much pressure off, knowing whether you're going to work or not. It's also given me a certain amount of flexibility, for example, being able to spend 3 days on a job if necessary instead of just a two-day freelance assignment. I can put a bit more time into my pictures. I don't enjoy the business side of photography, I enjoy shooting the pictures.

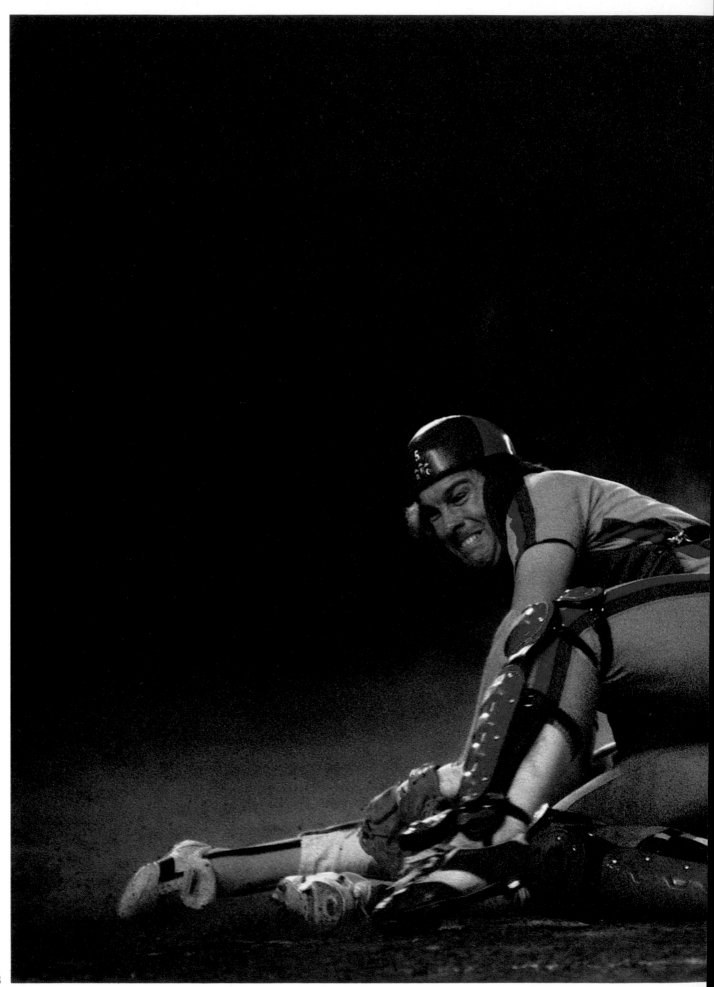

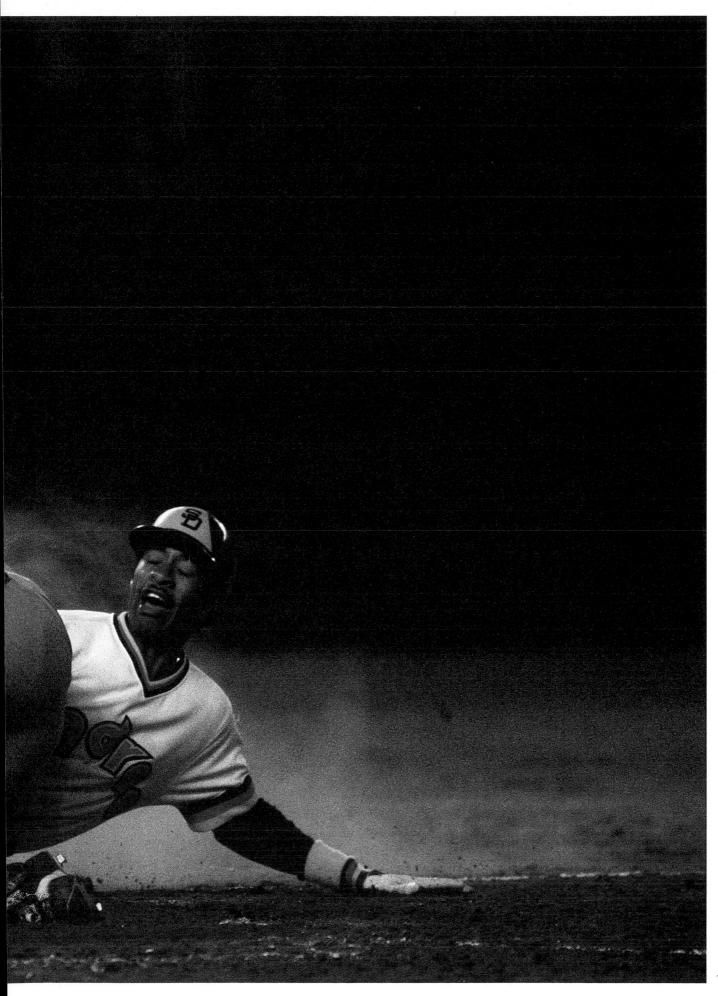

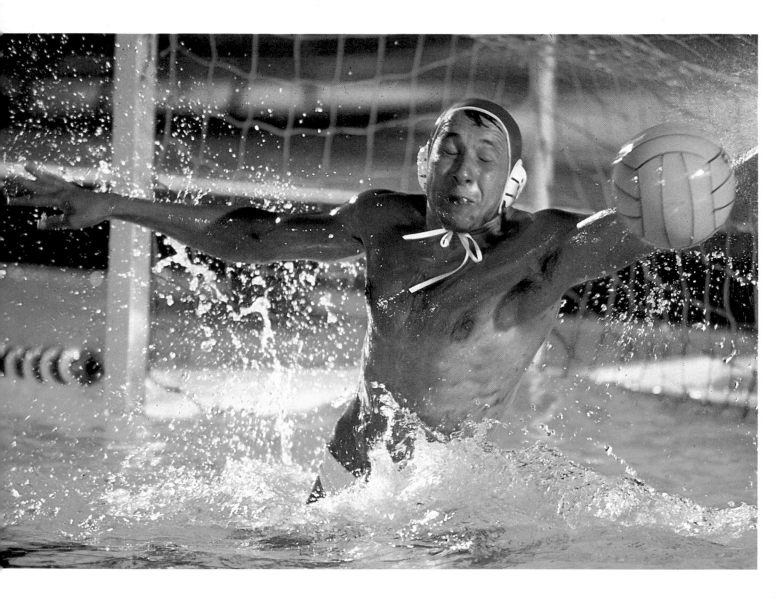

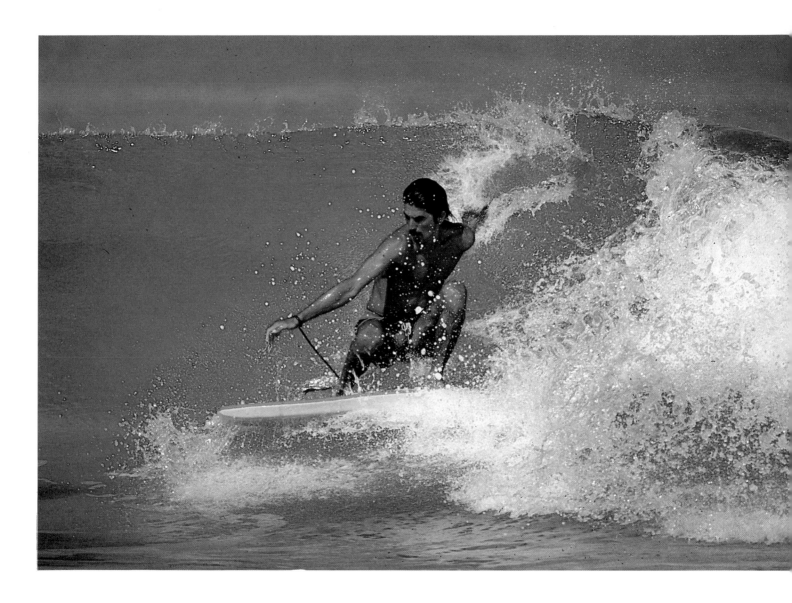

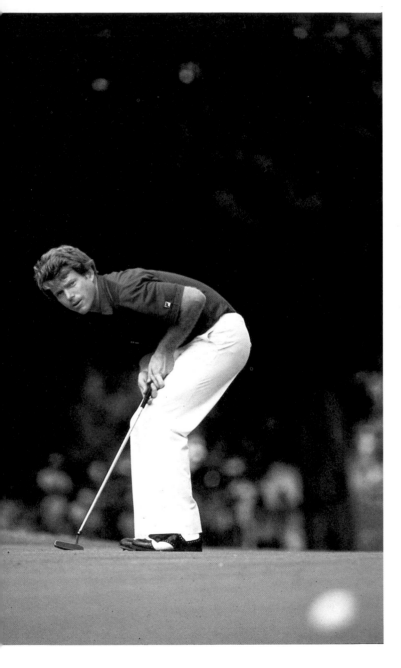

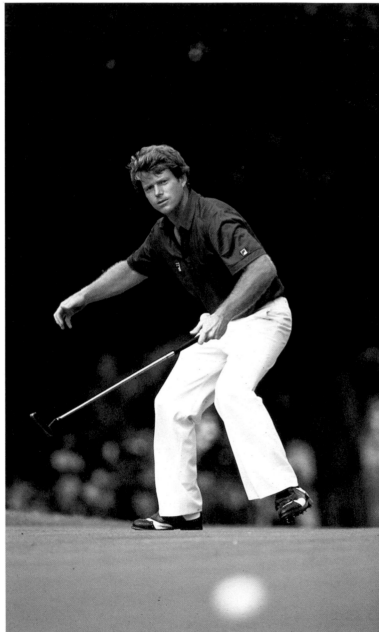

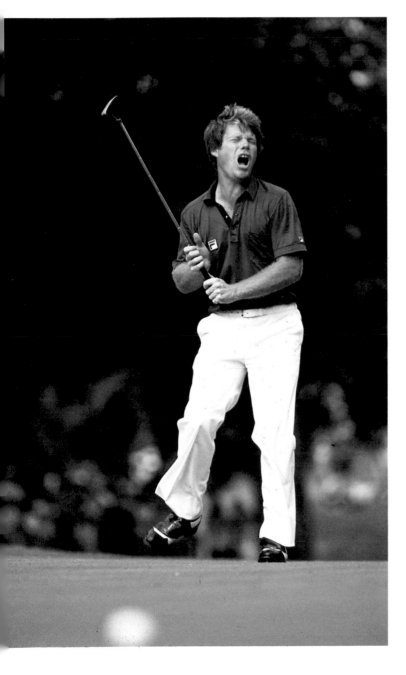

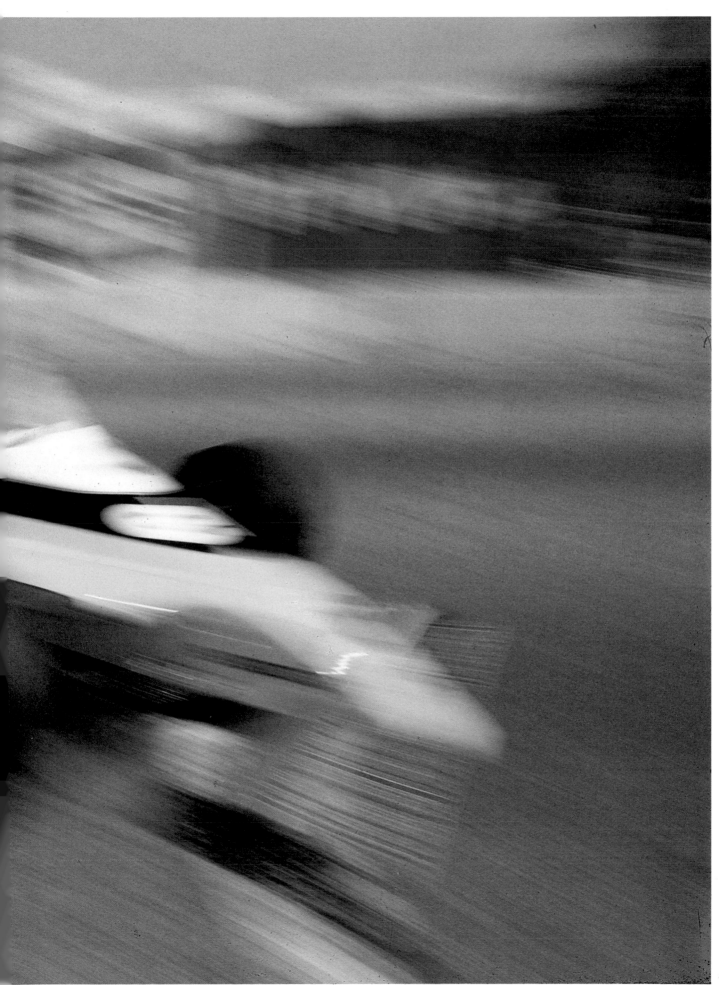

BIOGRAPHY

1957 Born in New York, N.Y. Moved to San Diego, California, when he was 12 years old
1975/77 Attended Arizona State University
1977/80 Staff photographer with *Los Angeles Times*
1980 Worked as freelance and then as contract photographer with *Sports Illustrated*
1981 on Staff Photographer with *Sports Illustrated*

AWARDS

1982 1st Prize, Colour Action, in the National Football League Photo Contest

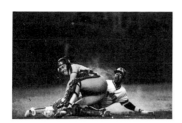

San Diego, 1981 *pages 128–9*
If you are photographing in colour under stadium lights, or any other kind of artificial illumination, it is important to know whether their colour temperature is suitable for daylight-type or tungsten-type film. This point is explained further in Techniques and Equipment (pages 143 to 158). This night baseball game took place under daylight-balanced lights and Andy Hayt used Ektachrome 400 which had to be 'pushed' 2 stops.

Equipment – Nikon camera and f3.5 400 mm Nikkor lens.
Film – Ektachrome 400 'pushed' 2 stops.

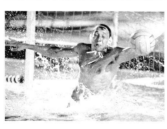

U.S.A. v U.S.S.R. FINA World Cup, Long Beach, California, 1981 *page 130*
This was the kind of situation where the professional photographer needs to pull out all the stops. The game was an important one but it was taking place at night in an outdoor pool with inadequate existing light for quality colour action photography. So *Sports Illustrated* erected scaffolding at each corner of the pool, brought in a generator to supply power and set up 4 Spedatron 2400 watt-second flash units to give even light coverage. All the wiring and equipment had to be insulated to keep it waterproof.

Equipment – Nikon FE camera and f2 200 mm lens.
Film – Ektachrome 64 'pushed' half a stop.

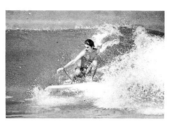

Hawaii, 1982 *page 131*
Surfaces like water, sand and snow are excellent reflectors of light and this must be taken into account when calculating exposures – you will probably have to give at least one stop less than normal. Using a very long lens, Andy Hayt shot this picture of a knee-board surfing demonstration from the water's edge.

Equipment – Nikon camera and f4 600 mm lens.
Film – Ektachrome 64.

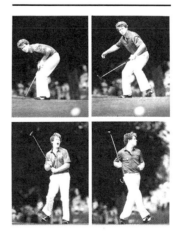

Tom Watson, Forth Worth, Texas, 1980 *pages 132–3*
Missing this putt lost Tom Watson a million dollar bonus prize on the final day of play in the Colonial Invitation Golf Tournament. Andy Hayt used a 400 mm lens wide open to throw the background quickly out of focus and a motordrive to capture the sequence of expressions and movements. Because of the noise of a motordrive, it should not be fired until after the golfer has played the shot. Andy also fitted a blimp to the camera to deaden the sound.

Equipment – Nikon camera and f3.5 400 mm lens.
Film – Ektachrome 64 'pushed' half a stop.

Jodi Anderson, Olympic Trials, Eugene, Oregon, 1980 *page 134*
Framing a high-jumper this tightly calls both for good timing and an accurate estimate of the best point to focus. There is no time to focus a massive telephoto with the athlete already in mid-leap, even though the new internal focusing lenses are quicker to operate than the older models and are probably less likely to cause camera shake.

Equipment – Nikon camera and f4 600 mm lens.
Film – Ektachrome 64.

Ray Mancini, Las Vegas, 1982 *page 135*
At the end of a title fight, such as this, there is usually pandemonium, with handlers, TV crews and photographers all scrambling to get into the ring. It is a time to work fast and intuitively. Exposures will have been worked out beforehand and it may well have been necessary to prefocus. Under these conditions, it pays to know your equipment well.

Equipment – Nikon camera and 28 mm lens.
Film – Ektachrome Professional Tungsten, 160 ASA, 'pushed' 1 stop.

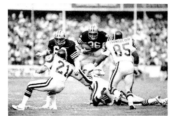

Long Beach Grand Prix, 1981
pages 136–7
Andy Hayt is not over-fond of photographing motor racing because so little of the human figure is visible. After shooting the usual stock pictures of cars and drivers at this Grand Prix, he began to experiment and found a position at a tight turn where the cars came in close to the guard rail. He leaned over with a very wide-angle lens and exposed at a relatively slow shutter speed of 1/30 sec., producing this blur of colour and form.

Equipment – Nikon camera and 20 mm lens.
Film – Ektachrome 64.

San Francisco 49ers v Los Angeles, San Francisco, 1981
page 139
One of the major advantages of a motor-drive is that you can keep the camera to your eye during a spell of intensive action and concentrate on focusing a heavy telephoto with its very limited depth of field. The monopod is a very popular accessory with professional sports photographers. It helps support weighty equipment, is handier to use than a tripod and packs away into a much smaller space.

Equipment – Nikon camera and f3.5 400 mm lens.
Film – Ektachrome 64 'pushed' half a stop.

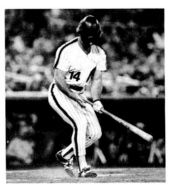

Frank Cephous, Berkeley, California, 1982 *page 138*
Many photographers, like Andy Hayt, would prefer to shoot Kodachrome but because of their tight deadlines, they have to use Ektachrome, which is quicker and simpler to process. It has two other advantages, film speeds up to 200 and 400 ASA, and it can easily be 'pushed' in processing to compensate for under-exposure, with, of course, some loss of quality. The introduction of wide-aperture, long focal-length lenses has made it more possible to use the relatively slow Kodachrome (64 ASA) to photograph action like this running-back racing for the goal-line.

Equipment – Nikon camera and f4 600 mm lens.
Film – Kodachrome 64.

Pete Rose, Philadelphia, 1980
page 140
In sport, photography or any obsessional activity, a touch of humour is no bad thing. Andy Hayt caught the moment as Pete Rose's helmet fell over his eyes after a big swing. Even using a wide aperture telephoto, the light was so poor that the fast film had to be 'pushed' 2 stops.

Equipment – Nikon camera and f2.8 300 mm lens.
Film – Ektachrome 400 ASA. 'pushed' 2 stops.

Techniques and Equipment

A CAMERA SYSTEM

Professional sports photographers do not so much buy a camera, as buy into a photographic system offering a vast range of camera bodies, lenses and accessories. Of course, few people invest in a complete outfit at one go; they are much more likely to acquire equipment gradually as they need it. Once they have settled down with a system, they tend to remain loyal to it. A rival manufacturer may suddenly introduce a quicker motor drive or faster telephoto lenses, but the top firms rarely steal a march on one another for long. Any changes that are made at

the professional end of the market are likely to be genuine improvements and not merely sales gimmicks.

The most popular systems are based on the 35 mm single-lens reflex camera but some photographers still prefer to use medium format (6×6 and 6×7 cm) models for part, or even most, of their work. In both cases, the choice of equipment is enormous. The diagram below, which shows quite an extensive outfit, includes only a fraction of what is available.

The use of all these items, and possible alternatives, is fully described in the following pages.

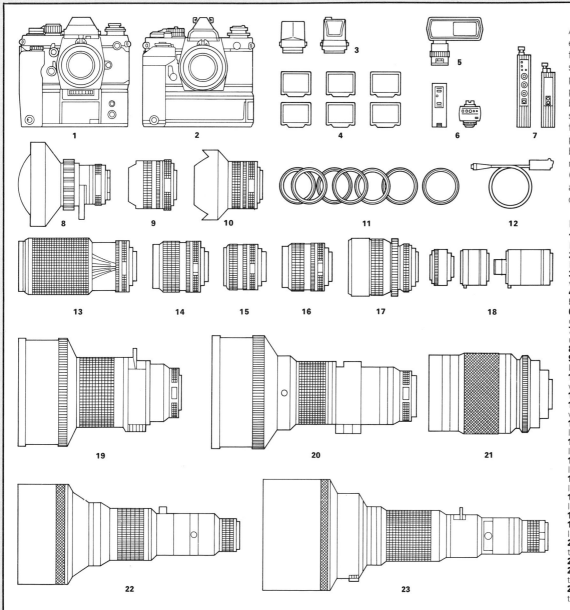

A typical range of equipment selected from one camera system, as used by a professional sports photographer. This is based on the Nikon system, the one most favoured by the photographers in this book, but other manufacturers, such as Canon and Leitz, offer a similar variety of products.

KEY
1. Nikon F3 camera and MD-4 motor drive.
2. Nikon FE2 camera and MD-12 motor drive.
3. Interchangeable viewfinders.
4. Focusing screens.
5. SB-12 flashgun.
6. Modulite remote control unit.
7. Radio remote control unit.
8. f2.8 8 mm fish-eye lens.
9. f2.8 16 mm fish-eye lens.
10. f3.5 15 mm ultra wide-angle lens.
11. Filters.
12. Remote control cord with button release.
13. f2.8 80–200 mm zoom lens.
14. f2 28 mm wide-angle lens.
15. f1.4 50 mm standard lens.
16. f2 85 mm telephoto lens.
17. f2 135 mm telephoto lens.
18. Teleconverter lenses.
19. f2 200 mm telephoto lens.
20. f2.8 300 mm telephoto lens.
21. f8 500 mm mirror lens.
22. f3.5 400 mm telephoto lens.
23. f4 600 mm super telephoto lens.

VIEWING AND FOCUSING

The 35 mm single-lens reflex camera is the workhorse for most professional sports photographers. It is small and light enough, even when fitted with a motor drive, for several bodies equipped with different focal length lenses, and perhaps loaded with different types of film, to be carried ready for action, so that the photographer can switch easily from one to the other.

This is equally true of other 35 mm cameras but the major advantage of the SLR is the convenience and efficiency with which it can be used with the widest possible range of interchangeable lenses.

Both coupled rangefinder and twin-lens reflex cameras create problems, especially at close focusing distances, with parallax – broadly speaking, the difference between what you see through the viewfinder and the view covered by the taking lens. No such difficulty arises with the SLR, since you view through the taking lens itself.

The field is dominated by the SLR. Its development has been paralleled and stimulated by the introduction of an increasing variety of interchangeable lenses, ever wider, longer, faster and more sophisticated – fish-eye, ultra wide-angle, super telephoto, zoom, mirror, macro, and perspective control objectives. The SLR shows you in the viewfinder the full-frame image as seen by the lens, whatever its focal length. The standard SLR pentaprism viewfinder displays the image right way round and right way up, that is, as seen by the naked eye.

A tiny fraction, about 2 per cent, of the lens's field of view is cut off at the edges of the viewfinder but, in practice, this can usually be ignored. It is less than most slide-mounts encroach on the image.

The invention of the instant-return mirror and the fully automatic lens diaphragm means that viewing at full brightness is only very briefly interrupted at the instant you take a picture, except with slow shutter speeds because the viewing mirror has to be swung out of the light-path for the duration of the exposure. This effectively blacks out the image (see diagram, top right).

The brightness of the viewfinder image and the ease with which it can be focused, depends on the lens in use, the type of focusing screen – usually interchangeable, and the type of viewfinder – also usually interchangeable on more advanced cameras. This wide interchangeability of parts allows you to tailor the camera to your personal requirements, long-term or short-term. It is another significant contribution to the versatility and popularity of the 35 mm SLR.

Automatic focusing is already available as one more option in the system, but it is much too early to be certain of the reaction of professional sports photographers. They have very mixed feelings about automatic exposure control, though many of them seem to like through-the-lens metering as a guide to exposure or as a quick check on the conditions. Most top pros want to keep the different elements of photography as much under their own control as possible.

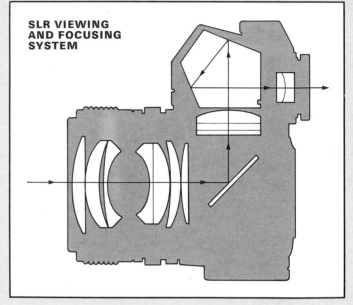

SLR VIEWING AND FOCUSING SYSTEM

INTERCHANGEABLE FOCUSING SCREENS

Below Three of the more useful focusing screens for the sports photographer from the many available designs: *Top*, plain matt fresnel field; *centre*, same background with central microprism; *bottom*, same background with central diagonal split rangefinder.

Above The SLR's prime advantage is its viewing and focusing system. The viewfinder image is formed by the taking lens itself and so the photographer can see the precise, full-frame image produced by the lens, right up to the instant of exposure.

Light from the subject passes through the lens, strikes a viewing mirror set at a 45° angle and so is reflected into the viewfinder where the image can be focused. When the shutter release is pressed to take a photograph, the viewing mirror is moved out of the path of light, the lens diaphragm adjusts to the required aperture, the shutter opens and exposes the film to light for the required length of time, before closing or ending its travel, then the diaphragm reopens to full aperture and the mirror swings back into place, restoring the viewfinder image. This whole automatic operation happens incredibly quickly with fast shutter speeds, but clearly, the longer the exposure, the longer the mirror is kept out of the light-path, so blacking out the viewfinder.

EXPOSURE

INTERCHANGEABLE VIEWFINDERS

Nikon waist-level finder

Nikon auto-focus finder

Canon Speed finder

Waist-level viewing

Eye-level viewing

Left The standard 35 mm SLR viewfinder is the pentaprism. There are two important reasons why these finders are made interchangeable on more advanced cameras: firstly, they can easily be replaced if damaged, and secondly, it allows the use of accessory viewfinders for special applications.

The waist-level finder
There are times when the eye-level pentaprism finder is inconvenient to use, for example, at very low camera positions. One solution is just to tilt the camera at an estimated angle. Another possibility is to remove the pentaprism and look directly on to the screen. This method works quite well but can be a bit fiddly if you are trying to hold the camera steady and shield the screen so that you can view and focus clearly.

The most convenient way is to use a waist-level finder which shields the image well and also has a built-in, foldaway magnifier. The disadvantage of this type of viewfinder for general use is that it reverses the image left to right. This can be especially confusing when watching a moving subject.

Automatic focusing viewfinder
This new Nikon finder provides fully automatic focusing when used with the 80 mm and 200 mm AF-Nikkor lenses – both fitted with a servomotor – and focus confirmation with other lenses. It focuses the image by contrast measurement, rather than by infra-red radiation or ultrasonic signal, the two other commonly used autofocus methods.

The action finder
The exact name of this kind of viewfinder varies according to the manufacturer, for example, the Action Finder by Nikon, and the Speed Finder by Canon. Its value is that it gives you a clear eye-level view of the image even with the eye a couple of inches away from the finder or not central to it. This can be particularly useful if the photographer is wearing spectacles or protective goggles.

One advantage of the Canon Speed Finder is that it can be quickly swivelled to give waist-level viewing, as in the two bottom diagrams.

One of the most important developments in SLR camera design has been the incorporation of exposure measuring and controlling systems. This has been achieved with remarkably little increase in size and weight, largely due to the increasing use of electronic circuitry.

The first step was the built-in exposure meter, with readings simply being transferred manually to the camera controls. The next major advance was through-the-lens metering, with the light actually transmitted by the lens being measured. A metering scale was visible in the camera viewfinder and by turning the camera's shutter speed or aperture controls, a moveable pointer could be brought into alignment with the meter needle. When the two overlapped, the correct exposure was set on the camera.

Today there is a choice of fully automatic exposure control systems, sometimes with different cameras and sometimes as options on the same camera.

The programmed mode gives fully automatic exposure, progressively opening up the aperture and simultaneously giving a slower shutter speed as the light decreases.

Aperture priority automation allows you to pre-select the lens aperture and the camera automatically sets the correct equivalent shutter speed.

Shutter priority is the exact opposite. You pre-select the shutter speed and the camera automatically adjusts the correct aperture. This principle makes most sense for sports photo-

EXPOSURE CONTROLS

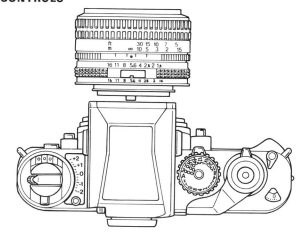

This top view of the Nikon F3 camera shows the convenient grouping of the exposure controls. On the right, the shutter speed dial and the battery on/off switch are next to the shutter release. On the left are the film speed settings (not visible from this angle) and the exposure compensation dial. Protruding just to the right of the lens is the depth of field preview button. The depth of field scale is marked on the lens immediately in front of the aperture ring.

EXPOSURE continued

Different metering sensitivity patterns as shown on the interchangeable focusing screens for the new Canon F-1 camera. Top left – centre-weighted average metering. Top right – selective area metering. Left – spot metering.

graphy, since usually it is more important to you to be certain what shutter speed you are working at, rather than what stop. Aperture priority is a valuable feature when depth of field is critically important, as in architectural or landscape photography. Programmed automation is useful for the snap shot when there is no time to set anything.

There are times when a photographer wants to keep working on automatic but realizes that he has to compensate for either over or under-exposure because the camera's metering system has misread a situation. For example, if you are shooting into the light or using a wide-angle lens to set a subject against the sky, the meter will assume that more light is falling on the subject than actually is, and so the result will be under-exposure. A compensating device built into the camera allows you to give up to 2 stops more or less exposure. The dial is usually calibrated in intervals of $\frac{1}{3}$ stop. It is more handily placed and more easily manipulated in some cameras than others.

As mentioned earlier, some cameras offer a range of automatic exposure options and manual override, for example, the Canon A-1 and the Leica R4. Many other models are almost as versatile as these cameras.

Cameras also vary in the way they measure the light from the subject, both in the positioning of the light sensitive cells and in the balance of their sensitivity over the full picture frame.

Some cameras average out the light distribution over the whole field but giving preference to the central area, where, it is assumed, the most important part of the subject is usually likely to be placed. This is known as centre-weighting and the degree of preference also differs according to the manufacturer.

The opposite alternative is spot metering, where a reading is taken only from a tiny central area of the frame, usually outlined on the focusing screen.

An in-between method may also be offered – selective area metering, reading from a larger portion of the frame than with spot metering.

The Nikon F3, for example, is heavily centre-weighted; the Leica R4 can be quickly switched from a lighter centre-weighting to spot metering; and the Canon F-1 provides any one of the three methods, depending on your choice of interchangeable focusing screen.

The major problem with automatic exposure systems, especially the less integrated measurement methods, is that one has to be careful which part of the subject is being read by the metering area. If it happens to be a random highlight or deep shadow, the result will be under or over-exposure.

It is possible to avoid this snag, given the time. A reading taken directly from the main part of the subject can be locked into the system while the picture is recomposed and then exposed. This is done by holding down the memory lock button on the camera body.

Another worry with modern cameras is their dependence on batteries, not just to provide power for the exposure meter but also for the shutter. Some cameras provide a single mechanical shutter speed of 1/60–1/100 second, in case of battery failure. Sometimes motor drives can also supply the necessary power to operate the camera fully.

One of the most attractive features of the new Canon F-1 is that it has a full range of mechanical high shutter speeds from 1/2000–1/125 second, also flash synch. at 1/90 second, and B. The slower speeds, from 1/60 second to 8 seconds, are electronically controlled.

Another unique feature of the F-1 is that shutter priority automatic exposure control can be obtained by fitting the camera with its special motor drive or power winder, and aperture priority automation by means of a special viewfinder.

VIEWFINDER EXPOSURE INFORMATION

Viewfinder exposure readings allow you to switch instantly from composing and focusing the image, to checking the exposure, without having to move your eye. The readings vary from camera to camera and these examples are just three out of many.

Left, the Nikon F3 display is clear and uncluttered; aperture and shutter speed shown in separate windows. On manual override, plus or minus signs indicate over or under-exposure. *Centre,* with the Canon F-1 in shutter priority mode, an aperture scale and the selected shutter speed are shown to the right of the screen. *Right,* typical simple display with the over, under or correct exposure indicator illuminated.

EXPOSURE TECHNIQUES

'FREEZING' ACTION

The camera has an astonishing ability to stop high-speed action in full flight and to produce an image of that split-second of suspended movement. This technique is often described as 'freezing' the action and it relies on the use of either a very fast shutter speed or a mechanism that draws the film extremely rapidly across a fixed slit where it is exposed. (The possibilities of flash photography are discussed separately on page 158.)

The slit camera, as employed by Neil Leifer for his picture on pages 86–87, is a very specialized piece of equipment. Fast shutter speeds, on the other hand, are relatively common today, even on quite modest cameras.

The frozen action image can be outstandingly dramatic and also show us details we would otherwise have missed, even as the most privileged spectators. The Grand National picture, right, was taken at 1/1000 sec.

BLURRING ACTION

In 'freezing' action, one sometimes loses the feeling of movement in the picture. Everything is too sharp, too unreal. So photographers have experimented with different kinds and degrees of blur, from highly impressionistic images devoid of precise detail, to more conventional pictures with just a touch of fuzziness about the fastest moving parts of the subject. It is a technique that works best, but not solely, in colour.

The blur is caused by movement of the image during exposure, so that detail is not recorded sharply but instead is streaked across the frame. The effect varies according to the slowness of the shutter speed and the speed, and direction, of movement of the subject, the camera or the lens. In the photograph on the right, the motion blur caused by a shutter speed of 1/15 sec, contrasts with the sharp foreground.

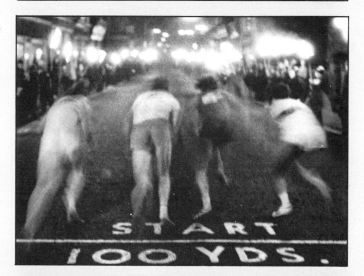

PANNING

Panning with the action is a way of producing a relatively sharp image of a moving subject but blurring the background, so creating a strong feeling of speed and also helping to separate the two elements. The effect in colour can be seen in Fred Joch's photograph on page 69.

A slow shutter speed should be used, within the range of 1/125–1/4 second depending on the subject. The technique is to swing the camera smoothly in line with the movement of the subject and in the same direction, keeping the subject in approximately the same position in the viewfinder. It is important to 'follow through' the movement during and after exposure. This photograph, right, was taken at a shutter speed of 1/30 sec, following the movement of the leading runner.

MEDIUM FORMAT SLR

PENTAX 6×7

This camera offers pentaprism viewing as standard, a feature that gives the camera its characteristic SLR shape. But it is larger and heavier than a 35 mm SLR. With a standard lens it weighs 2235 g whereas a professional 35 mm SLR weighs only 950 g. But the camera's quality, combined with its generous film format, make it the choice of many professionals.

HASSELBLAD

This is one of the most widely used medium-format cameras. Its distinctive feature is the interchangeable magazine at the back of the camera. This enables you to change rolls quickly or to switch instantly from one film type to another. It is shown here with the standard viewing hood, which you can replace with a pentaprism.

Many professional photographers prefer to use medium format cameras. These models use 120, 220 and 70 mm rollfilm, which means that the image actually produced in the camera is much larger than that given on 35 mm film. The two medium formats most often chosen by sports photographers are 6×7 cm (giving an image area of 3850 sq mm) and 6×6 cm (with a 3025 sq mm image area). The obvious advantage over 35 mm (image area 864 sq mm) is that you have to enlarge less to produce a print of the same size, so that there is a significant gain in image quality.

The medium format cameras usually chosen by sports photographers have the same viewing principle as the 35 mm SLR. The Pentax 6×7 model is designed to combine the advantages of the 35 mm SLR with those of the larger format and it is clearly recognizable to 35 mm users as an SLR. It has a pentaprism for eye-level viewing, a focal plane shutter and a single-throw film wind-on lever. In addition, a special pentaprism head is available that also incorporates a TTL meter. The camera is part of a system, which includes interchangeable focusing screens and viewfinders and a range of lenses.

The principal disadvantages of this type of camera are its large size and heavy weight. The massive lenses required to cover the 6×7 format and the bulky pentaprism needed to view the image add considerably to the weight: the standard lens alone weighs about twice as much as a typical standard lens on a 35 mm camera. A further drawback is that lenses tend to have smaller maximum apertures, a particular restriction in sports photography where fast shutter speeds, and the shallow depth of field provided by a large aperture are often needed.

The 6×6 cm (or 2¼ square) camera is another type often favoured by professional photographers. It comes with a waist-level viewing system that eliminates the heavy pentaprism of the 6×7 type. The most unusual feature of this camera is its interchangeable film magazines. You can preload a number of magazines with film before an assignment, which means that changing film is simply a matter of removing one magazine and fitting another. You can also change film type in mid-roll without rewinding your film or risking fogging it by exposure to light. Bulk film backs are also available.

Most lenses for 6×6 cameras have built-in leaf shutters with speeds controlled by a ring on the lens barrel. Leaf shutters allow faster flash synchronization speeds than the focal plane shutters on other types of SLR. Another benefit is that shutter and aperture rings can be connected. With these two controls meshed together, you can turn the combined ring to give a range of equivalent shutter and aperture settings.

The 6×6 SLR most chosen by professionals is the Hasselblad, a camera that forms part of an extensive system. Apart from lenses and film magazines, viewing aids and remote control equipment, specialized motor-driven and wide-angle cameras are available. The accessory viewfinders are especially useful because the image in the standard focusing hood is reversed left-to-right, making it difficult to follow moving subjects in the viewfinder. A pentaprism or a simple frame sportsfinder overcomes this problem.

RANGEFINDER CAMERAS

UNDERWATER CAMERAS

With this type of camera you view and focus through a viewfinder that is separate from the picture-taking lens. A device called a rangefinder produces a double or split image in the centre of the viewfinder until the subject is in focus. Although you do not see the image as rendered by the picture-taking lens, the rangefinder system has several advantages. Focusing is very precise, even if you are using a small-aperture lens in poor light, and the camera is lighter than an SLR. It is also quieter, since there is no mirror that has to move when you press the shutter. This is an obvious advantage in some sports, where noisy cameras can seriously affect competitors' concentration.

The different positions of the viewing and picture-taking lenses can lead to framing errors, known as 'parallax errors', especially when the subject is close to the camera. To overcome this, a brightline frame in the viewfinder defines the area of the image you can see that will actually appear on the film. An incidental advantage of this is that the viewfinder shows a larger area of the subject than the final image, so that you can watch a moving subject enter the frame.

There is a wide choice of 35 mm rangefinder cameras, but most professionals choose from those models that offer interchangeable lenses, such as the Leica M4P and the Minolta CLE.

NIKONOS

Photographers who want to work underwater usually choose the Nikonos, which is purpose-built for this type of photography. It offers aperture-priority automatic exposure; an LED indicator in the viewfinder flashes if there is insufficient light or if the illumination is too bright. To keep camera operation straightforward, the shutter release button also incorporates the meter switch.

LEICA

Leitz produces one of the few rangefinder cameras that accepts a range of interchangeable lenses. When you change lens, the brightline frame in the viewfinder also alters to allow for the different field of view. The Leica's well-proven design, compact size and quiet operation have made it popular with sports photographers.

MINOLTA CLE

The Minolta CLE camera features TTL metering, an unusual feature on a rangefinder camera. Light entering the lens is reflected off the shutter curtain down on to a light-sensitive cell at the bottom of the camera. Readings taken with this method have a high accuracy. The shutter blind itself bears a random pattern, designed to give an even reflection, without bias towards any particular part of the scene.

Occasionally a sports photographer who wants to produce unusual pictures of swimming or other water sports will choose a camera specially designed for use underwater. The most frequently chosen camera is the Nikonos, a 35 mm amphibious camera with its own range of four interchangeable lenses. It has extra-large controls designed specially for ease of use underwater, including two rotating knobs that control focusing and lens aperture. Automatic exposure and a specially produced flashgun help overcome lighting problems and an accessory frame finder can be attached to the camera to simplify viewing.

The Nikonos has a resin-treated body and all the joints and mounts are sealed by O-rings. This makes it safe for use at depths down to about 150 feet (50 metres). But it can also be useful on land, particularly at events such as winter sports, when weather conditions are poor and conventional cameras are likely to break down.

An alternative to an underwater camera is a watertight housing for a 35 mm or medium format SLR. Several professional camera systems offer such housings, and they are safe at even greater depths than the Nikonos. But they are also bulkier, and very costly given their limited range of applications.

Whichever film format you choose the way lenses work underwater is different from their performance on land. For example, water increases image magnification, so you are likely to need shorter focal lengths underwater. The Nikonos range of interchangeable lenses therefore offers 15 mm, 28 mm, 35 mm and 80 mm focal lengths. The greater subject-to-camera distances generally necessary with longer focal lengths can pose further problems. Light diffusion, caused by impurities in the water, can present a particular difficulty if you move too far from your subject.

MOTOR DRIVES

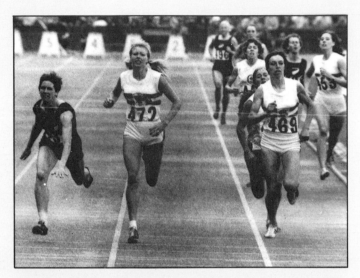

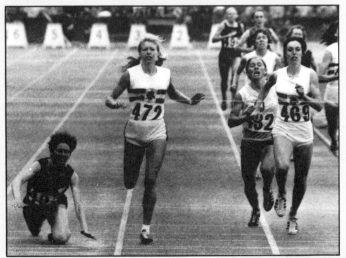

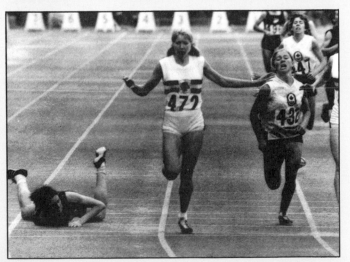

Some people seem to think that the motor drive converts a 'still' camera into a movie camera. They believe that the photographer just presses the button and the motor drive takes care of the rest, capturing the action wholesale. The truth is far different.

Nikon claim that the MD-4 motor drive for their F3 camera is the fastest model in standard production. Its top speed is 6 frames per second, with the viewing mirror locked up. Most motor deives operate at between 3.5–5 fps. Now let us assume that we are photographing a champion skier travelling at 60 mph. That is equivalent to 88 feet per second. With a 6 fps motor drive, the skier would move more than 14 feet between exposures. That is hardly movie standard.

A British photographer tells a good yarn about how he and a colleague set up 4 motor drive cameras fitted with 28 mm and 21 mm wide-angle lenses to photograph a skier leaping over them. The cameras were laid out near a mound of snow and operated at 4 fps on remote control by another inexperienced person. They ran through the stunt several times and took hundreds of exposures. Only three of them included the skier. This is not as surprising as it sounds. With the skier travelling at 60 mph, if the first exposure was mistimed, he would move on 22 feet before the second exposure was made and so out of a moderately tightly composed photograph.

Power winders usually work at about 2 fps and are not widely used by pros. The saving in weight does not compensate for the loss of operating speed. A professional may not always draw on that full speed but it is good to know that it is there if necessary.

In fact, amateurs may not realize how often a pro will operate the motor drive in single shots. Its huge advantage in everyday use is that it advances the film automatically, so you do not have to alter your grip or move your face from the viewfinder to wind on manually. You can concentrate on the subject and be instantly ready for the next exposure. The best photographers prefer to wait for the precise moment to take a picture, rather than firing off a burst as soon as the situation looks promising. Then there are times when the action is developing so rapidly that sequence firing is the obvious answer and the motor drive comes into its own.

The set of pictures on the left was taken with a Nikon F camera and one of the early motor drives working flat out. Just before the athletes reached the tape in this middle distance event, the legs of the girl on the left just seemed to buckle under her and she collapsed on the finishing line. Thanks to the motor drive, the photographer was able to capture the entire incident.

There are certain sports where the motor drive needs to be used with special discretion and consideration for the competitors. Golf is an obvious example but in fact, any occasion when the racket of a motor drive could cause a distraction.

Andy Hayt partly muffled the noise of his motor drive with a simple blimp case when he shot the sequence of Tom Watson missing a million dollar putt (pages 132–3), but he still waited until the ball began to roll before making an exposure.

REMOTE CONTROL
AND SPECIALIST CAMERAS

MOTOR DRIVE CONTROLS
Rear view of the Nikon MD-4 motor drive for the F3 camera, showing the controls for both motorized film advance and rewind. It is powered by eight AA batteries, as shown, or by rechargeable NiCads. A mains unit is also available.

MODULITE REMOTE CONTROL SET

Nikon's Modulite Remote Control Set will trigger the MD-4 motor drive for the F3 camera or the MD-12 motor drive for FM2 or FE2 cameras, at distances up to 200 feet. A receiver is mounted on the camera and the hand-held transmitter can send a modulated-light signal either directly or indirectly, by reflection. However, it does have to be accurately aimed.

MOTOR DRIVE OPERATION

A motor drive screws into the tripod bush in the camera baseplate and links up through contacts with the camera's film-wind mechanism. It can be operated on single frame or continuous run and it can also be locked to avoid accidental exposure. Sometimes it also provides powered film rewind. Operating speeds vary according to the model and the type of battery power. At the highest speeds, the viewing mirror should be locked up to prevent undue mechanical strain.

250 EXPOSURE BACK

A 250 exposure back can be fitted to the Nikon F3 camera and MD-4 motor drive, a useful accessory for a unit that can operate at 6 fps.

Canon offer a 100 exposure film chamber for the new F-1 camera, compact and light enough, they claim, for hand-held sports photography.

REMOTE CONTROL OPERATION

The choice of remote control accessories includes the pneumatic release (slow to respond) and the electronic push button cord, which are suitable for shorter distances. The Modulite light-pulse set, as described above, and the infra-red beam system, as offered by Canon, can be used from about 200 feet. Radio remote-control can operate at distances up to almost half-a-mile.

HULCHER MODEL 112
This camera uses bulk 35 mm film and can work at up to 60 fps. It takes Nikon lenses, or others as adapted, and focuses through the lens. 70 mm film models are also available.

HASSELBLAD 500EL/M
This is the system's motorized camera and operates at a speed of just over 1 fps. Remote control accessories and an interval timer are also available.

LENSES

A lens redirects the rays of light that come from the subject so that they create an image on the film. The most important influence on the way that a lens forms an image is its focal length. This is the distance from the rear nodal point of the lens (the point from which the light rays seem to have come when they have passed through the lens) to the film plane. Cameras normally come supplied with a single standard lens. This is a lens with a focal length approximately equal to the diagonal of the film format. So a 50 mm lens is standard for 35 mm cameras while rollfilm cameras normally take an 80 mm or 90 mm standard lens. But many other focal lengths are available for both formats and professionals carry a number of lenses because of the variety of effects they can achieve. In particular, lens focal length influences the amount of a scene that is reproduced on the film, the degree of image magnification, and how much of the subject is sharply focused.

ANGLE OF VIEW AND PERSPECTIVE

The focal length of a lens controls the amount of a subject that you can include in the frame. The shorter the focal length of a lens, the wider its angle of view and the more of the subject you can include. A 50 mm standard lens gives an angle of view of 46°, while a 24 mm wide-angle gives 84° and a 200 mm telephoto about 12°. But image magnification increases with focal length, so that although the telephoto reproduces less of the subject, it magnifies the part it does include, bringing distant objects closer. Telephoto lenses are particularly useful to photographers for this reason. In many sports even a professional is not allowed to get really close to the action.

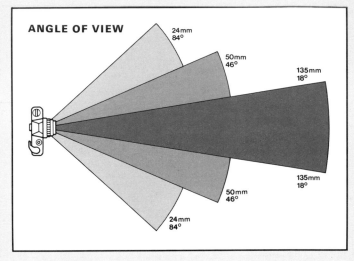

ANGLE OF VIEW

The longer the focal length of a lens, the narrower its angle of view.
Above, the angle of view of the 50 mm standard lens for 35 mm cameras, the popular 24 mm wide-angle and the 135 mm telephoto.

But the use of different focal lengths is not restricted to accommodating larger or smaller areas of the subject from the same camera position. If you change your viewpoint you can soon see how focal length influences the perspective of the image. Move close up to an athlete with a wide-angle lens and notice how the figure dominates the frame, with background objects diminishing in size and importance the closer you get. A telephoto produces the opposite effect from a distant viewpoint. Objects appear closer to each other and the image perspective seems 'squashed'.

APERTURE AND DEPTH OF FIELD

The other important feature of any lens is its maximum aperture. As well as regulating the intensity of light that enters the camera the aperture influences the amount of the subject that is sharply focused. The distance between the nearest and farthest points in a scene that are sharp is known as the depth of field. The wider the aperture, the shallower the depth of field. Depth of field is also influenced by the focal length of the lens. The shorter the focal length, the more extensive the depth of field. In sports photography, where confusing backgrounds are often a problem, it is often useful to keep depth of field to a minimum, so that only a single figure, or even a face, is in focus.

Sometimes it is desirable to maximize depth of field. You can do this by focusing on the hyperfocal point. This is the closest point to the camera that is sharp when the lens is focused on infinity. If you focus on the hyperfocal point, the image will be sharp from infinity to a position halfway between the camera and the hyperfocal point itself. For example, if the hyperfocal point at f11 is at about 30 feet, and you focus on this point, everything in the frame more than about 15 feet away will be absolutely sharp.

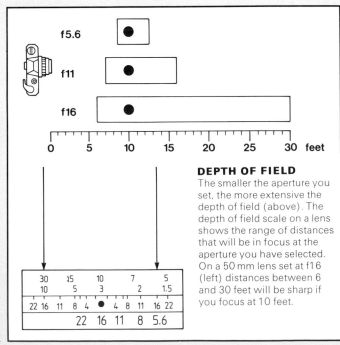

DEPTH OF FIELD
The smaller the aperture you set, the more extensive the depth of field (above). The depth of field scale on a lens shows the range of distances that will be in focus at the aperture you have selected. On a 50 mm lens set at f16 (left) distances between 6 and 30 feet will be sharp if you focus at 10 feet.

WIDE-ANGLE LENSES

Wide-angle lenses have a short focal length compared to the diagonal of the film format they are designed to cover. As well as general-purpose wide-angles (with focal lengths from 35 mm down to 24 mm) there are the so-called ultra-wide-angle lenses with focal lengths from 20 mm to 13 mm. If you tilt the camera when using a focal length below 20 mm, the image will be dramatically distorted, but if you use them with care, holding the camera horizontally, wide-angles give only minimal distortion.

Most camera manufacturers produce at least one 35 mm wide-angle, but with an angle of view of only 62° its effect is hardly dramatic. But some photographers, who find a 50 mm standard lens rather narrow for most assignments, often use a 35 mm lens as standard. If you do this you do not sacrifice the 50 mm lens' maximum aperture since 35 mm f1.4 lenses are included in some systems.

The most popular wide-angle is the 28 mm lens, which combines low distortion with a 74° angle of view. But the majority of sports professionals, while carrying a 28 mm lens, also use a 24 mm lens, which gives a more generous 84° angle of view. This focal length also gives greater depth of field, without creating exaggerated distortion or being too bulky – recent developments in optical glass have allowed lens designers to reduce the size of this lens considerably.

For more spectacular image effects you must use one of the ultra-wide-angles. You have to use these lenses with great care, paying particular attention to objects in the foreground. At focal lengths as short as 15 mm it is difficult to avoid distorting objects at the frame edges, but sometimes one can make use of this quality, adding a dynamic element to the image.

A particular problem with the shorter focal lengths is protecting the large curved front element of the lens. Both 13 mm and 15 mm lenses suffer from this drawback. While their curvature is not as extreme as that on a fisheye lens (see page 155), it still protrudes appreciably from the front of the lens barrel and many photographers would not want to risk using this expensive piece of equipment if it was likely to get damaged. As a compromise, a 20 mm lens is more compact, lacks the bulging front element, and still has a 94° angle of view.

Another difficulty with these lenses relates to unwanted flare, which sometimes appears when you are shooting towards the light. You should use the appropriate lens hood (the wrong one can cause vignetting) and it is worth stopping down to the aperture you want to use to see the full effect on the image. On the shorter focal lengths, filters can also pose a problem. Some lenses have filters built-in while others take only filters that you attach to the back of the lens before fitting it to the camera.

Most of the features of wide-angle lenses can be turned to advantages in sports photography. This is true whether you are using the lens' wide angle of view to show the vast proportions of an entire stadium, or moving up close to a smaller subject, to create a dynamically distorted image of a single moving figure.

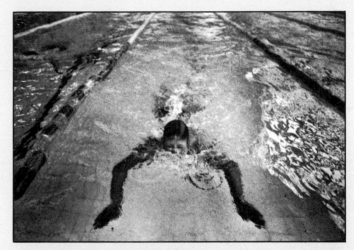

These two photographs taken from roughly similar positions and distances, show the different effects of 24 mm wide-angle (top) and 105 mm telephoto lenses.

TELEPHOTO LENSES

These lenses, with focal lengths longer than the diagonal of the film, give you the opportunity to make distant objects seem nearer and larger. The range of telephotos is enormous, and most have an important role to play in action photography. They extend from a modest 85 mm lens that is only a little longer than standard, to large and expensive super-telephotos with focal lengths from 600 mm to 1200 mm.

Although telephotos are large and heavy, most professionals carry a number of different focal lengths on all their assignments. These would include 135 mm, 200 mm, 300 mm, 400 mm and 600 mm telephotos, though some photographers might take a more restricted range of focal lengths, together with a set of teleconverters (see page 155), if it was important to travel light. Another way of eliminating some of these lenses is to use a zoom. But zooms have one particular disadvantage. They do not have the wide maximum apertures of fixed-focal-length lenses.

Wide maximum apertures are particularly important in sports photography for a number of reasons. First, they make it easier to shoot successfully in low light when it is difficult or impractical to use flash. Second, a wide aperture is often necessary to balance a fast shutter speed when the photographer wants to 'freeze' a moving subject. And third, wide apertures give the shallow depth of field that is often useful when you want to separate a subject from its background. For all these reasons, professionals are prepared to pay the extra cost of wide aperture long lenses, and to put up with their additional bulk and weight. Both of these are considerable. For example, a 200 mm f2 lens is almost twice as long and five times as heavy as the 200 mm f4 type chosen by most amateur photographers. The f2 lens is also much more expensive. But the photographic opportunities offered by these lenses mean that a professional will often choose a 300 mm f2.8, a 400 mm f3.5 and a 600 mm f4 as well as the 200 mm f2.

Telephotos pose a number of practical problems which are exaggerated when the subject is moving. Supporting a long, heavy lens so that it is steady enough to take sharp pictures is one difficulty. The best solution is to use a tripod or a monopod.

Another difficulty when using a telephoto with moving subjects is focusing quickly enough, especially if you want to take advantage of the lens' shallow depth of field at maximum aperture. Some photographers find that a rapid focusing grip such as the Novoflex offers the solution. This has the added

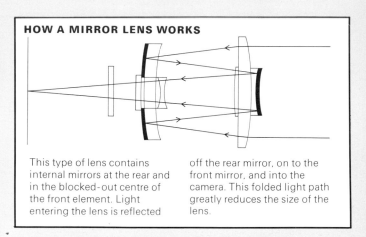

HOW A MIRROR LENS WORKS

This type of lens contains internal mirrors at the rear and in the blocked-out centre of the front element. Light entering the lens is reflected off the rear mirror, on to the front mirror, and into the camera. This folded light path greatly reduces the size of the lens.

benefit of providing steady support for the lens. It allows you to operate the lens focusing control by squeezing a trigger, while you fire the shutter with your other hand, pressing a button that is connected to a motor-drive. You can also use the unit without a motor-drive, firing the camera shutter manually in the normal way. With short telephotos, some photographers use a pistol grip. This steadies the camera and lens, and provides a shutter release button, but you have to focus manually.

MIRROR LENSES

Lens designers have found one ingenious way of cutting down on the size and weight of telephoto lenses. This is to use mirrors inside the lens to 'fold up' the path of the light that passes through. Lenses with this design are called mirror lenses; (they are sometimes known as reflex or catadioptric lenses). The compact design and light weight of these lenses means that they are easy to use without the elaborate supports often necessary with conventional telephotos – you can hand-hold a 500 mm mirror lens at fast shutter speeds without fear of camera shake. Mirror lenses will also focus sharply at closer subject distances than conventional lenses of the same focal length.

But there are also some drawbacks with this type of lens. Apertures are not adjustable and are small by professional standards. A typical 500 mm mirror lens has an aperture of f8, useful in many applications but not ideal for action photography. In addition out-of-focus highlight areas always appear as doughnut-shaped blurs in images taken with a mirror lens. With some subjects this effect can be attractive, but it appears so regularly that pictures taken with these lenses can easily seem monotonous unless the sharply focused part of the subject forms a strong image in its own right. For this reason most photographers use these lenses only sparingly, for subjects with a plain background or when no other lens will produce the desired effect. Another reason for using a mirror lens would be to obtain the benefits of an extremely long focal length. Both 1000 mm and 2000 mm mirror lenses are available, though few photographers would buy lenses of such limited use – they would hire them for particular assignments.

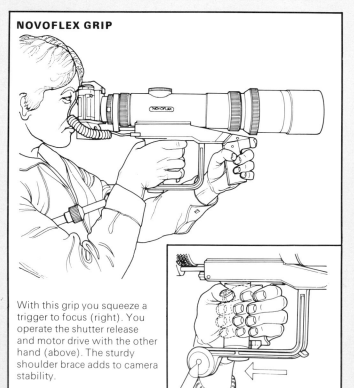

NOVOFLEX GRIP

With this grip you squeeze a trigger to focus (right). You operate the shutter release and motor drive with the other hand (above). The sturdy shoulder brace adds to camera stability.

TELECONVERTERS

Using a converter to increase the focal length of your lens is another way of cutting down on heavy equipment while still having a range of lens options. Since optical quality is enhanced if you match lens and converter, most photographers use more than one. Two X 2 teleconverters, one for lenses up to 200 mm, another for those of 300 mm and above, are useful. With these, your 200 mm lens can double as a 400 mm and your 300 mm as a 600 mm.

The drawback of teleconverters, apart from a slight loss in image quality, is that they decrease the maximum aperture of the lens. A 200 mm f2 lens, when used with a X 2 teleconverter, becomes a 400 mm f4. For this reason Nikon produces a X 1.4 converter which gives only a one-stop cut in lens aperture – an f2 lens has its aperture decreased to f2.8. An additional advantage of this design is that the smaller magnification results in only a minimal difference in optical quality.

FISHEYE LENSES

One special lens type sometimes used by sports photographers is the fisheye lens. This is a lens with a focal length even shorter than a wide-angle that produces dramatically distorted images. There are two types. Full-frame fisheyes have a focal length of about 16 mm and fill the whole of the film format. Circular-image fisheyes, with 8 mm and 6 mm focal lengths, cannot produce an image that will cover the entire film format. All lenses produce a circular image, though the camera normally uses only a section of this to cover the film. But fisheyes, in order to encompass an angle of view of 180° or even 220°, vary image magnification according to distance from the centre of the frame. A circle, using the entire image produced by the lens, is appropriate for an image with this varying magnification.

Because fisheyes are expensive lenses with only limited applications, few photographers own more than one. Most choose a 16 mm full-frame lens, and hire the shorter focal lengths when they are needed. The advantage of the 16 mm lens is its compact size: it is only slightly larger than a standard lens. This makes it easier to use than circular-image types. In addition, it lacks the protruding front elements of the 8 mm and 6 mm lenses, which are very vulnerable to damage.

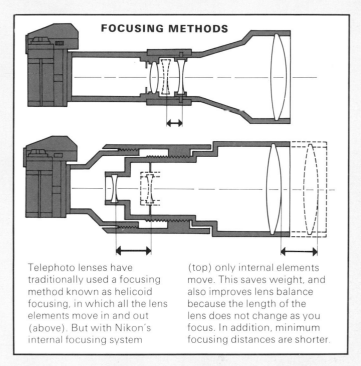

FOCUSING METHODS

Telephoto lenses have traditionally used a focusing method known as helicoid focusing, in which all the lens elements move in and out (above). But with Nikon's internal focusing system (top) only internal elements move. This saves weight, and also improves lens balance because the length of the lens does not change as you focus. In addition, minimum focusing distances are shorter.

LENSES FOR MEDIUM FORMAT CAMERAS

A range of interchangeable lenses is also produced for medium format cameras. The standard lens for 6 × 6 cm cameras has an 80 mm focal length, while 6 × 7 cm cameras take a 90 mm standard lens. Wide-angles between 38 mm and 75 mm, and telephotos from 105 mm to 800 mm are also available. Although focal lengths are made for most applications, the choice is more restricted than for the 35 mm format. Lenses are also larger and heavier, but optical quality is very high. Bigger lens elements, lower demand, and the fact that some brands contain built-in leaf shutters, make these lenses more expensive than their 35 mm counterparts.

FISHEYE CONSTRUCTION
The most prominent feature of a fisheye lens is its large light-gathering front element. This protrudes from the front of the barrel, making the lens extremely vulnerable to accidental damage. For this reason, and because fisheyes are large and heavy, most photographers only carry them if they are required for a particular assignment.

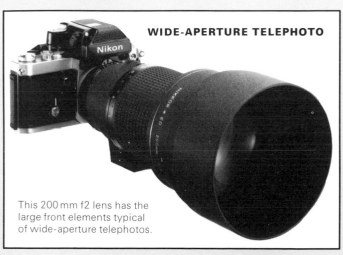

WIDE-APERTURE TELEPHOTO

This 200 mm f2 lens has the large front elements typical of wide-aperture telephotos.

FILMS AND FILTERS

COLOUR FILM

The demands of magazine and book publishers mean that most professional sports photographers shoot mainly in colour. The majority of them have a personal preference for colour in any case – sport provides colourful subject matter and only a few photographers, such as Chris Smith, favour black and white. Slide film, rather than colour negative material, is usually chosen. It is easier to store a larger number of positive images on file, printing from transparencies is straightforward and there is a wide range of film speeds on the market. Many professionals standardize on one particular film type, so that they can get to know exactly how it will respond in every photographic situation.

There are many types of slide film available, but for most photographers the choice is between Kodachrome and Ektachrome. Kodachrome is the most popular film, provided that lighting conditions are good enough for its relatively slow speeds of 25 ASA or 64 ASA. It produces strong, warm colours and its grain is fine, giving high-quality enlargements. Ektachrome is available in a range of speeds, but the 400 ASA High-Speed Ektachrome is particularly useful because of its sensitivity in low light, though its colours are certainly cooler and its grain is coarser.

There is one other important difference between the two films. Ektachrome has colour couplers built into the emulsion, whereas Kodachrome does not. This means that Kodachrome has to be sent back to the manufacturer for processing, whereas any colour laboratory will process Ektachrome. This makes Ektachrome a quicker film to process, an important factor when you are working to tight deadlines.

One additional factor affects the choice of colour film. Most films are designed to work well in daylight or when you are using flash. But other types of lighting have a different colour content or 'colour temperature', and a cast will appear if you use the wrong film. So-called 'tungsten' film, which is balanced to suit the colour temperature of tungsten studio lights, is designed to overcome this problem. But if neither film type suits your particular lighting, you can use one of a series of colour-balancing filters to improve colour rendition.

BLACK AND WHITE FILM

When working in black and white, most photographers use Ilford HP5 or Kodak Tri-X, both 400 ASA films. This is fast enough for most situations and can be 'pushed' to provide extra speed when this is required. For even greater flexibility one of the newly developed chromogenic dye films, which you can rate at speeds between 125 and 1600 ASA, can be used.

HOW FILTERS WORK

Filters work by absorbing part of the light that comes from the subject before it reaches the film. Most photographers carry a number of filters because these accessories have a number of important uses apart from the creation of special effects. A skylight or UV filter is one of the most useful. It cuts out haze, but many photographers leave one on each lens to protect the front element.

Single-colour filters absorb all light except that of their own colour. As well as producing unusual images when you are working with colour film, these filters are also useful for the black and white photographer. A yellow or green filter will darken the sky tones, while a red filter will show this effect more strongly. The filter will also lighten the tone of any object of its own colour; a green filter will make vegetation appear lighter, for example. If you only want the filter to affect the sky, you can use a graduated colour filter, strongly coloured towards the top and clear at the bottom.

Another useful filter is the polarizer. This allows you to deepen the colour of blue skies while other subject colours remain unchanged. It can also be used to suppress reflections from glass or water. It works by blocking the polarized light that is reflected. Polarizers are not easy to use because it is often difficult to see their effect through the viewfinder. You have to rotate the filter until the maximum effect is reached, but it is often easiest to take several shots at different degrees of rotation.

Some photographers also carry neutral density filters. These reduce the amount of light entering the lens without influencing colour or tone. They therefore provide a way of controlling exposure when the available combinations of shutter and aperture settings are inadequate. With cameras now available offering shutter speeds as fast as 1/4000 second, it is unlikely that neutral density filters will be used widely. But if you want to show subject movement by producing a blurred image, and the light is too strong for a slow shutter speed, a neutral density filter could still be useful.

You normally attach filters to the front of the lens, either by screwing them into the specially provided filter thread or by using a holder which also incorporates a lens-hood. Some lenses, particularly mirror lenses and fisheyes, have a front element that is too large for accessory filters. Most of these lenses have filters built in or fitted to the rear element.

EXPOSURE METERS

Although most cameras contain a through-the-lens exposure meter, few photographers trust it in every situation, and most carry at least one hand-held exposure meter. This is because camera meters can easily give readings that are misleading, even if they are accurate. For example, a camera meter that makes centre-weighted measurements will not necessarily give the best reading if the main part of your subject is not in the frame centre. It is possible to overcome this difficulty by re-aiming the camera after you have made a reading, but most professionals prefer to use a more versatile hand-held meter.

Among sports photographers, the most popular meter is the Minolta Flashmeter III, a model that has proved its worth in available-light photography as well as in flash work. It is chosen for its accuracy, ease of use, clear digital readout and versatility. Because exposure meters are delicate and essential pieces of equipment, many photographers have two of these general-purpose models. In addition, some also use a spot meter. This has a very narrow angle of view, ideal when using long lenses, or when you want to measure the light from a small area of the subject. If a tiny but important part of a subject is lit very differently from the rest of the scene, a spot meter is ideal.

USING HAND-HELD METERS

If a subject is evenly lit and does not show any dramatic variations of light and dark tones a simple reflected reading of the subject will be adequate. To make this type of measurement you stand at the camera position and point the meter's light-sensitive cell directly at the subject. Most general-purpose meters have an angle of view similar to that of a standard lens, so if you are using a wide-angle lens, you should remember to take into account illumination around the edges of the scene.

If the subject is not lit evenly, with bright highlights or deep shadows, an incident reading will give a more accurate result. To achieve this you use a white diffusing dome that fits over the

MINOLTA FLASHMETER III

Minolta's versatile meter gives a digital readout and incorporates a conical diffuser for incident light readings.

MINOLTA SPOTMETER M

This meter takes readings from a 1° angle but, for ease of aiming, shows a 9° view of the subject in the viewfinder.

meter cell and aim the meter at the sun. When subject contrast is very high, it is often worth making both an incident and a reflected reading and averaging the two. A spot meter is also useful in difficult lighting situations. If you do not have a specially made spot meter, some conventional meters have an attachment to reduce their angle of view, allowing you to take spot readings.

REFLECTED READING

You point the meter directly at the subject, to measure the light it reflects.

INCIDENT READING

Using the diffuser, you read light which is coming from the sun itself.

SPOT READING

Looking through the meter's viewfinder, take a reading from the subject.

Automation has increased in flash photography as in other areas of the medium. The latest dedicated flash units are automatically integrated with the camera's electronic system, simply by sliding them into the camera's hot shoe or using a remote control cable. The flashgun is automatically fed the film-speed set on the camera and gives a viewfinder signal when it is fully charged ready to fire. The camera automatically sets the correct flash synch. shutter speed.

One of the advantages of most professional flash equipment, as with other advanced photographic systems, is interchange-ability, giving maximum flexibility, convenience and efficiency of operation. For example, the Bowens Quadmatic system is based on a power pack with a maximum output of 1500 watt/seconds. Two packs can be combined to double the output or four packs to quadruple it. Two flash heads can be used directly from each pack or more via a splitter box. A wide range of standard and specialized heads, reflectors, stands, remote control triggering devices and other accessories is available.

On the more advanced cameras, a light sensor built into the body directly measures the amount of light striking the film and automatically controls the output of the flash. This operates at any pre-set aperture within the given distance range, which will, of course, vary considerably according to the power of the flash unit.

Most 35 mm cameras used to be synchronized for flash at a shutter speed between 1/60–1/90 second. This caused problems when the existing light was sufficiently strong to record a 'ghost' image around the flash exposure. Under such conditions, professional photographers, as some of them have explained earlier in the book, would sometimes switch from 35 mm cameras to leaf-shuttered rollfilm models, such as the Hasselblad or the Rolleiflex, which offered flash synch. up to 1/500 second.

The situation has altered somewhat with the introduction of the Nikon FM2 and FE2 cameras which can be synchronized at 1/200 second and 1/250 second respectively. It makes sense for the Nikon user to carry one of these bodies for flash work and so take advantage of the range of other Nikon lenses and accessories. That is why an FE2 body was included in the system diagram on page 143.

AUTOMATIC FLASH EXPOSURE
This diagram illustrates the operation of the Minolta CLE camera and its dedicated flash unit. Light from the flash strikes the subject and is reflected on to the film where it is measured by a light sensor built into the camera body. Once the correct exposure has been reached, relative to the pre-set aperture, the flash output is automatically terminated.

INTERCHANGEABLE FLASH REFLECTORS
Four of the many varied reflectors for the Bowens Quadmatic flash system. *Top left:* deep reflector giving a very even spread of light over a 50° angle. *Top right:* barn doors limit the spread of light. *Bottom left:* an umbrella reflector diffuses the light. *Bottom right:* the snoot highlights an area about 2 ft in diameter from 5 ft away.

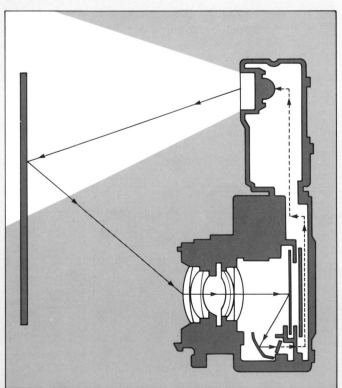

INDEX